A sign is something
by knowing which
we know something more

Charles Sanders Peirce

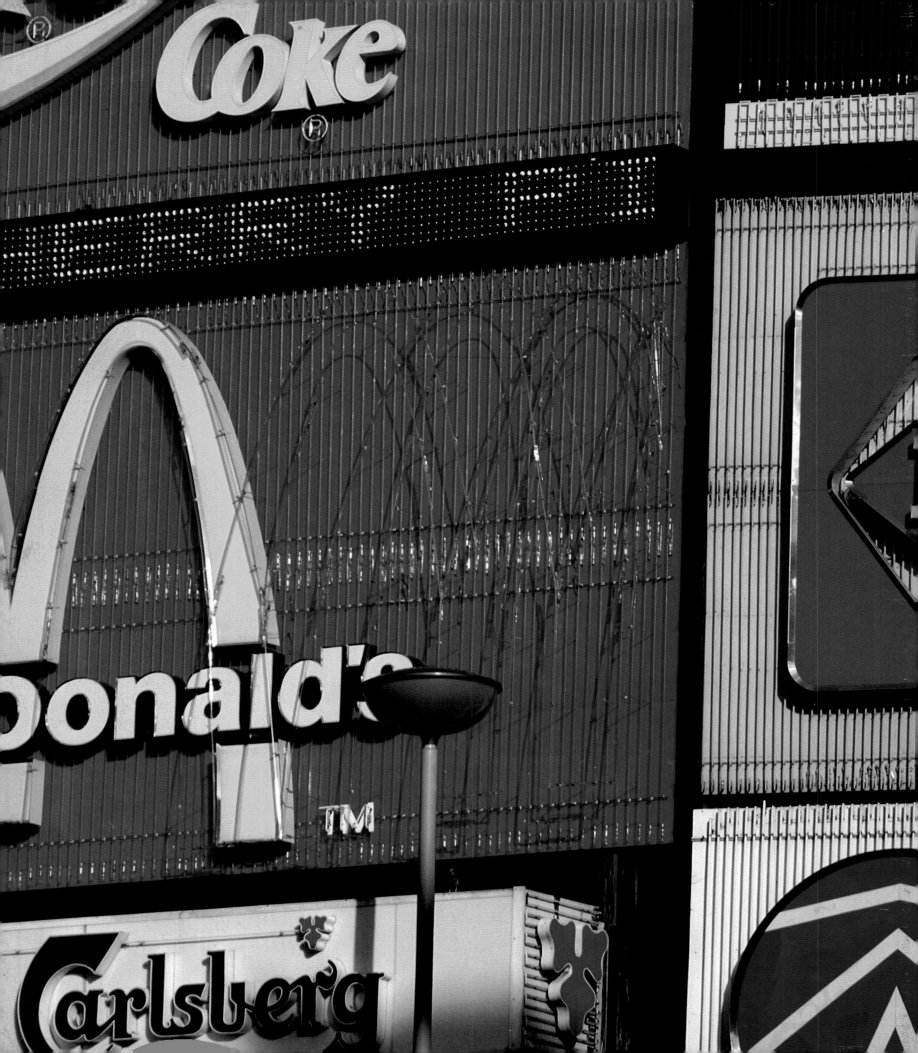

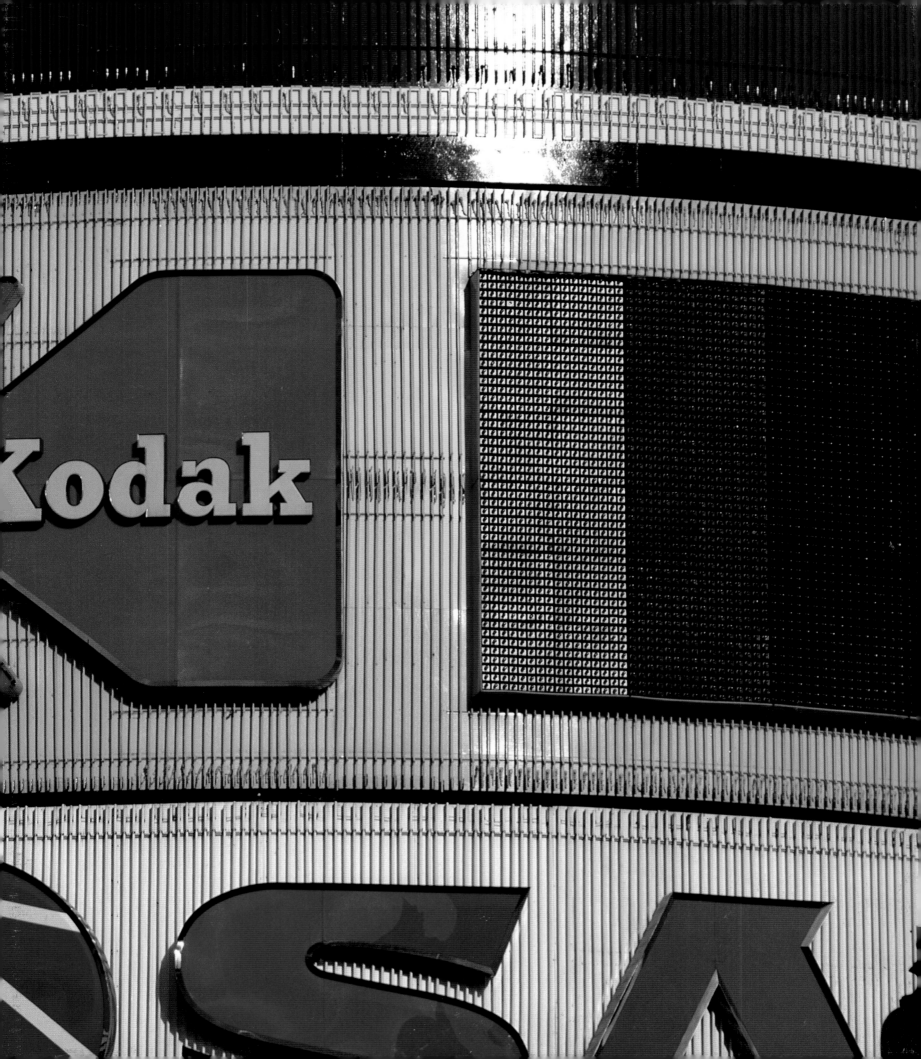

Per Mollerup

Marks of Excellence

The history and taxonomy of trademarks

Contents

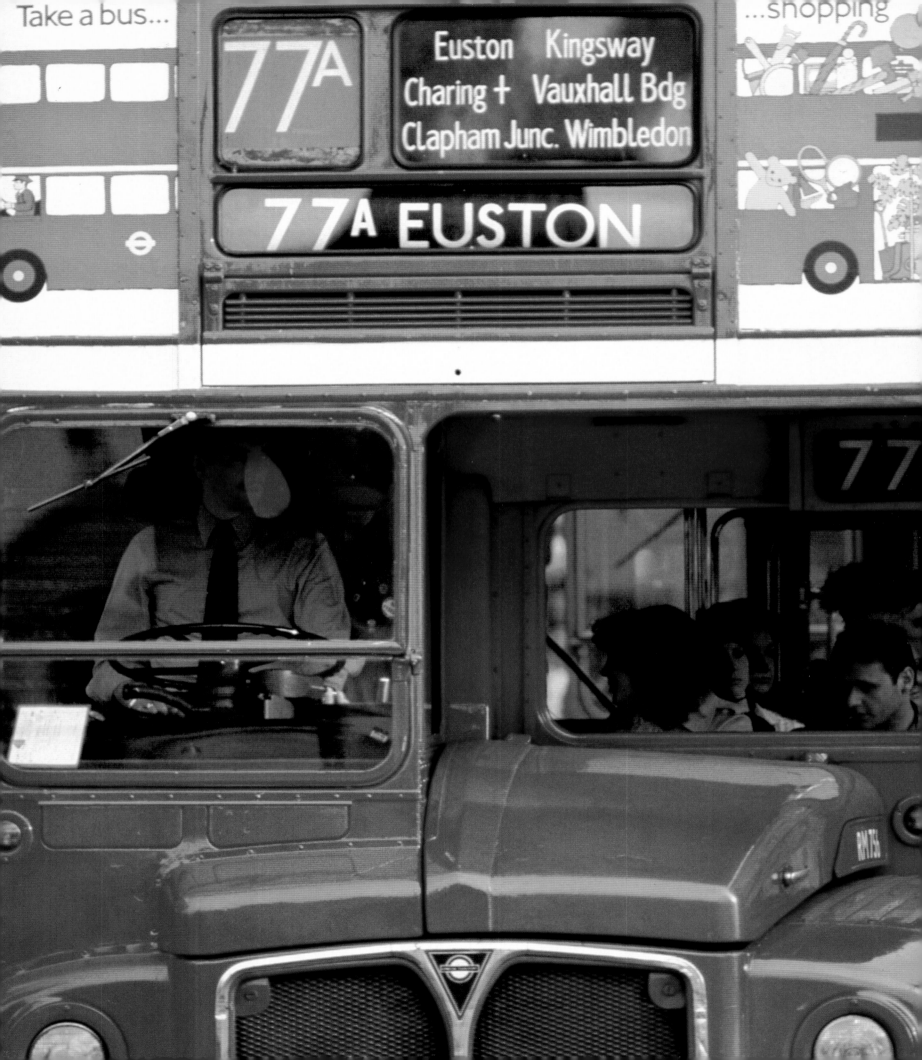

Introduction

A trademark is a sign. The sender of a trademark
uses his mark to identify himself to the world.
This he may do in one of three ways: he may
identify himself as an owner, as a manufacturer
or simply as the sender of a message. All three
types of identification can be seen on a
typical London bus: the trademark above the
radiator grille on the front of the bus tells us that
London Transport owns it (left); Leyland will
display its trademark saying that it made it; and
the trademark on the advertising streamer tells
us that the Tate Gallery is sending us a message
(below, left).

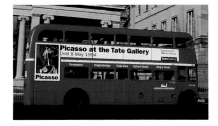

1
Opening pages
Piccadilly Circus, London.
Trademarks are everywhere.
This omnipresence enables
companies like Kodak,
Coca-Cola, McDonald's and
Carlsberg to maintain their
position as world brands.

2–3
Highly visible and forever
on the move, the London
double-decker bus carries
a number of trademarks.

What do you have to say about Swissair's new route to Atlanta?

On March 29, 1987, the United Swissair Destinations of America will include a city which is not only the home of a world-famous soft drink, but a hub for the entire Sun Belt. Offering countless connections to the American South and West. So what do you have to say about Swissair flying there nonstop, pampering you all the way in its First Class, Business Class or Economy Class? Just take a look above and you'll find the answer right before your eyes.

swissair

The main purpose of *Marks of Excellence* is to look at the nature of trademarks and the way that they produce meaning. In so doing, the book should also encourage clients to commission trademarks that are both distinctive and descriptive, and inspire designers to design them.

In spite of their omnipresence, very little has so far been written about trademarks. An exception is the subject of legal protection of trademarks, which has been dealt with in depth elsewhere, because of the economic implications. As legal protection differs from country to country, and as this book focuses on the function of trademarks per se, legal protection is not explored here.

The three examples of trademarks on a London bus establish that trademarks are signs and, more specifically, visual identifiers. As signs, they should permit fast identification. It is easier and faster to 'read' the Jaguar radiator mascot of a car than to read the written name of the make. The words 'Coca-Cola' are more immediate in the instantly recognizable script of their trademark than in another typeface.

Apart from serving the purpose of identification, a trademark can also allude to the nature of a company or a product. For example, the leaping jaguar suggests that the car and the cat share the relevant qualities of speed and elegance. The name Coca-Cola was coined to tell the customer that the coca leaf and the kola nut are important ingredients of the drink.

A trademark occasionally does more than individualize a company or its products and say something about them. It can have a value in its own right, and that value adds to the value of a company, a product or a service. Companies may develop the trademark through advertising and by their reputation. In either case, the product is worth more with the trademark than without it.

Identification, description and the creation of value are just some of the possible functions of a trademark. To explain how trademarks function, this book looks at a selection of trademarks from a number of different angles. No single discipline offers an exhaustive explanation.

The study of trademarks has its roots in fields as diverse as anthropology, history, heraldry, psychology, marketing, semiotics, communication theory and, of course, graphic design.

The first chapter of this book is concerned with the historical roots of modern trademarks. It traces the earliest examples back some 5,000 years.

Evaluating a trademark implies a broad knowledge of the context in which the trademark must be used. The second chapter deals with this functional context. In the third chapter, trademarks are discussed in the light of communication theory, of semiotics and their production of meaning; a list of practical requirements of trademarks is also presented. In the fourth chapter the central theme of the book – the classification, or rather the characteristics of trademarks – presents itself. The fifth chapter addresses a number of issues about trademarks and classifies further examples within the taxonomy presented in chapter four.

The sixth and final chapter is concerned with the development and evolution of trademarks over time. No design is timeless, and trademarks must occasionally be updated. A trademark may be supplemented by a small family of marks, or expanded from two to three dimensions and transformed into sculpture. Sometimes a trademark is translated for use in other languages and other cultures.

The theory of trademarks presented here is based on empirical data. Practical experience, studies of communication theory, semiotic analysis and theoretical sampling provide the findings in this book.

5
Trucks are irresistible rolling billboards to trademark owners.
Company The Coca-Cola Company, USA.
Design Frank M Robinson, 1887.

6
This still from a TV commercial shows how under normal circumstances airlines proudly display their trademarks.
Company Lufthansa, Germany.

7
After a crash, many airlines follow the standard procedure of covering the aircraft's identification marks, even if there are no deaths or serious casualties. One example was the 'happy' SAS crash landing north of Stockholm's Arlanda airport on 26 December 1991.
Company SAS, Denmark, Norway, Sweden.

4
In this advertising poster Swissair has used part of the Coke trademark to endorse its own services. Even reduced to two letters, the trademark is immediately recognizable.
Company Swissair, Switzerland.
Design CGK Zurich, 1987.

8
Overleaf
Piano players are never in doubt what instrument they are playing. Many can hear it, more can see it.
Company Steinway & Sons, USA.

History

Trademarks, or devices with the function of a trademark, have existed for at least 5,000 years. Some, such as ceramic marks, continue to be used today; others, such as heraldic marks, are often quoted or paraphrased in modern designs. Even the idea of the visual pun on a name was used in ancient canting arms. Historically, trademarks have been primarily 'senders' marks, which are more concerned with the person sending them than the receiver.

Motivation

The historical forerunners of modern trademarks evolved from the need and desire for social identification on the part of the individual or group. They were a means of establishing the distinguishing character of something.

A farmer may mark his cattle to protect them against theft: a potter may mark his bowl out of sheer pride. There is no mutually exclusive relationship or implied dominance between need and desire; historically, these motivations can be related to social life, war, commerce, traffic and sport as well as other leisure activities.

These early equivalents of trademarks were used to state identification in three ways:

Social identity: who is this or who says that

Ownership: who owns this, and

Origin: who made this

The three types of statement, coupled with the two types of motive, give six possible motive/statement combinations.

We do not know when someone first demonstrated identity, ownership or creative and productive parenthood by means of a graphic device. We can, however, assert that the first attempts in all three categories were made with pictures and not with letters.

Perhaps the first 'graphic' identification mark was an owner's mark. It may have been a simple sign to show that a weapon belonged to a particular man.

Certificates of origin have probably existed for as long as mankind has had specialized occupations and traded goods. The urge to take credit, to show pride and to claim responsibility must be universal and at least partly rooted in psychological need.

Early craftsmen in many trades demonstrated pride and responsibility by marking their products. This tradition was continued in the first craft-based industries. The shapes of makers' marks

were conditioned by the physical material in which the craftsman worked: ceramics, stone, paper, silver or wood.

While the exact origin of trademarks cannot be proven, some early precedents can be shown. The categories of trademark precedents are carefully chosen, in terms of both purpose, ie the kind of statement, and visual form.

It is a reasonable assumption that all the social identity marks and all these certificates of origin are the results of both need and desire. It is equally safe to assume that branding, earmarks and farm marks have almost exclusively been inspired by need.

Marks	Statement	Motive
heraldry	social identity	need/desire
monograms	social identity	need/desire
branding	ownership	need/(desire)
earmarks	ownership	need/(desire)
farm marks	ownership	need/(desire)
ceramic marks	origin	need/desire
stonemasons' marks	origin	need/desire
hallmarks	origin	need/desire
printers' marks	origin	need/desire
watermarks	origin	need/desire
furniture marks	origin	need/desire

Table one Trademark precedents

Heraldry

Today, the word 'heraldry' has two meanings; it refers to both armorial signs themselves as well as to their study and design. The term originates from *ars heraldica,* the art of the herald. The herald was an official at medieval tournaments of arms who was responsible for the identification of fighting knights. He would scrutinize the insignia of prospective combatants and announce their identity to the spectators. As the knights were often covered by armour, heraldic marks on shield, dress, helmet and horse helped to identify combatants.

Heraldry has its origins in the mid-twelfth century. It has been suggested that heraldic marks were first used by crusaders who answered the Papal call of 1095 for participation in the Crusades (1096–1270) to fight Muslims in Palestine.[1] Heraldic marks on clothing, shields and flags helped crusaders to recognize each other. Some historians have expounded that the contact with Eastern culture during the Crusades resulted in an Oriental influence on heraldry.[2]

Today, a heraldic mark in the shape of a shield is generally called a coat of arms (or just arms) after the surcoat with armorial bearings worn by a knight. Sometimes the term crest is used in its place and attributed with the same meaning. In medieval times, the crest was the identifying mark on a knight's helmet.

Expanding an early role as messenger, the heralds gradually served a more important ceremonial and diplomatic function. They organized coronations, peace celebrations and other events where tournaments were often an important part of the entertainment.

Heralds recorded existing coats of arms in rolls of arms. They also dealt with problems concerning similarity of coats of arms and created new armorial bearings. Early in the development of heraldry, heralds established a specific vocabulary as well as certain rules for the design of coats of arms.

Heraldic rules cover, among other things, the design and designation of lines of partition and the basic shapes on the shield, known as the ordinaries. They also extend to the colours used, referred to as tinctures and metals, and the cadency marks, denoting a man's descent and his position in the male line.

Lines of partition divide fields – shields and parts of shields – in a number of ways: per fess, per pale, per bend, per bend sinister, quarterly (per cross), per saltire and per chevron. Partitions may be repeated. Repeated quarterly partitions result in a checked field, and repeated per saltire partitions result in a lozenged field.

Lines of partition can be decorated in the following ways: invected, wavy, nebulé, indented, dancetté, embattled, raguly, dovetailed, potent, embattled grady, arched, double arched, urdé, rayonné, fir tree and fir twig.

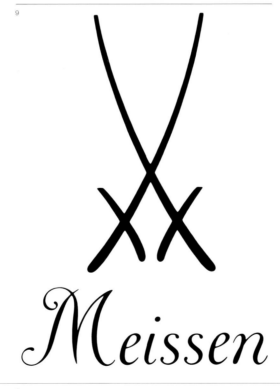

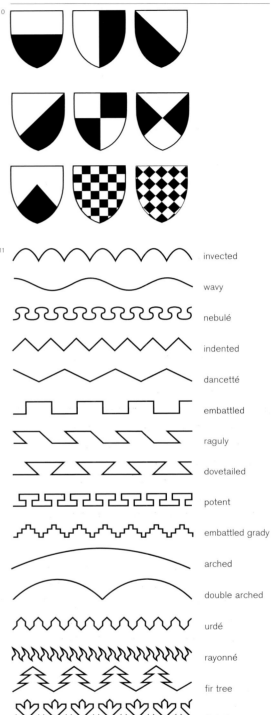

10

11 invected

wavy

nebulé

indented

dancetté

embattled

raguly

dovetailed

potent

embattled grady

arched

double arched

urdé

rayonné

fir tree

fir twig

9
The Meissen trademark was originally the arms of the Duke of Saxony. Sax means sword in Old Saxon.
Company Staatliche Porzellan-Manufaktur Meissen, Germany.
Design 1723.
Redesign 1972.

10
Lines of partition.
From top, left to right
per fess, per pale, per bend, per bend sinister, quarterly (per cross), per saltire, per chevron, repeated quarterly partitions, repeated per saltire partitions.

11
Decorated lines of partition.

12
Overleaf
A fifteenth-century French manuscript, *Tournois du Roy Rene,* showing fighting knights presenting their coats of arms to the duc de Bourbon.

Heraldry

The most important ordinaries are: fess, pale, bend, bend sinister, cross, saltire, chevron, chief, pall, pile, quarter, canton, gyron, inescutcheon and bordure. Most of the ordinaries can be multiplied.

The heraldic colours – tinctures and metals – are often designated by their original (old) French terms:

Tinctures	red	gules
	blue	azure
	black	sable
	green	vert
	purple	purpure
Metals	silver	argent
	gold	or

Table two Heraldic colours

In heraldic terms, the colour white is equal to silver, and the colour yellow is equal to gold. Sometimes the term 'tincture' designates both (real) tinctures and metals. The rules of 'good' heraldry state that tincture must alternate with metal on a shield. For instance, red should meet white or yellow – not blue, black, green or purple.

When coats of arms are inherited, the cadency is shown by cadency marks in the arms of the ten eldest sons:

Eldest son	label
Second son	crescent
Third son	mullet
Fourth son	martlet
Fifth son	annulet
Sixth son	fleur-de-lis
Seventh son	rose
Eighth son	cross moline
Ninth son	anchor
Tenth son	double quatrefoil

Table three Cadency marks

Charges – heraldic signs depicted on heraldic arms (which are themselves charges) – may include all kinds of figurative or non-figurative marks. Figurative charges may depict natural phenomena, such as plants and animals, artefacts or imaginary phenomena, such as mythical animals.

Canting arms have a special relevance in the subject of trademarks. They are a coat of arms that make a visual pun on the owner's surname, either through literal meaning or from the sound of the name. They imply that the name existed before the arms. However, the causal relationship has sometimes been the other way around: the bearer took his family name after his arms. When the Danish king, Frederik I, in 1526 decided that the nobility should adopt surnames, some noblemen simply chose a description of their coat of arms. Rosenkrantz, Danish for 'wreath of roses', is an example of such a descriptive name.

Heraldry offers a body of thought and terminology that is relevant to the creators of modern trademarks. Among the useful ideas is the concept of simplicity. Although simplicity initially characterized medieval heraldry in warfare, when it became part of civilian life it became more elaborate and esoteric. In modern heraldry, simplicity is preferred both in composition and in technical execution. The contemporary flat style is more heraldic and graphically more powerful than the elaborate style of many Renaissance arms. Good heraldry is simple heraldry; it omits the non-essential.

13
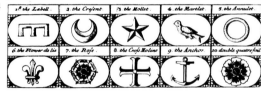

14
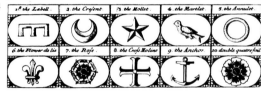

15

13
Ordinaries – basic shapes on a shield.
From top, left to right
fess
pale
bend
bend sinister
cross
saltire
chevron
chief
pall
pile
quarter
canton
gyron
inescutcheon
bordure

14
It is possible to tell the position of a son in a family by his cadency mark. The marks shown here illustrate table three.

15
The Bell's Whisky miniature bottle is a modern three-dimensional example of canting arms. The shape of the bottle is a pun on the distiller's name.
Company United Distillers, UK.

16
The pawnbroker's sign, with its three balls, stems from the coat of arms of the Italian medieval Medici family, which had six balls. The Medici were not only noblemen; they were also merchants and moneylenders.

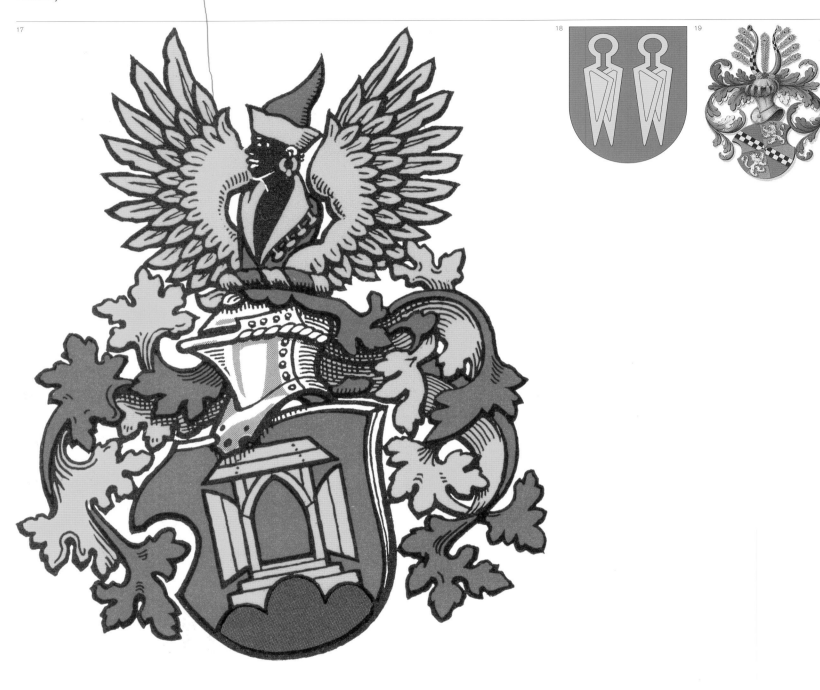

18

19

17
Canting arms of Albrecht
Dürer (1471–1528).
The door is a pun on the
family name.

18
Canting arms of the Danish
town of Sakskøbing. The
two pairs of wool scissors
(in Danish the word for
'scissors' is 'saks') are a
pun on the town's name.

The motif is first seen on
a coin from Sakskøbing of
about 1320.

19
The Danish noble family
Rosenkrantz (wreath of
roses) took their name
from their arms.

20
Despite being drawn with
a single line, this mark's
shape in the form of a
shield is enough to give it
strong heraldic associations.
Company Württemberger
Hüpo, Germany.
Design Karl Duschek
and Georg Engels/Atelier
Stankowski and Duschek,
1988.

21
The left (heraldic right or
dexter) part of the arms
shows the arms of the city
of Milan. The right (heraldic
left or sinister) part shows
the arms of the Duchy of
Milan, essentially those of
the Visconti family.
Company Alfa Romeo, Italy.
Design Tovaglia, 1970.

22
The griffin's head is a
reference to the arms of
the county of Scania. At the
beginning of the twentieth
century, the griffin's head
was used in a trademark
for the truck manufacturer
Scania. Later, after a
merger, it was included in
the Scania-Vabis trademark.
After another merger, the
griffin's head was included

in the Saab-Scania
figure mark.
Company Saab-Scania,
Sweden.
Design Carl Fredrik
Reuterswärd, 1984.

From individuals and families, coats of arms have been adopted by towns, regions and countries and today most places in the Western world can claim their own. These are sometimes, in their turn, incorporated into the trademarks of companies, showing their place of origin. The car manufacturers Alfa Romeo, Porsche and Saab-Scania have incorporated in their trademarks the arms, or part of the arms, of Milan, Stuttgart and Scania respectively. Other companies, such as BP, Württemberger Hüpo and Amro Bank, have adopted basic heraldic elements, such as shields, helmets and crowns, or ordinaries such as chevrons and gyrons.

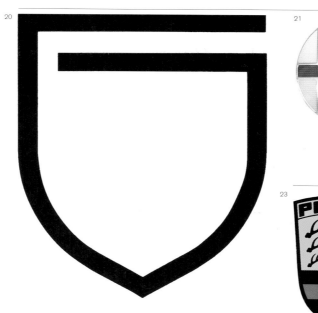

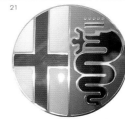

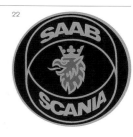

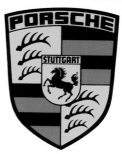

Chevron

23
Porsche cars are made in Stuttgart, the capital of Württemberg. Porsche's trademark consists of the coat of arms of the city of Stuttgart, a rampant horse, superimposed on the antlers and red and black stripes of the coat of arms of Württemberg with the Porsche inscription at the top.

Company Porsche, Germany.
Design Lapper, Franz Xaver Reimspiess, 1952.

24
Company BP, UK.
Design 1930.
Redesign Siegel & Gale, 1989.

25
ABN Amro's trademark is a shield with a gyron, a heraldic motif in which two lines drawn from the edge of a charge meet at its centre.
Company ABN Amro, Netherlands.
Design Landor, 1992.

26–7
Standard Oil of California took its current name after its coat of arms trademark and called itself 'Chevron'.
Company Chevron, USA.
Design Raymond Poelvoorde/ Lippincott and Margulies, late 1960s.

Monograms

The original Greek meaning of the term 'monogram' is 'single line', understood as something written or drawn in outline. Today the word is normally used to indicate a design made up of the initials of a person's name.

As early as the first century AD, the Greek philosopher Plutarch (*c*45–*c*125) refers to monograms. The emperor of the Eastern Roman Empire, Justin I (*c*518–*c*527), who could neither read nor write, signed his name with a monogram; they were often used instead of a real signature to compensate for illiteracy.[3]

The Frankish kings Thierry III (673–690) and Pepin le Bref (751–768) signed their names with a cross. In the Middle Ages, ordinary people in France would also sign with a cross; a single document might have a long row of crosses, each representing one signature. It was customary for some notaries to prepare for the subscription of a document by drawing a horizontal line, across which the signatories could draw their personal vertical lines.[4]

From Charlemagne, King of the Franks (768–814) to Philippe IV (1285–1314), French monarchs signed with monograms. Charlemagne and most other monarchs signed with a monogram constructed as a cross with a lozenge in the intersection. As early as the fourth century, the Roman orator and consul, Symmacus, suggested that monograms should be recognized rather than read.

There is a parallel between early monograms and contemporary letter trademarks that are recognized rather than read in parts of the world where literacy is not widespread. More people can recognize the Coca-Cola name mark than spell the name. Very few can explain what the name literally stands for.

In kingdoms, the sovereign's monogram may include an 'R' for Rex (king or head of state) or Regina (queen), for example, ER II, Elizabeth Regina the Second. A royal monogram signals both authority and ownership. In the first meaning it may be seen as a mass-produced, abbreviated, easy-to-read signature. Royal monograms are used as signs of legitimacy on coins, on products with royal warrants and on public buildings with a role derived from the authority of the Crown.

28

29

30

28
Monogram of Pepin Le Bref (751–68).

29
Monograms of French kings (dates refer to reigns). *From top, left to right*

Charlemagne (768–814)

Carloman (882–4)

Charles III (893–922)

Louis d'Outremer (936–54)

Lothaire (954–86)

Philippe I (1060–1108)

Philippe IV (1285–1314)

30
Monogram of Thierry III (673–90).

31
Monogram of Elizabeth Regina the Second (1952–) on an English cast-iron letter box.
Company Royal Mail, UK.

32

 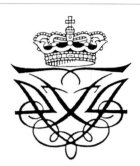

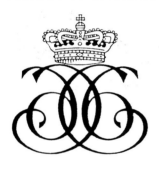 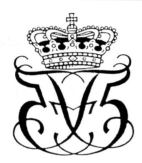 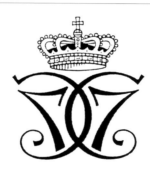 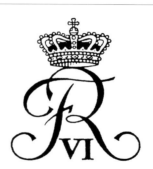 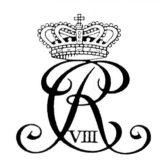

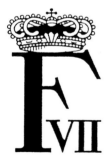 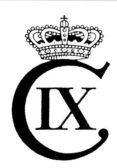 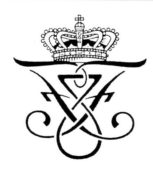 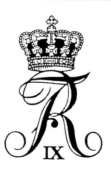 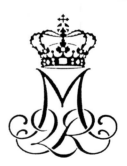

32
Danish royal monograms.
From top, left to right

Christian I (1448–81)

Hans (1481–1513)

Christian II (1513–23)

Frederik I (1523–33)

Christian III (1534–59)

Frederik II (1559–88)

Christian IV (1588–1648)

Frederik III (1648–70)

Christian V (1670–99)

Frederik IV (1699–1730)

Christian VI (1730–46)

Frederik V (1746–66)

Christian VII (1766–1808)

Frederik VI (1808–39)

Christian VIII (1839–48)

Frederik VII (1848–63)

Christian IX (1863–1906)

Frederik VIII (1906–12)

Frederik IX (1947–72)

Margrethe II (1972–)

The monogram of Queen Margrethe II of Denmark is contentious. It has been argued that the combination of the Arabic numeral '2' and the Latin abbreviation 'R' is incorrect. It is certainly a breach of tradition. Until the present Queen's reign, Danish monarchs used Arabic numerals without the R, or Roman numerals with or without the R.

Branding

Branding – marking livestock with burning irons – has been practised for at least 5,000 years. Cattle, goats, horses, sheep and swine have traditionally been marked in this way.

In Egypt, tombstones dating from 3000 BC depict domestic animals with brands. At the tomb of Khemuheted (tomb no 3) at Beni Hassan dating from 1900 BC (the twelfth dynasty of the Middle Kingdom), a painting shows a man leading an ox by a rope. The ox is marked with a brand with hieroglyphics, measuring about one square foot.

At the battle of Crécy-en-Ponthieu in France, in 1346 during the Hundred Years' War, the English horses were reported to carry the broad arrow, or the imperial brand, later known as the king's mark.[5]

Nowhere, however, has the branding of domestic animals reached the level that it has attained in the United States. Inspired by economic interests, branding has been thoroughly organized. Brands are registered in state brand books. Rules have been developed to specify how and where livestock were branded and how the brands are described verbally.

The rules of branding are, in some respects, parallel to those of heraldry. A good example is the system for showing cadency.

American livestock brands may consist of letters, numbers and figures, or any combination of these elements. The size of a brand does not normally exceed a surface area of twenty-five square inches. Sometimes the impact of a cattle brand was so great that a ranch would be named after the brand burned onto their cattle. Often cattle owners were referred to in a form of nickname based upon the name of their brand.[6]

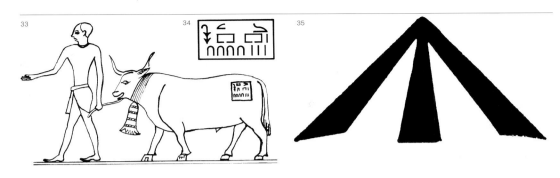

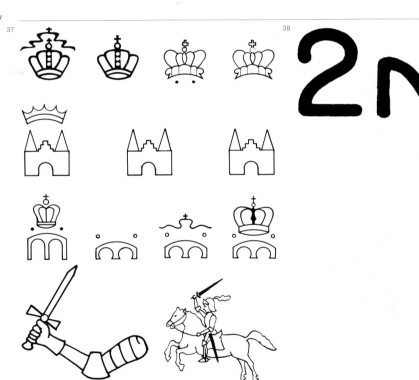

33
Tomb of Khemuheted (tomb no 3) at Beni Hassan, Egypt, 1900 BC. The text of the brand on the ox says: 'Royal Agriculture Administration, 43'.[7]

34
Detail of fig 33.

35
The Broad Arrow was the imperial brand used on English horses in 1346 during the Hundred Years' War.

36
Examples of Mexican cattle brands showing cadency: Don Miguel, first son, Carlos, second son, Luis, third son, José and fourth son, Mario.

37
German horse brands.

38
An American cattle brand is read from left to right, from top to bottom and from the periphery to the centre.

This brand reads 'two lazy two P', or, as cowboys might say, 'Too lazy to pee'.

39
Overleaf
Common American picture brands. Motifs are chosen for a number of reasons. They can be humorous, sentimental, illustrative or risqué, as above (fig 38).

Earmarks

In the United States, other forms of marking domestic animals include earmarking and tattooing, which have developed alongside branding. Most branded cattle are also earmarked; the double identification is a means of security.[8] Earmarks may be easier to identify than brands in winter, when cattle have long hair, or in summer, when their branding may be obscured by dust.

Farm marks

While farmers in northern Europe may not have had herds as large as those in the United States, they still had to mark their livestock. Dutch immigrants to the Danish island of Amager outside Copenhagen in the sixteenth century marked their livestock with the same marks used to identify their other belongings. Some of these marks were still in use at the beginning of the twentieth century.

It is not clear whether the marks belonged initially to the farms or to the families living on them. Some families took over a farm as well as its mark, while others took their mark with them when leaving a farm.

The Dutch farmers on Amager had adjoining fields with no natural boundary between them. They also shared collectively-owned pastures. In the former, farmers marked their boundary stones, and perhaps tools that might be left in the field. In the latter, they marked livestock at pasture. In both cases, it was useful to have a mark. Farm marks were also used to identify hams that were sent out for smoking.[9]

Dutch farmers' marks were probably part of a Dutch tradition.[10] They have similarities with the ancient Danish runic alphabet, as well as with certain stonemasons' marks.

42

42
Amager farm marks
reproduced from three sides
of a 'farm mark stick' at the
Museum of Amager,
Denmark.

Ceramic marks

Ceramic artefacts of antiquity have produced a wealth of trademarks. Greek vases have pen- or brush-made marks, called *dipinti*, or incised marks, called *graffiti*. Some vase marks are actually those of the traders who bought the vases from potters and sold them in distant markets. Other marks are potters' or owners' marks, and some are vase names or even price marks. It is not always possible to distinguish one type of mark from another.[11]

Roman building elements, such as bricks and tiles, sometimes bear embossed trademarks. The stamps used for this may have been made of bronze or oak. The trademarks may denote the name of the manufacturer, the building contractor, the origin of the clay, or the name of the consul, the emperor or another member of the imperial family.[12]

Embossed or incised trademarks are found on Roman oil lamps, or *firmalampen*, which were made during the first three centuries AD, primarily in northern Italy, but also in central Italy.[13] In contrast to other more elaborate and craft-based lamps, *firmalampen* seem to be early examples of industrial design. The trademarks reinforce the impression of modern mass production. Some manufacturers, such as Fortis and Stroboli from Modena and the Modena region in northern Italy, may have had either a very good distribution system or production workshops in different areas; lamps carrying their trademarks are found in the most distant corners of the Roman Empire. It is also possible, however, that their trademarks were widely copied; there was no legal protection for trademarks at that time.[14]

43
Roman brick marks from the first three centuries AD.

44
Roman oil lamps from the first two centuries AD with factory marks LMARMI and FORTIS.

45
This bronze stamp was used to mark Roman pottery with the trademark VI♥SE during the first-century AD.

Since the sixteenth century, ceramic objects, including those of majolica, faience, stoneware and porcelain, have been marked with letters, figures and pictorial signs. Some marks clearly establish the identity of the maker and the year of manufacture: 'fatto in Roma da Gio Pavlo Savino MDC' (Made in Rome by Gio Pavlo Savino). Sometimes the marks are more cryptic. Factory marking was only introduced in European pottery in the eighteenth century.[15]

Although the obvious purpose of ceramic marks is to identify the maker of the objects, the marks themselves have sometimes become objects in their own right.

A number of the ceramic marks include typical heraldic charges, such as crowns and labels (tournament collars). Other marks show coats of arms; a porcelain mark from Florence shows the six balls of the Medici family and the Meissen porcelain mark features the crossed swords of the Duke of Saxony (fig 48).

Marks on ceramics have been copied, paraphrased and used as inspiration by other manufacturers. The crossed swords of Meissen have been imitated and forged by English factories; Meissen used 'Chinese' marks for a period during the eighteenth century; and the name and mark of Wedgwood has been copied by other English manufacturers.

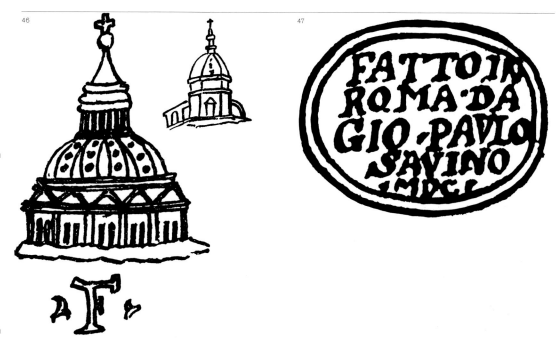

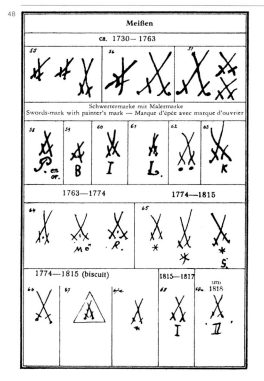

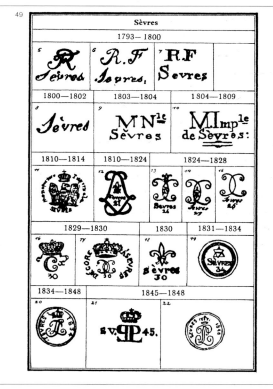

46
Florence porcelain marks, Italy.

47
Italian majolica mark.

48
Meissen porcelain marks, Germany.

49
Sèvres porcelain marks, France.

Stonemasons' marks

Medieval stonemasons were great builders in more than one sense. They acted as architects, engineers and skilled workers. German stonemasons believed in a personal development that grew from the mastery of technique to mastery of construction to mastery of style: from skills to knowledge to creation. The three disciplines corresponded to three degrees of the stonemason's development: the Geselle had skills; the Parlirer had skills and knowledge; and the Meister mastered skills and knowledge, as well as creativity. Stonemasons were organized in associations and guarded their trade with secrecy and mysticism. Freemasonry has its roots in the stonemasons' associations.[16]

Perhaps to immortalize themselves, perhaps to show personal pride, and probably to identify their work in order to get properly paid, stonemasons from the twelfth century and throughout the next six centuries cut their personal marks in stone. While most ceramic marks in antiquity had some linguistic content, the marks of the stonemasons were generally non-alphabetical. The main reason for this was probably medieval illiteracy, perhaps reinforced by the requirement of secrecy.[17]

German stonemasons' marks exist in great numbers, partly because of the great number of stonemasons at work, and partly because of the durability of stone. More than 1,500 different stonemasons' marks have been found in Strasbourg Cathedral alone.[18]

In his speculative book, *Studien über Steinmetz-Zeichen* (Studies of Stonemasons' Marks), Franz Rziha develops the theory that stonemasons' marks were, as a rule, designed on the basis of *Mutterfiguren* (mothermarks), grids which were themselves based on the square, triangle and circle. According to Rziha, the fundamental *Mutterfiguren* were part of the *Steinmetz-Grund*, the secret geometric basis on which the stonemasons constructed their buildings.[19]

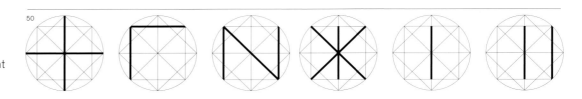

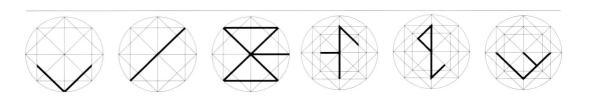

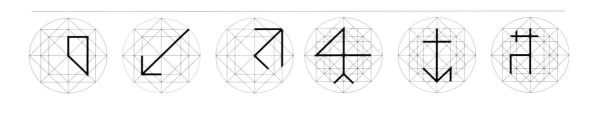

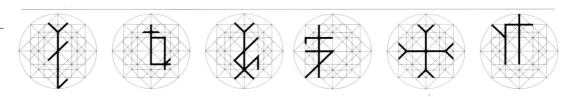

50
Stonemasons' marks from Vienna Cathedral. As part of his research, Rziha analysed 9,000 stonemasons' marks and eventually induced fourteen fundamental *Mutterfiguren*. The marks are shown with their *Mutterfiguren* as background.

Hallmarks

The word 'hallmark' is often used to indicate a distinguishing characteristic of something. To the British goldsmith, silversmith or collector, the hallmark refers to Goldsmiths' Hall in London, where articles of gold, silver and platinum were traditionally assayed and stamped. The stamps, which take the form of hallmarks, attest to the purity of the metal.

The complete British hallmark comprises four marks:

1. The standard mark indicates the composition of the metal. A lion passant has been stamped on silver since 1300 (apart from the period 1697–1720 when the figure of Britannia was adopted). A crown followed by the proportion of gold in parts per thousand represents gold while an orb and cross mark are applied to platinum.

2. The assay-office mark indicates the assay office – today either London, Birmingham, Sheffield or Edinburgh – where the article is assayed.

3. The date letter indicates the year the article was assayed. Each year had its specific letter in a specific style. When the full alphabet in one style is used, a new alphabet in another style takes over. The letter for the year 1995, for example, is 'V'.

4. The sponsor's mark, which has been mandatory since 1363, identifies the maker of the article of silver. Only the sponsor's mark identifies the manufacturer. The three other marks deal with description of the product and confirmation of its quality.

The rules for marking silver vary from country to country. The importance of international trade has inspired the emergence of so-called 'convention marks' that are acknowledged by a number of countries.

An article of silver manufactured in Copenhagen during the period 1685–1852 typically carries a hallmark that is similar to those of British hallmarks, consisting of four separate marks:

1. The Copenhagen town mark with three towers and the year of manufacture has been used since 1608; the three towers are also shown in the city's coat of arms. Since 1977 the town mark has been used without the year of manufacture. The Copenhagen town mark inspired the colloquial term 'three tower silver'. Since 1893 the term has been used about silver with a fineness of 830 parts per thousand. This term later inspired the misnomer 'two tower silver', used to describe electroplate ('Victorian') silver.

2. The assay-master's hallmark was used from 1679 to 1988.

3. The mark of the month, used from 1685 – 1852, signifies not the month but the zodiacal period in which the article was manufactured.

4. The maker's mark has been required by decree since 1491, and denotes the origin of a product.

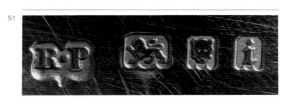

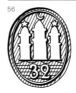
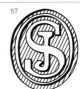
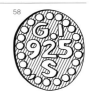

51
British hallmarks on a silver tray from 1924.

52–5
Examples of British hallmarks. The marks are shown here at about four and a half times their actual size.

52
The Standard mark for sterling silver.

53
Assay-office mark, London.

54
A sponsor's mark.

55
The date letter for 1924.

56–8
Danish hallmarks at about four and a half times their actual size.

56
The Copenhagen town mark, 1932.

57
The assay-master's mark. Jens Sigsgaard.

58
The maker's mark. Georg Jensen.

Printers' marks

Almost immediately after Johann Gutenberg invented the art of printing with loose type in the middle of the fifteenth century, printers began to mark their products. Printers' marks of the fifteenth and sixteenth centuries demonstrate variety in conception and variable artistic quality in execution.

Early printers' marks were cut in wood or metal and printed on the title page or at the end of the book, in black or red. Later, the marks became more elaborate. They were eventually replaced by illustration and publishers' marks.[20]

An early printers' mark could be a pure pictorial device, often including the orb and cross or orb and four-cross motifs which symbolized the world and the Christian faith. The pictorial device could be expanded with ornamentation, with a motto and possibly with the initials or the full name of the printer in addition to other devices. Sometimes the pictorial device was a visual pun on the printer's name.

Heraldic marks consisting of one or more shields were also used.

Over a period, one printer might use several variations on the same theme. Several printers also used virtually the same mark.

59

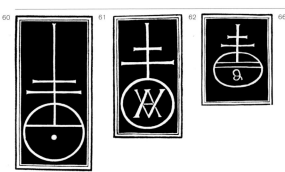

60 61 62 66

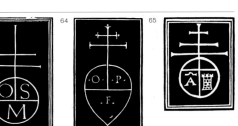

63 64 65

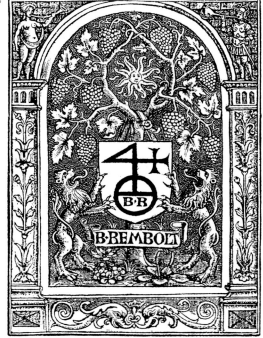

59
The world's first printers' mark was used by the printers who took over some of Johann Gutenberg's typefaces after a court case. Printers' marks were not legally protected; this mark was later adopted and used by several other printers. Johann Fust und Peter Schöffer, Mainz, Germany, 1457.

60
The orb and cross motif is about 200 years older than the mark, and variations were used in many other trades as well as by other printers. Giovanni de Colonia, Germany, Nicolaus Jenson and Co, Venice, Italy, 1481.

61
Orb and cross.
Nicolaus Jenson's successor, Venice, Italy, 1482.

62
Orb and cross.
Dionysis Bertochus, Modena, Italy, 1499.

63
Orb and cross.
Heir of Octaviano Scotus de Modoetia, Venice, Italy, 1514.

64
Orb and cross.
Octaviano Petrucci, Fossombrone, Italy, 1513.

65
Orb and cross.
The tower is a pun on the printer's name (*torre* means tower in Italian). Andreas Torresanus, Venice, Italy, 1479.

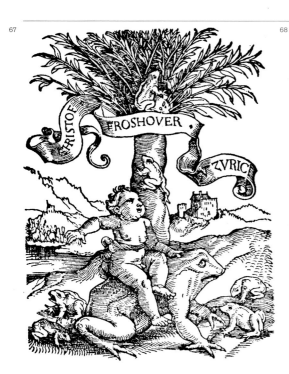

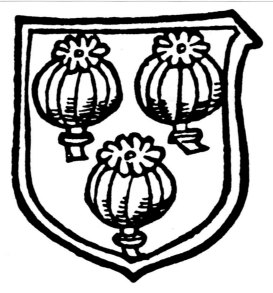

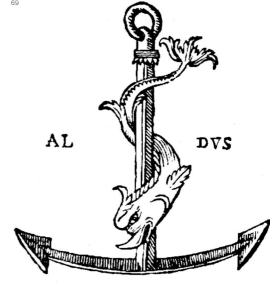

70 71 72

HISTORIALE
DESCRIPTION
DE L'ETHIOPIE,

Contenant vraye relation des terres , & païs du grand Roy, & Empereur Prete-Ian, l'affiette de ſes Royaumes & Prouinces , leurs coutumes, loix, & religion, auec les pourtraits de leurs temples & auͨ tres ſingularitez , cy deuant non cogneues.

Auec la table des choſes memorables conteͨ nues en icelle.

AET.36.

EN ANVERS,
De l'Imprimerie de Chriſtofle Plantin,
à la licorne d'or.
1 5 5 8.
AVEC PRIVILEGE ROYAL.

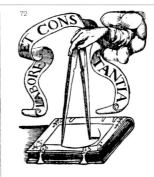

66
Shield with orb and four, with a cross, supported by lions.
Rembolt, Paris, 1512.

67
The frogs in this mark are a pun on the printer's name (*Frosch* means frog in German).
Christoph Froschauer, Zurich, Switzerland, 1560.

68
The poppy heads in this mark are a pun on the printer's name (*Mohn* and *Kopf* mean poppy and head, respectively, in German).
Mohnkopf-Druckerei, Lübeck, 1487.

69
The anchor and the dolphin in this Venetian mark are supposed to illustrate Horat's oxymoron *festina lente* (hasten slowly).
Aldus Pius Manutius, Venice, Italy.

70
The shield with the boots in this French mark must be a pun on the printer's name (*marchant* means walking in French).
Guy Marchant, Paris, 1483.

71
Historiale description de l'Ethiopie.
De l'Imprimerie de Christofle Plantin, à la licorne d'or. (Historical description of Ethiopia from the printing workshop of Christoph Plantin, at the golden compasses).
Antwerp, Belgium, 1558.

72
Labore et constantia: the outer leg of the pair of compasses symbolizes work; and the inner leg stands for constancy.
Christoph Plantin, Antwerp, Belgium, 1555–89.

Watermarks

The production of good paper for printing was as necessary for the modern development of the printing industry as the invention of loose type. Manufacturers of good quality paper were aware of that fact, and they wanted to put their mark on the final product. They did this through translucent, permanent watermarks, impressed in the paper while it was in the mould.

As well as being certificates of origin, watermarks were also used to indicate paper quality and paper size. The old English paper sizes were, in fact, named after watermarks. The names pot, foolscap, post, crown and elephant all denote paper quality and size.

The first known watermarks date from the thirteenth century in Italy. One anthology, *Les filigranes* (The Watermarks), shows more than 18,000 different watermarks organized according to motifs such as the lamb, eagle, anchor, angel and ring.[21] In the context of mass-produced papers today, the very presence of a watermark in a piece of paper is seen as a proof of quality.

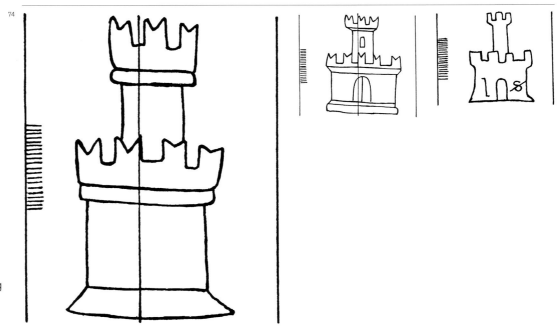

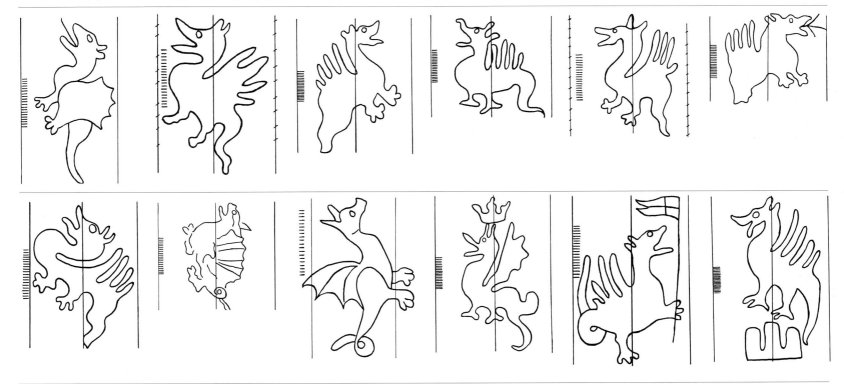

73
Conqueror writing paper. Today, the very presence of a watermark is seen as a proof of quality. *Company* Arjo Wiggins Fine Papers Ltd, UK. *Design* 1888.

74
Watermarks
From top, left to right.

Watermark, tower. Ljubljana, Slovenia, 1532.

Watermark, tower. Alexandria, Egypt, 1513.

Watermark, tower. Venice, Italy, 1491.

Watermark, dragon. Genoa, Italy, 1339.

Watermark, dragon. Florence, Italy, 1375–7.

Watermark, dragon. Reggio d'Emilia, Italy, 1439.

Watermark, dragon. Ferrara, Italy, 1501.

Watermark, dragon. Ferrara, Italy, 1392.

Watermark, dragon. Ferrara, Italy, 1449.

Watermark, dragon. Reggio d'Emilia, Italy, 1429.

Watermark, dragon. Autoin, France, 1400.

Watermark, dragon. Troyes, France, 1412.

Watermark, crowned dragon. Ferrara, Italy, 1506.

Watermark, dragon holding a forked flag. Ferrara, Italy, 1395.

Watermark, dragon on three mountains. Mantua, Italy, 1482.

Furniture marks

Between 1751 and 1791 in Paris, when the guilds and their privileges had come to an end, signing furniture became mandatory. In spite of the decree that members of the Paris guild should stamp their furniture with their names, much furniture from this period carries no mark. It might have been that the manufacturer was not a member of the guild or that he deliberately avoided marking his furniture: chairmakers saw the stamps as a device created by the government to control them.[22]

In Denmark, marking furniture with the manufacturer's name was only mandatory for members of the Copenhagen Chairmakers' Guild in the period from 1813 to 1841. Two or three letters were stamped into the furniture. After 1841, all chairmakers were required to mark their chairs with the mark of their guild.[23] Danish cabinetmakers were required to have their furniture marked by their guild between 1837 and 1842, but marking furniture with their name was never compulsory. Its main aim was to protect the trade against unaffiliated manufacturers. *Det kongelige Meubelmagazin*, The Royal Furniture Magazine (1784–1815), which was founded to promote the production of Danish furniture by encouraging its development and sales, marked its products with a lacquer seal. Some Danish cabinetmakers and chairmakers in the nineteenth century marked their furniture voluntarily. The marks were usually printed paper labels which were so anonymous in their design that they were hardly identifiable as trademarks. Today, most manufacturers of quality furniture mark their furniture.

In the United States, the workshops of the Shaker communities in the eastern states marked their austere, simple furniture with decals (transfer designs). The oldest known mark on Shaker furniture is from Mount Lebanon, New York, in 1873.

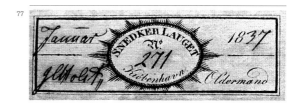

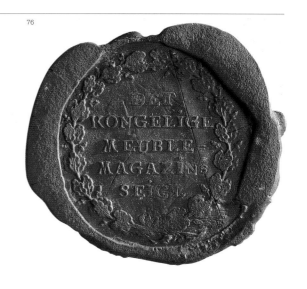

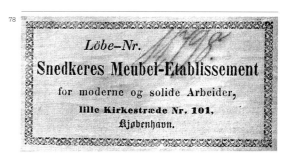

75
Eighteenth-century Parisian furniture stamps.

76
Lacquer seal for *Det kongelige Meubelmagazin*, Denmark, 1784–1815.

77
Label for the Copenhagen Cabinetmakers' Guild, Denmark, 1837.

78
Furniture label for Copenhagen cabinetmaker Schou, Denmark, *c*1852.

RUD. RASMUSSENS FABRIK
FOR EGETRÆSMØBLER,

NØRREBROGADE 45. KØBENHAVN

RUD. RASMUSSENS
SNEDKERIER
KØBENHAVN N
DANMARK

SHAKER'S
NO 1
TRADE MARK
MT. LEBANON. N.Y.

79
Furniture label for
Copenhagen cabinetmaker
Rud Rasmussens
Snedkerier, Denmark.
Design 1904

80
A more recent label for
Rud Rasmussens
Snedkerier.
Design Kaare Klint, 1930.

81
Rud Rasmussens's
label for furniture
designed by Kaare Klint.
Design Gunnar Biilmann
Petersen, 1930.

82
Shaker furniture mark,
Mt Lebanon, New York,
USA, 1873.

83
Overleaf
The display of airline
colours and trademarks on
the tail fins of aeroplanes
is a modern adaptation
of the heraldic tradition.
It allows the aircraft to be
recognized instantly – on
the ground or in the air.

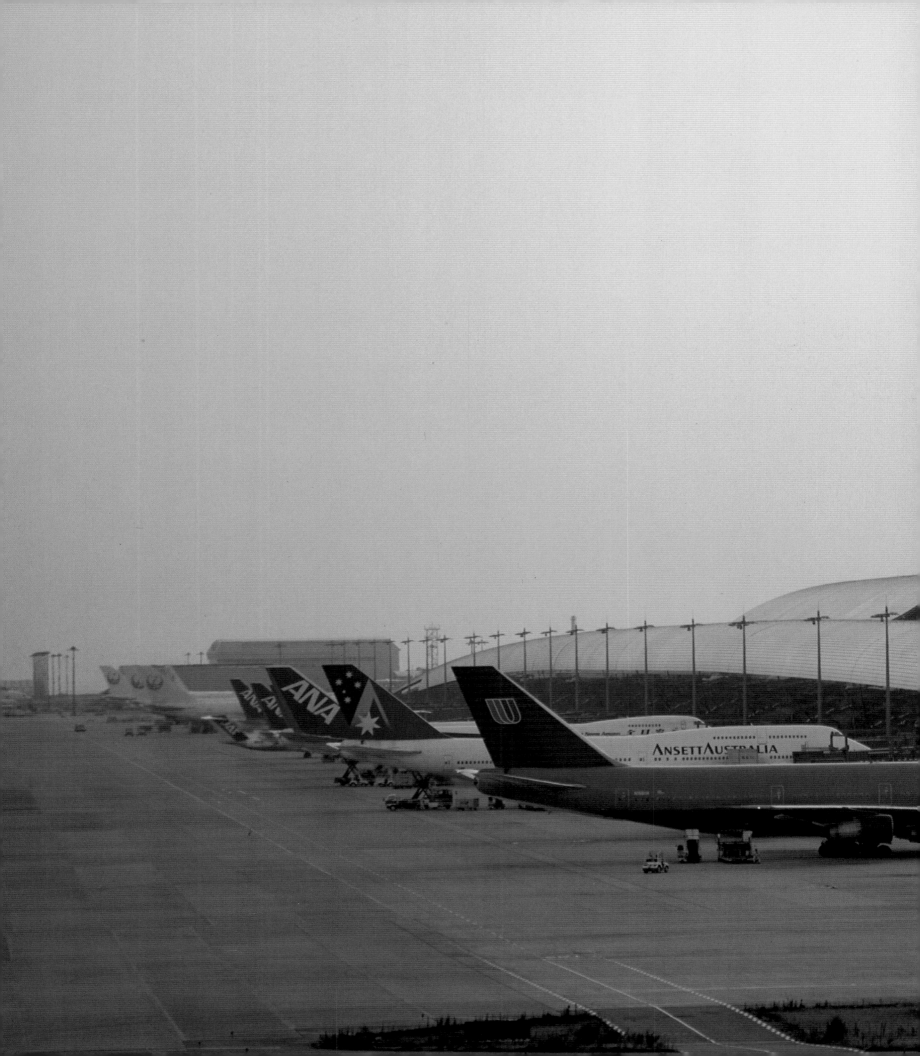

Function

The function of a trademark is identification. This chapter explains modern trademarks in relation to two other issues: design programmes and branding. Identification often takes place within the framework of a design programme. The term 'branding' has been adopted in modern marketing terminology to mean the marking of products.

Both design programmes and branding are methods for controlling corporate identity, one on the organizational level, the other on the product level. Trademarks, design programmes and branding are tightly linked: one or more trademarks are dominant elements in most corporate design programmes, and trademarks are instrumental in branding.

The realm of the design programme

The part of a company's corporate identity that is visual is generally referred to as the visual identity. Every company has one, whether the members of the company think about it or not. Some companies carefully create and sustain their visual identity, while others neglect it.

Part of a company's visual identity can be controlled by a design programme, a plan that specifies the visual forms that the company will use to present itself.

Through its design programme and the resulting visual identity, a company can inform people, inside and outside the organization, what or who it is and how it is (or how it wants to be). In some respects, a company's distinguishing characteristics make it like other companies; in others, they differentiate it. This is done by description and distinction.

The message of description is basically signalled by likeness: the XYZ company is – or aspires to be – such and such. The message of distinction is basically signalled by difference: this is a different company, this is the XYZ company, this is not any other company.

A design programme consists of a number of basic elements and a number of rules for their application. The most usual basic elements are:

Trademarks
 Letter mark
 Picture mark
Typefaces
Colours

The common applications of a design programme are:

correspondence vehicles
sales literature signage
advertising shop fronts
products shop interiors
packaging uniforms

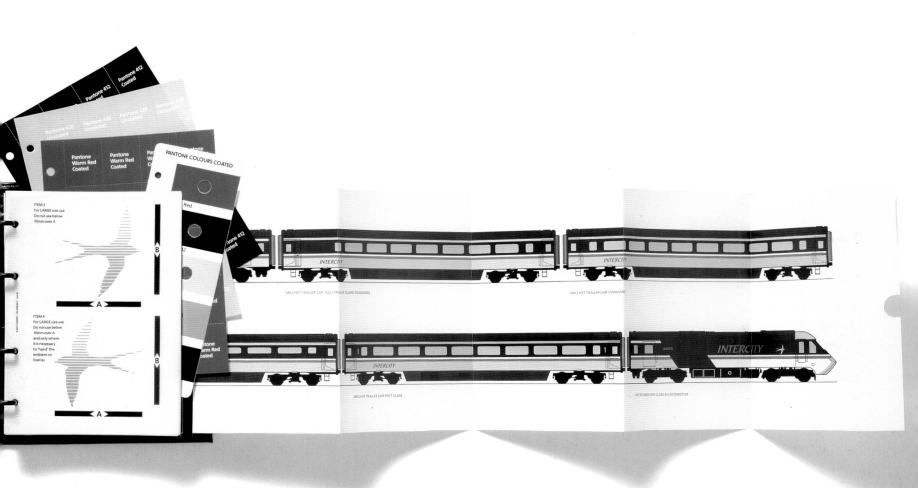

This design manual
helped to turn around the
fortunes of InterCity. When
Newell and Sorrell were
asked in 1986 to produce
a corporate identity for the
UK rail network, InterCity
was little more than a
label for one of the five
businesses attached to
British Rail. More to the
point, its existing public
image was so negative that
it was the butt of national
jokes.

In spite of this, the
emphasis for the new
identity had to be on quality
since travelling by InterCity
was never going to be a
cheap option. The basic
elements of the identity
have a classic engineered
effect. The most important
of these is the silver swallow.
It has been central to the
drive to raise standards
within the company and to
motivate staff. Employees
have to earn the silver
swallow badge.

As illustrated by the
manual above, the design
programme was intended
at its inception to extend
to train livery. However, to
ensure that the identity
reached into every area of
the business in practice, a
strong management system
was set up within InterCity.
Soon everything from on-
board services, uniforms
and signs to literature and
publicity, had all been
developed in line with the
fundamental design strategy.
Company InterCity, UK.
Design Newell & Sorrell,
1987.

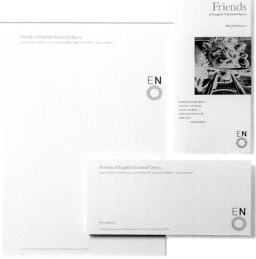

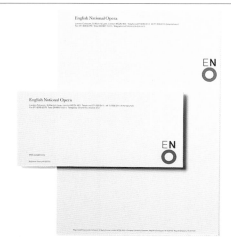

85–6
Before CDT Design redesigned the English National Opera's corporate identity, it was confused, even invisible. Advertising for the Opera tended to concentrate on individual performances rather than the company per se. CDT Design's solution was to produce a simple but memorable logo that could be applied to many different media. For literature, a strict house style was introduced that used only two typefaces. This created a corporate unity and freed the designer to concentrate on the type of eye-catching imagery featured on the pamphlets above.

Company The English National Opera, England.
Design Mike Dempsey/ CDT Design, 1992.

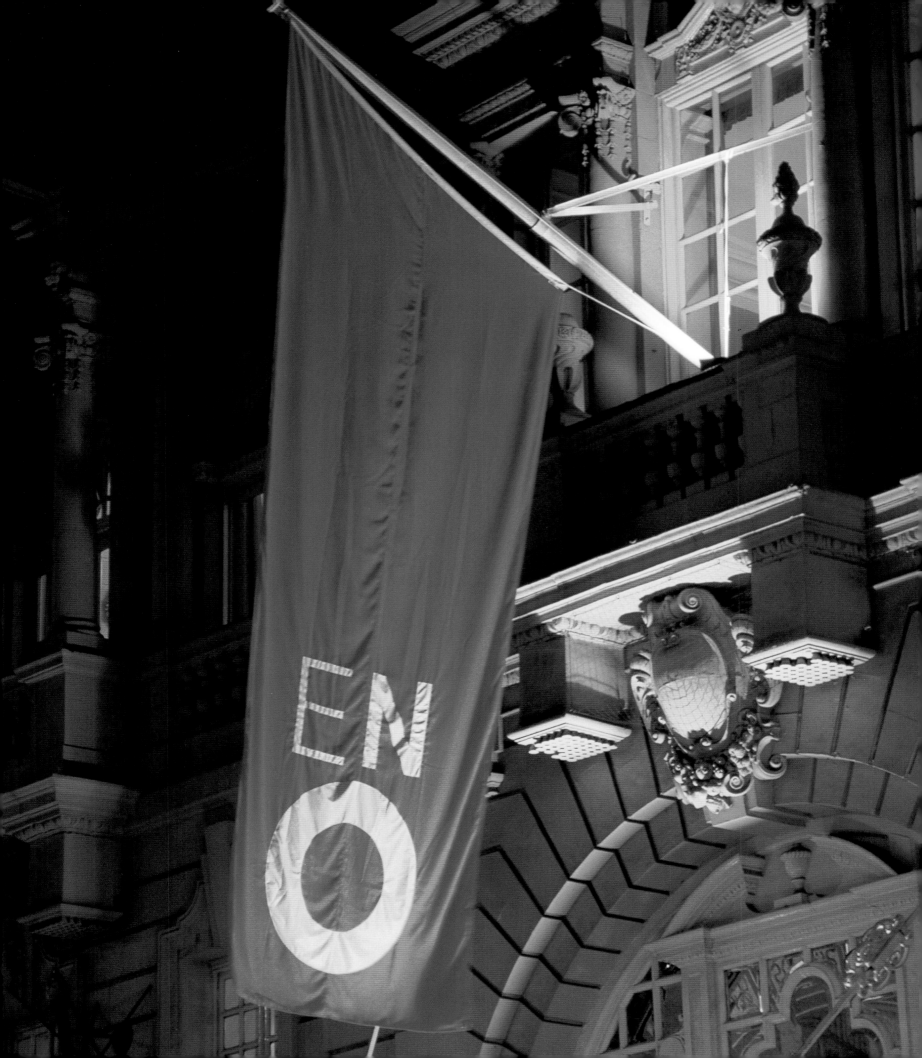

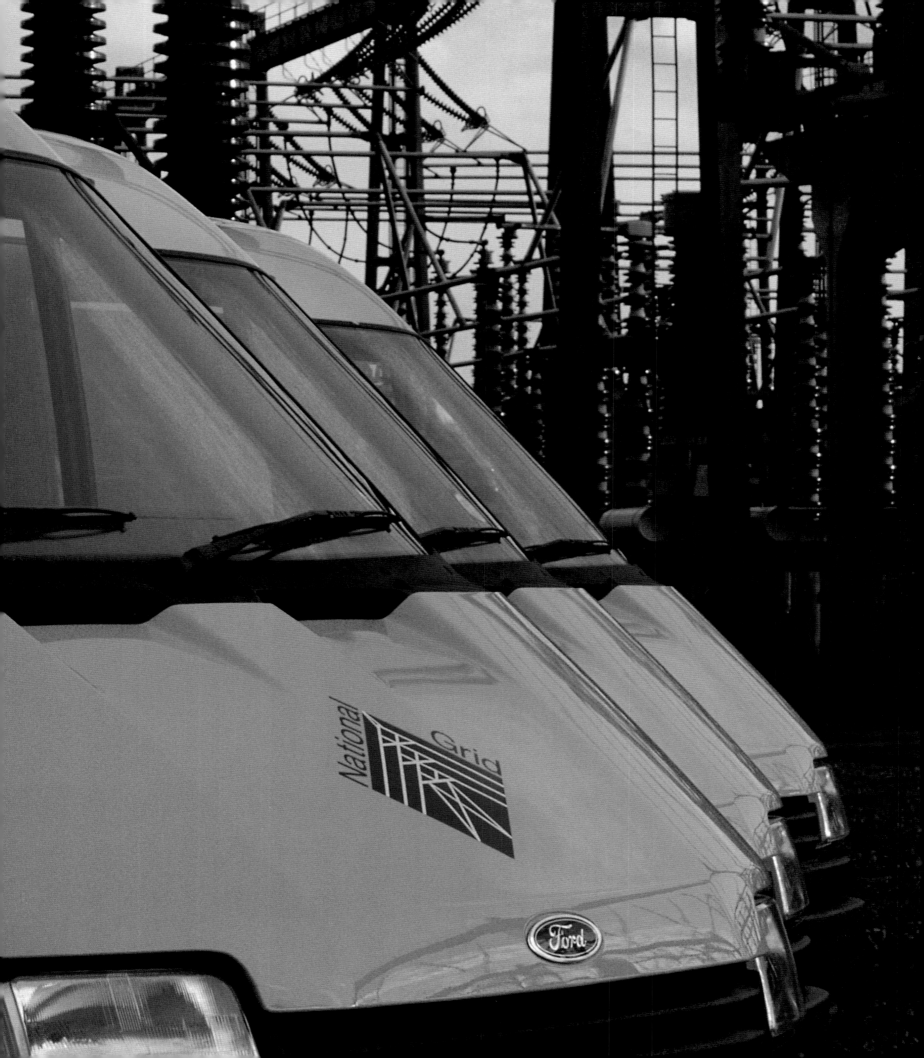

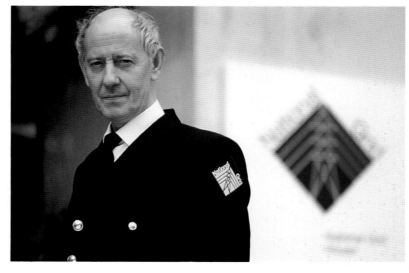

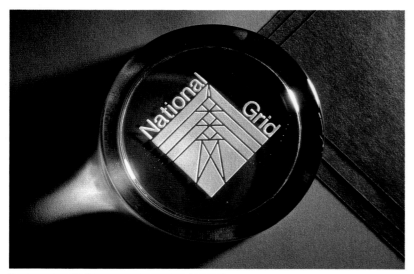

87–8
For a newly privatized British company, the National Grid, which performs the technical and operational functions of electricity transmission, Pentagram designed a trademark that describes the company in two ways. The symbol is both a stylized pylon and a grid. Appearing in both green and blue, the mark has been applied in a wide variety of situations.
Company National Grid, UK.
Design John McConnell and Justus Oehler/Pentagram, 1989.

89

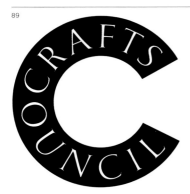

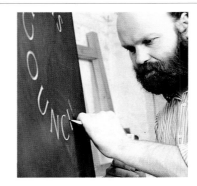

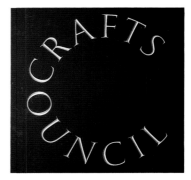

89
This graphic design programme was commissioned for the Crafts Council, the British national body for the promotion of craft professions, to help increase public awareness of the Council's activities and to coincide with a move to new premises. Appropriately, Pentagram's design for the identity uses craft to convey the message; the hand-cut typeface of the logotype is by Tom Perkins, a letter cutter (see photograph above).
Company Crafts Council, UK.
Design John Rushworth/ Pentagram, 1991.

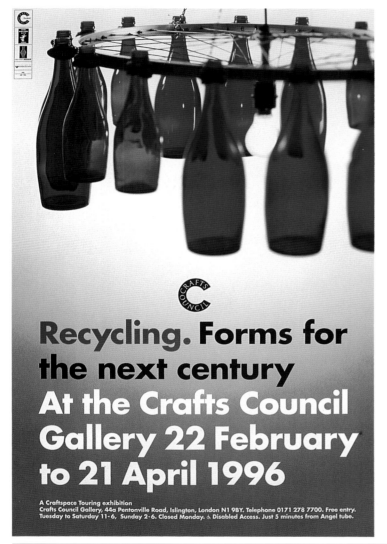

Recycling. **Forms for the next century** At the Crafts Council Gallery 22 February to 21 April 1996

A Craftspace Touring exhibition
Crafts Council Gallery, 44a Pentonville Road, Islington, London N1 9BY. Telephone 0171 278 7700. Free entry.
Tuesday to Saturday 11-6, Sunday 2-6. Closed Monday. & Disabled Access. Just 5 minutes from Angel tube.

Out of this World The Influence of Nature in Craft & Design 1880-1995 **The Crafts Council Gallery from 13th April to 18th June**

Crafts Council Gallery
44a Pentonville Road
Islington, London N1 9BY
Telephone 0171 278 7700
Free entry Tues to Sat 11-6
Sun 2-6, Closed Mon.
& Disabled Access. Just 5
minutes from Angel tube.

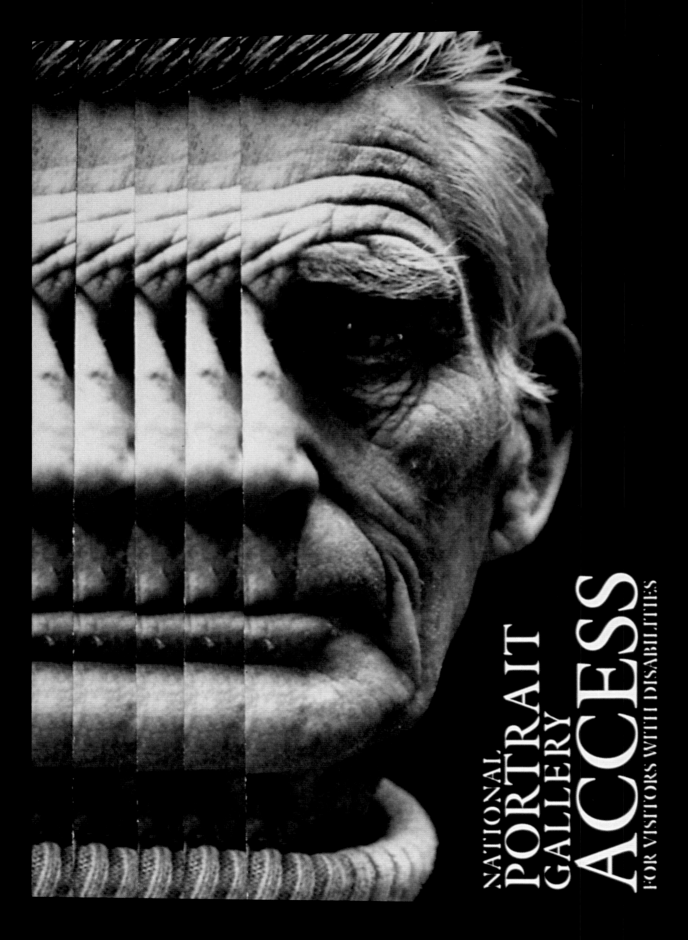

NATIONAL
PORTRAIT
GALLERY
ACCESS
FOR VISITORS WITH DISABILITIES

The goals of a design programme

When we work for, buy from or otherwise deal with a company, we become associated with that company and assimilate a little of its identity. It is important to the company to build an identity that is attractive to relevant internal and external groups.

A design programme should be a dynamic statement of aspirations that inspires employees, helping to improve company performance and customer satisfaction. When it succeeds in serving that goal, the design programme becomes a self-fulfilling prophecy. The aspirations come true. In the long run, the improvement of employee motivation, customer satisfaction and the satisfaction of other relevant external groups will positively influence the company's results and the fulfilment of overall business goals.

The immediately apparent goal of a design programme is to control an important part of the company's visual identity. Behind that, the goal is identification, telling who and how the company is or aspires to be. This identification can be split into identification for internal and external target groups.

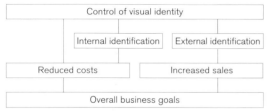

Table four The goals of a design programme.

External identification

A design programme should increase the company's visibility for relevant external target groups such as customers, business partners, investors, journalists and public authorities. Beyond that quantitative visibility, a design programme should improve the company's visual identity on a qualitative level in order to improve the image of the company. The image of a company is the sum of all perceptions of the company held by external groups.

Internal identification

A design programme should contribute to the company's self-understanding and in this way increase the motivation and loyalty of employees. Motivation and loyalty facilitate greater effectiveness. They can also have an external effect. A good image starts at home. If the employees of a company like to be there, their enthusiasm can have a positive effect on clients. If, on the other hand, the employees of a company do not like their situation, their poor morale will – sooner or later – influence clients and other external groups.

Economy

The economy of a company can be positively affected by a design programme in three ways:

Improved internal and external identification should increase company sales;

Internal identification should improve employee motivation and performance, and thereby improve cost effectiveness;

Simplification and standardization required by the clear communication of the design programme should also contribute to cost effectiveness.

Overall business goals

Increased sales caused by external and internal identification and reduced costs caused by internal identification and rationalization will together further the economy of the company and, beyond that, its overall business goals.

90
This leaflet for visitors with disabilities was part of a wider brief that Pentagram fulfilled for London's National Portrait Gallery, in which they revitalized the logotype and provided a recognizable house style for a range of printed items. Here, a powerful photographic portrait is combined with elements from a distinctive design programme.
Company National Portrait Gallery, UK.
Design Justus Oehler/ Pentagram, 1995.

Branding

Trademarks do more than denote companies or parts of companies. They also denote products and groups of products. The Nivea trademark does not denote a company, but a class of products made by Beiersdorf. When trademarks are applied to a product or a class of products they are sometimes called 'brands'. In effect, a brand is more than the visual trademark.[1] A brand is a product (or a class of products) including its trademark, its brand name, its reputation and the atmosphere built up around it. When we talk about a brand we talk about verbal, visual and conceptual aspects of product identity.

A brand is fuelled by whatever is associated with the product: always by a trademark and by product quality, sometimes by packaging, and often, to a great extent, by advertising.

Brands are convenient to both producers and consumers. Producers use brands to individualize goods that otherwise may be difficult to distinguish from those of other producers. Individualization gives way to the creation of a valuable identity, which in turn may allow the producer to charge more, sell more, or both. To the consumer, trademarks promise good quality and supply desirable identity. Furthermore, trademarks help consumers to repeat successful purchases.

Branding does for sales what mechanization does for production: it facilitates advantages of scale.

The distinction has been made between freestanding product brands and more generalized corporate brands. Here the word 'brand' is used for the first phenomenon; the second phenomenon will be labelled 'organizational-monistic identity'.

The goals of branding are, in principle, the same as those of a corporate design programme, with an emphasis on product issues; a brand implies a product-related design programme.

91
The flip-top Marlboro packet presents two different trademarks which are used individually: the namemark and the red angular figure at the top of the packet.
Company Marlboro, USA.
Design Frank Gianninoto, 1955.

arlboro **Marlboro** **Marlboro** **Marlb**

EEC Council Directive (89/622/EEC) EEC Council Directive (89/622/EEC) EEC Council Directive (89/622/EEC)

ING CAUSES CANCER TOBACCO SERIOUSLY TOBACCO SERIOUSLY TOBACCO SER

DAMAGES HEALTH DAMAGES HEALTH DAMAGES HE

LTER CIGARETTES FILTER CIGARETTES FILTER CIGARETTES FILTER CIGARE

arlboro **Marlboro** **Marlboro** **Marlb**

EEC Council Directive (89/622/EEC) EEC Council Directive (89/622/EEC) EEC Council Directive (89

ACCO SERIOUSLY TOBACCO SERIOUSLY SMOKING CAUSES SMOKING CAUSES

MAGES HEALTH DAMAGES HEALTH HEART DISEASE

LTER CIGARETTES FILTER CIGARETTES FILTER CIGARETTES FILTER CIGARE

arlboro **Marlboro** **Marlboro** **Marlb**

EEC Council Directive (89/622/EEC) EEC Council Directive (89/622/EEC) EEC Council Directive (89/622/EEC)

OKING KILLS TOBACCO SERIOUSLY TOBACCO SERIOUSLY TOBACCO SER

Types of corporate identity structure

A business can use one of two different principles: organizational identity or branded identity. A company with an organizational identity bases its identity on one or more organizational units; a company with a branded identity features the identity of one or more products.

Within each of these two principles, a company can choose from three further principles: monistic identity, endorsed identity or pluralistic identity.*

Monistic identity implies that there is only one identity; endorsed identity implies that one identity is supported by another identity; and pluralistic identity implies that a number of identities are working side by side.

The two principles combined with the three principles give a total of six possible identities:

	Organizational identity	Branded identity
Monistic identity	organizational-monistic *monolithic*	branded-monistic
Endorsed identity	organizational-endorsed *endorsed*	branded-endorsed
Pluralistic identity	organizational-pluralistic	branded-pluralistic *branded*

Table five Six kinds of corporate identity. Olins's three categories are italicized.

Organizational-monistic identity
A company with an organizational-monistic identity works, in principle, with only one organizational identity that represents the company itself.

IBM works primarily with an organizational-monistic identity. Product names are, as a rule, nothing but model designations and are never marketed without the IBM name as the main attraction. Strictly speaking, IBM has both an organizational (-monistic) and a lot of branded (-endorsed) identities. The organizational identity is strong; the branded identities are relatively weak.

92

Branded-monistic identity
A company with a branded-monistic identity works with only one branded identity that presents the company's only product or only class of products.

Beiersdorf is a relatively unknown German company with a weak organizational identity. However, its products are known in large parts of the world by a strong branded-monistic identity. The product name is Nivea.

93

Organizational-endorsed identity
A business with an organizational-endorsed identity is often identified by a variation on the form 'ABC, a DEF company' or 'ABC, a company in the DEF Group', where DEF is the parent company.

In Scandinavia, Diners Club was until 1994 a company with an organizational-endorsed identity. All visual material from Diners Club was endorsed by the owner, Scandinavian Airlines System.

94

*Wally Olins suggests three different types of corporate identity structure:

Monolithic identity: the organization uses one name and visual style throughout;

Endorsed identity: an organization has a group of activities or companies that it endorses with the group name and identity;

Branded identity: the company operates through a series of brands that may be unrelated either to each other or to the corporation.[2]

While Olins's monolithic identity and endorsed identity are orientated towards organizations or parts of organizations, his branded identity is orientated towards products. However, one could also think of monolithic identities and endorsed identities that are product-related, and of 'series of identities' that are organizational. In fact, a company's visual identity can be structured according to six basic principles.[3]

92
IBM has an organizational-monistic identity.
Company IBM, USA.
Design Paul Rand, 1960.

93
The German company Beiersdorf has a branded-monistic identity. Most of the people who know the product have never heard of the company. (In the UK, Eire, Australia, New Zealand, Canada and South Africa the Nivea brand is owned by Smith and Nephew.)
Company Beiersdorf, Germany.

Branded-endorsed identity

A branded-endorsed identity implies that a company that has its own organizational identity owns a product or class of products that receives support from the company's organizational identity and, in return, supports the company identity.

For example, Volkswagen identifies its cars with branded-endorsed identities. A Volkswagen Polo is marked both with Polo and with Volkswagen.

Endorsed identity involves two names, a supporting name and a supported name. If the endorsed part is not a real name but just an adjective or a generic product designation, then the type of identity is monistic rather than endorsed. McDonald's, for example, has a basically organizational-monistic identity. Most of the product names – Big Mac, McFeast, McNugget, McDonut, and so on – make any further reference to the company name superfluous.

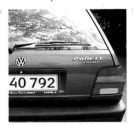 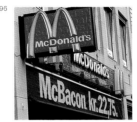

Organizational-pluralistic identity

A company with an organizational-pluralistic identity comprises several subsidiaries. The visual identity of each subsidiary company is based on its own special characteristics and each company is run in its own way. Nothing visible ties them together.

The manufacturer of Danish aquavit, De Danske Spritfabrikker, is owned by Danisco, which also owns several other companies. The identity manifested by the label shown, which was in use in 1994, is organizational-pluralistic.

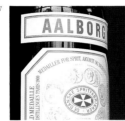

Branded-pluralistic identity

A branded-pluralistic identity applies to a company with a number of products that each maintains its own identity while the manufacturer remains in the background. Procter & Gamble has a branded-pluralistic identity. Buyers must read the fine print to discover which products are made by Procter & Gamble.

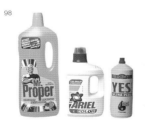

The six possible visual identities are not mutually exclusive. They usually exist side by side in many combinations. Many product-based companies have both organizational and branded identities. Colgate-Palmolive, for instance, sells products with organizational-monistic identity as well as products with a branded-pluralistic identity.

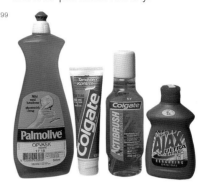

94
The Diners Club in Scandinavia was owned until 1994 by SAS. Until then Diners Club maintained an organizational-endorsed identity. Material from Diners Club in Scandinavia rarely appeared without an endorsement by SAS. *Company* Diners Club, USA. *Design* Chermayeff & Geismar, 1966.

95
Volkswagon Polo has a branded -endorsed identity. The company is Volkswagon, the product is Polo. Polo is endorsed by Volkswagon. *Company* Volkswagon, Germany.

96
McThis and McThat. McDonald's identity is not endorsed but basically organizational-monistic. *Company* McDonald's, USA. *Design* Jim Schindler and others, 1962 *Redesign* 1968.

97
Consumers of Aalborg Danish aquavit do not necessarily know that the manufacturer is part of the Danisco Group. The identity is organizational-pluralistic. *Company* De Danske Spritfabrikker, Denmark. *Design* Originally 1888.

98
As with other Procter & Gamble products, Mr Proper, Ariel and YES have branded-pluralistic identities. *Company* Procter & Gamble, USA.

99
Palmolive washing-up liquid, Colgate toothpaste and Colgate mouthwash are examples of products with organizational-monistic identity. Ajax cleaner has a branded-pluralistic identity. *Company* Colgate-Palmolive, USA.

Applications of a trademark

In chapter one, we saw how trademark provide three types of identification: ownership and origin.

The difference between origin identification described in chapter one (p 16) and branded identification described in this chapter (p 58) is that origin identification refers explicitly to the company, while branded identification does not necessarily do so.

Branded trademarks, however, work as *noms de guerre*, or assumed names, practical pseudonyms for the more or less identifiable company name. Under this assumption, branded identification functions as origin identification.

With the three types of trademark applications described above, the trademark identifies the company as communicator, owner and manufacturer, respectively.

The identification process works in two ways. The entities that are linked by identification are identified with, for example, the manufacturer and the product. What is identified with the trademark depends on the viewer's vantage point. To the informed customer who already knows the Campbell's brand, the trademark on the soup can identifies the soup itself. To the unprepared soup buyer, the trademark identifies the manufacturer of this soup.

The social identity application
the social identification mode, the trademark identifies the sender in many kinds of company communications.

The trademark by itself may be the shortest possible company communication. A trademark on a company letterhead belongs to this category as does that displayed in sports arenas to remind people of the existence of the companies they represent.

100
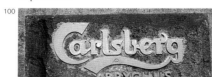

2 The ownership application
In the ownership mode, the trademark identifies the company as the owner of its property. A trademark on a delivery vehicle is an example of this category.

101
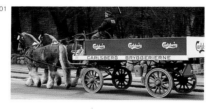

3 The origin application
In the origin mode, the trademark identifies the company as the provider of products and services. The brewery's trademark on a bottle of beer belongs to this category.

102
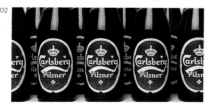

100
'Here is Carlsberg'.
A trademark used in the social identity mode.
Company Carlsberg, Denmark.
Label design Thorvald Bindesbøll, 1904.

101
As these vehicles are owned by Carlsberg, the trademarks on them are used in the ownership mode.
Company Carlsberg, Denmark.

102
As this beer is brewed by Carlsberg, the trademarks on the labels are used in the origin mode.
Company Carlsberg, Denmark.

103
Fashion-designer Donna Karan supports her own identity with that of New York, when advertising in New York and elsewhere.
Company Donna Karan New York, USA.

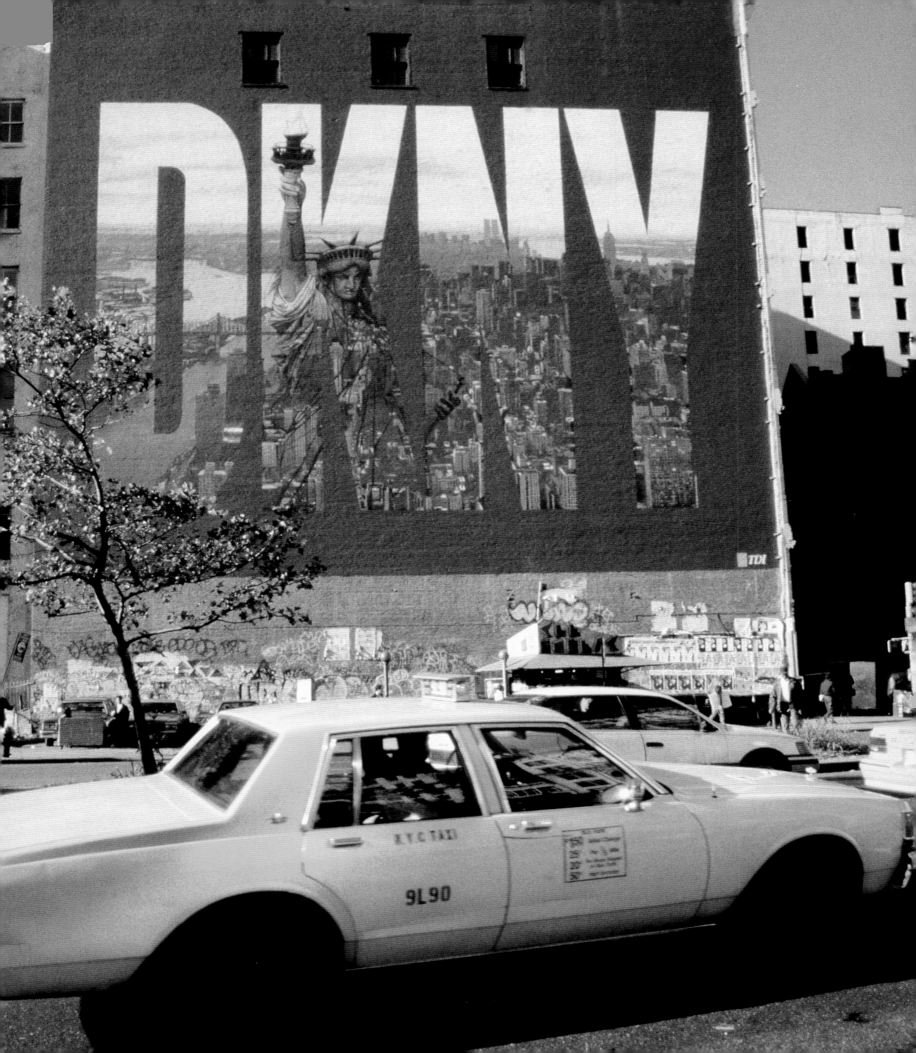

Kinds of identification

A trademark can provide identification in at least ten different ways:

1 Uniqueness

The basic task of the trademark is to distinguish the communications, the property and the products of a company: 'this is us, not anybody else; this is owned by us, not by anybody else; this is manufactured by us, not by anybody else'. This task implies that the trademark is different from those of its competitors and other companies.

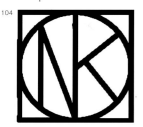

2 Value

Being or not being absolutely unique, a trademark can have an attention value that implies that it is easy to recognize. You cannot help noticing it. High attention value is likely to be followed by good memory-retention.

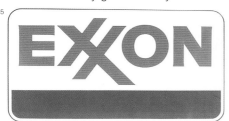

3 Holding power

Sometimes a trademark has the power to hold the attention for more than a split second, perhaps using some of the same qualities that give attention value. Double takes, illusions, puns, puzzles and twisted images are some ingredients that facilitate identification by holding power.

4 Description

Many trademarks include explicit information about the company and, or, its products.

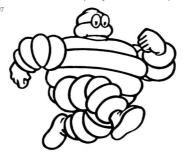

5 Association

Other trademarks inform the viewer by association in some relevant respect about the nature of the company and, or, its products.

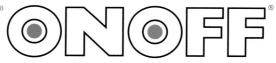

6 'Tone of voice'

Through its tone of voice, a trademark can say a great deal about the company or its products. The overall effect can be perceived in pairs of opposites: elegant/bold, aggressive/ subtle, humanistic/technological, natural/ technical, traditional/modern, common/exclusive and cheap/expensive. .

7 Graphic excellence

The trademark can add something to the company or its products and services through its own artistic and symbolic value. Graphic excellence functions as a synecdochical sign of managerial competence. It explains the whole by showing a part. Graphic design is read as circumstantial evidence of the quality of the company.

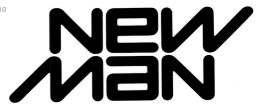

104
Although many companies have monogram-like trademarks, the Nordiska Kompaniet trademark is not easily confused with other trademarks in its practical use.
Company NK, Nordiska Kompaniet, Sweden.
Design David Blomberg, 1902. (The square was added in the 1960s).

105
When Standard Oil of New Jersey had to change its name from Esso, the firm chose Raymond Loewy as design consultant. Loewy, who coined the name Exxon, has stated: 'I valued the double x for its neo-subliminal memory-retention value and also for a certain similarity to the two s's in Esso.'
Company Exxon, USA.
Design Raymond Loewy, 1966.

106
The figure one figure/ground mark identifies the Danish national television station on screen to such a degree that at its launch angry letters were sent to national newspapers from viewers complaining that they could not see the programmes because of the small permanent identification mark in the upper corner of the screen.
Company DR TV, Denmark.
Design Per Mollerup Designlab, 1994.

107
Monsieur Bibendum, the tireless tyre man made of tyres, has advertised his product for nearly a century (see also figs 566–7).
Company Michelin, France.
Design O'Galop, 1898.

108
For a chain of shops selling radios, televisions and electric appliances, the ONOFF name mark goes straight to the point.
Company ONOFF, Sweden.
Design Inghald Andersson, 1982.

109
In an age when consumers are worried about the effects of chemical additives in food, the dairy Carlshamn's tone of voice conveys an easily decodable message of purity and innocence.
Company Carlshamn, Sweden.
Design Rönnberg & Co. 1993.

8 Reputation

A trademark can gain added value based on the reputation of its company or product. This value can then be extended to other products and services. Companies such as Cartier and Yves Saint Laurent use cross-branding, lending their famous trademarks to a long line of products that have nothing or little to do with their original fields of operation.

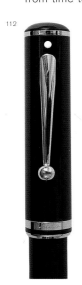

9 Discretion

The purpose of a design programme is to communicate. Some companies always want discreet identification, other companies want it from time to time.

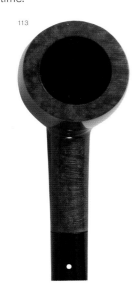

10 Repetition

The effect of all these characteristics can be dramatically increased by the repeated use of the trademark. Recognition by repetition is the traditional rationale behind all design programmes.

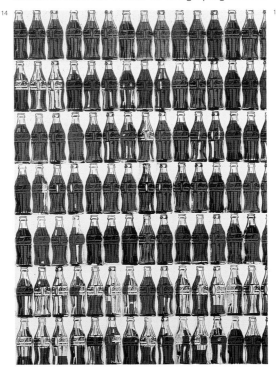

Some of the above kinds of identification work in opposition to each other. For instance, attention value and discretion will typically work in opposite directions. However, one trademark should, as a rule, provide several kinds of identification.

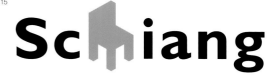

110
An upside-down rotation. The name can be read from two sides.
Company New Man, France.
Design Raymond Loewy/CEI, 1969.

111
The reputation of the fashion designer Yves Saint Laurent is visually transferred to other products by the Yves Saint Laurent trademark.
Company Yves Saint Laurent, France.

112–3
Both Shaeffer pens and Dunhill pipes are identified by a discreet – yet most visible – white dot.

112
Company Shaeffer, USA.
Design Walter A Shaeffer, 1924.

113
Company Dunhill, UK.
Design Alfred Dunhill, 1912.

114
In this picture Warhol acknowledges the allure of reiteration in a consumer society.
Andy Warhol, *Green Coca-Cola Bottles*, 1962.

115
One trademark can provide several kinds of identification. Schiang's name mark has uniqueness, attention value, holding power, description, association and graphic excellence.
Company Schiang, Denmark.
Design Per Mollerup Designlab, 1993.

116
Overleaf
Goodyear enjoys a unique airborne trademark exposure.
Company Goodyear, USA.
Design Frank A Seiberling, 1900.

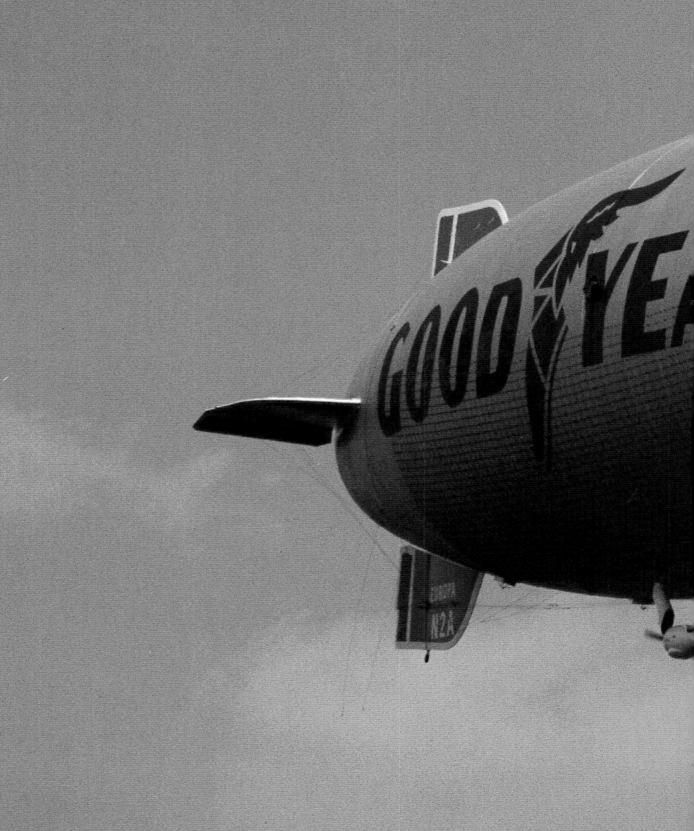

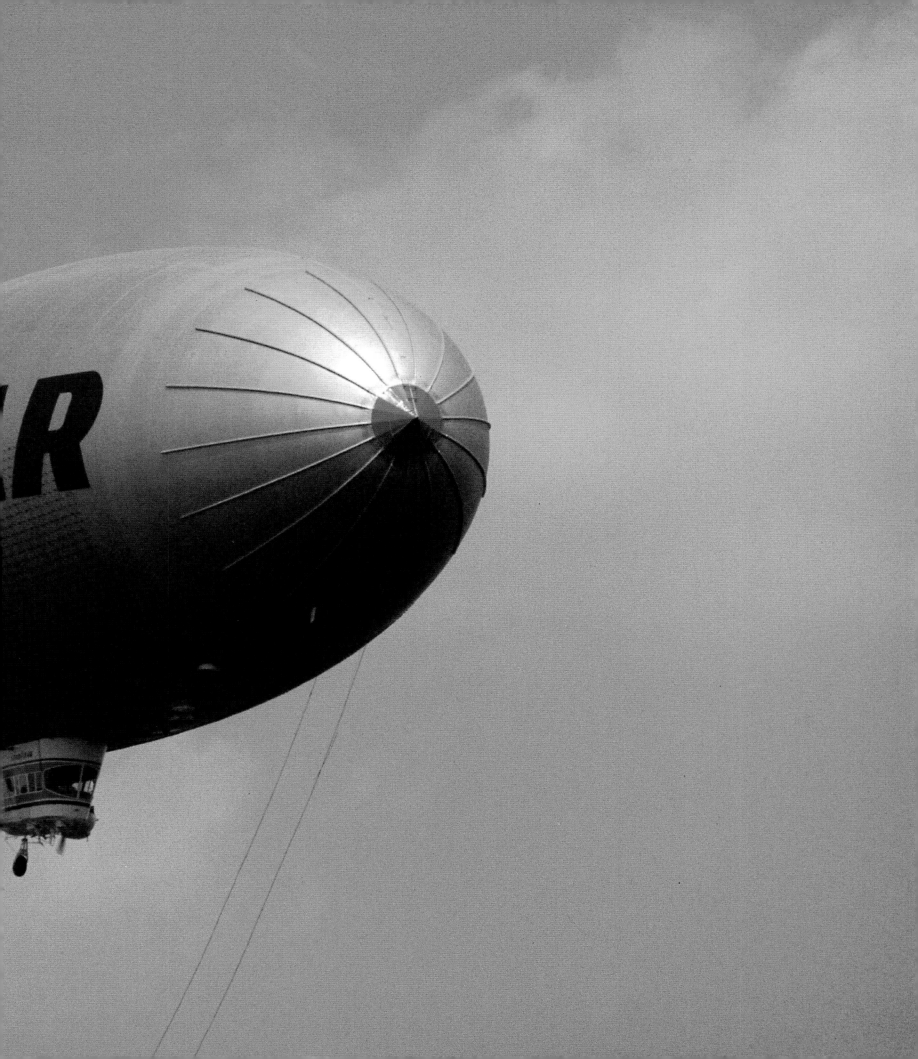

Communication

This chapter, which looks at the trademark's capacity for communication, goes beyond the usual parameters of graphic design and draws on other disciplines. Theories and models formulated in different fields, such as semiotics and communication studies, are applied to this aspect of the trademark.

The Swiss linguist, Ferdinand de Saussure, first defined semiotics as 'a science which studies the role of signs as part of social life'.[1] He used it to analyse language, which he regarded as a system of signs, but it has since gained a far wider application and been used for everyday signs: the referee's whistle at a football match, stamps, footprints and trademarks.

Taking a general theory of signs as the point of departure, this study includes language as one of many sign systems. Since many trademarks include both letters and words, their linguistic content will be analysed along with their non-linguistic content.

The transport of meaning

Communication is social interaction through messages. Messages are made up of signs that convey meaning. According to the American philosopher, Charles Sanders Peirce, a sign 'is something which stands to somebody for something in some respect or capacity'.[2]

Early studies in communication theory concentrated on the transport of messages. Since then much interest has focused on the nature and production of signs as studied by semiotics.

The transport viewpoint is clearly reflected in the communication model developed by Claude E Shannon and Warren Weaver in *The Mathematical Theory of Communication* (1948).[3] To Shannon and Weaver, communication was primarily a question of how channels – such as telephone cables and radio waves – could be used most efficiently.

Although they were primarily concerned with technical problems, Shannon and Weaver recognized that there were other kinds of problems in communication. They defined three levels of communication problems with three questions:

Level A
How accurately can the symbols of communication be transmitted? (The technical problem)

Level B
How precisely do the transmitted symbols convey the desired meaning? (The semantic problem)

Level C
How effectively does the received meaning affect conduct in the desired way? (The effectiveness problem)

On level A, the technical level, the message is considered as a signal. On level B, the semantic level, the message is considered as a carrier of meaning. On level C, the effectiveness level, the message is considered as a means of influence.

Shannon and Weaver devoted most of their work to the technical problems of level A, but asserted that their theory was 'helpful and suggestive for the level B and C problems'.[4]

The three-part division of problems suggested by Shannon and Weaver sheds light on some essential issues in the study of trademarks. The trademark of Montblanc, the manufacturer of the famous writing instruments, illustrates the point. The Montblanc trademark is a six-pointed star with rounded points. To the company, the star represents the Mont Blanc summit, complete with six surrounding valleys.

117

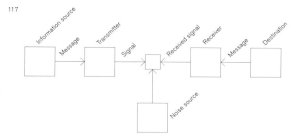

118

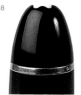

On Meisterstück No 149 – the flagship of Montblanc fountain pens – the white mountain top is conspicuously situated on the rounded top of the black cap. It is hard to avoid seeing the trademark. It works perfectly on the technical level.

117
Table six Shannon and Weaver's communication model, 1964, provides a useful paradigm for analysing trademarks.

118
Meisterstück No 149 with white summit and six valleys. *Company* Montblanc, Germany. *Design* 1913.

On the semantic level, the trademark is open to debate. Not everybody understands the significance of the number 4810, corresponding to the height in metres of Mont Blanc engraved on the nib. Even so, the brand is well advertised, well known and very popular, and the symbol is usually recognized by relevant target groups as the trademark of Montblanc. The subtle meaning originally intended may not get through, but the even more important meaning – here is a Montblanc – certainly does. On the semantic level the trademark seems to work well, after all.

Nevertheless, not all potential buyers of Montblanc pens seem comfortable with the trademark. In Saudi Arabia, Meisterstück pens are reportedly sold with a pure black cap, a Montblanc with no snow on the summit.

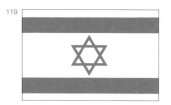

The problem is the similarity between the six-pointed Montblanc mountain top and the Magen David, the shield of David. There seems to be a difficulty on the effectiveness level as much as on the semantic level. Umberto Eco describes such a situation, when a sign is encoded with one meaning and decoded with another, as 'aberrant presuppositions' and 'aberrant decoding.'[5]

Applied to trademarks, the three-part division of communication problems raises the following questions:

Is the trademark visible enough?
This is a simple question, but it is often neglected.

Is the trademark understandable?
This chapter will discuss the question of meaning in depth.

Will the trademark create the desired effect?
Even though this question cannot be answered fully, it is useful to raise and to consider the issue.

Charles Morris proposed a three-part scheme of communication problems similar to that of Shannon and Weaver. He suggested 'syntactic', 'semantic' and 'pragmatic' levels: 'Pragmatics is that portion of semiotics that deals with the origin, uses, and effects of signs within the behavior in which they occur; semantics deals with the signification of signs in all modes of signifying; syntactics deals with combinations of signs without regard for their specific significations or their relation to the behavior in which they occur'.[6] The structure of Shannon and Weaver serves our purpose better than that of Morris. The technical considerations of Shannon and Weaver's level A are simply more relevant than the syntactic considerations of Morris. Trademarks are subject to technical problems. They have no serial syntax.

119
The Magen David on the
Israeli flag.

In the context of communication theory, 'noise' can mean anything that hinders the correct decoding of a message. The noise described in Shannon and Weaver's model is 'engineering noise'. It is the signal interference found on level A. However, Shannon and Weaver note that noise can also be semantic, disturbing communication on level B. 'Semantic noise' stands for 'perturbations or distortions of meaning which are not intended by the source but which inescapably affect the destination'.[7]

Applied to trademarks, the notion of noise raises the following questions:

Is the trademark too sensitive to engineering noise? For example, does it look very similar to the background against which it will be shown?

Is the trademark too sensitive to semantic noise? For example, does it look very similar to other trademarks or to other signs which will be seen by the viewer?

To Shannon and Weaver, communication that does not work as intended has failed. In contrast to this, semioticians typically think of semantic noise as differences in culture. Whether communication succeeds or not depends, in every instance, as much on the culture of the receiver and on the context in which it takes place as it does on the shape of the message.

Context and culture cause problems not only on the semantic level, but also on the level of effectiveness. However, problems on this level tend to be performance problems rather than communication problems.

The receiver may fully understand the message but not react as the sender intends. This may be the result of a difference of opinion about the appropriate reaction, or because the intended reaction is simply impossible for some reason or another. Different opinions can be the result of cultural difference, or other circumstances. When the reader of an advertisement does not buy the advertised goods even though it is possible for him to do so — economically and otherwise — it is not necessarily a problem of cultural difference. It may be that he can buy equal goods cheaper elsewhere or it may be that he does not want or need them.

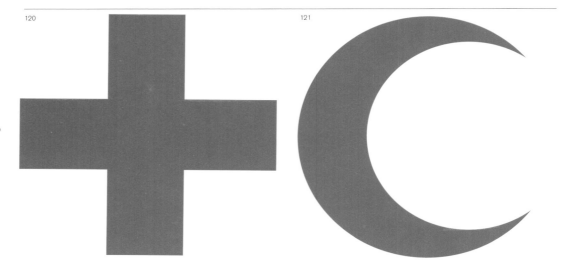

120

121

120–1
In order to avoid semantic noise, the International Red Cross uses the Red Crescent name and trademark in some countries in the Arab World.
Company International Red Cross and Red Crescent Movement, Switzerland.
Design Henri Dunant, 1863.

120
Red Cross.

121
Red Crescent.

122
The prominent display of the Red Cross symbol on the side of a ship does more than advertise the organization. It should also ensure the ship's safe passage in time of war.

Channels, media, formats

Shannon and Weaver defined a 'channel' as the physical means by which the signal is transferred after being encoded by the transmitter and before being decoded by the receiver.[8] A channel can be a telephone cable, radio waves, sound waves, light waves or anything that carries a signal.

A medium is the technical means of communication that converts the message into a signal that can be transmitted along the channel in question. The voice, telephone, radio and television are media, and so is print. The voice, face and body are 'presentational' media, while print, paint, photography and writing are 'representational' media.

Presentational media involve live performance, and the audience is present in time and space. Representational media offer recorded performance and the audience is absent in either or both time and space. The contents of presentational media are 'acts'. The contents of representational media are 'works'.

The telephone, radio and television are mechanical media that can transmit both presentational and representational media. The telephone produces acts when used normally, as do radio and television when they transmit live programmes. When telephones use answering machines and when radio and television transmit recorded material, they reproduce works.

Media can be further divided into 'formats'. The print medium can be divided into newsprint, books, brochures, and so on.

As primarily visual phenomena, trademarks are transferred by the channel of light waves and by visual media and formats.

Channels, media and formats constrain the variety of a trademark. In the case of newsprint, there can be three types of constraints:

The constraints of the light wave channel, ie the constraints of visuality;

The constraints of the print medium, ie the constraints of two dimensions and presentation by means of static images;

The constraints of the newsprint format that often carries no colour and has relatively poor resolution.

123 **REUTERS**

Channels, media and formats are not innocent means of message transfer; their constraints are not neutral to the message. 'The medium is the message,' said Marshall McLuhan. In graphic design, computers were introduced as tools that could do existing jobs in easier ways. Today, computers often determine what the jobs are.

While the constraints of channels, media and formats are determined by available technology, the way that they are used within their constraints is determined by culture. In spite of considerable cultural convergence in the appearance of contemporary graphic design, trademarks from different geographical areas often retain some form of regional quality.

As visual phenomena, trademarks address themselves to the sense of sight. Some also address the senses of touch and hearing, though trademarks that appeal to taste and smell are difficult to imagine.

Sometimes trademarks leap from two into three spatial dimensions. When they do, they can be touched. An embossed or punched out trademark in a brochure exemplifies this. So does a three-dimensional trademark like the Mercedes-Benz star on the top of the radiator grille. Finally, trademarks sometimes serve as sculptures.

124

123
On its letterhead and elsewhere Reuters has punched out its trademark.
Company Reuters, UK.
Design Alan Fletcher/Crosby Fletcher Forbes, 1968.

124
The Danish National Television station turned its two-dimensional trademark, a figure one, into a three-dimensional mark when it applied it to the back of meeting-room chairs.
Company DRTV.
Design Per Mollerup Designlab, 1994.

125
The Mercedes star was introduced in 1909 and it was encircled in 1916. It has been used as a three-dimensional radiator mascot since 1921 (see fig 575).
Company Mercedes-Benz, Germany.
Design Gottlieb Daimler, late nineteenth century.

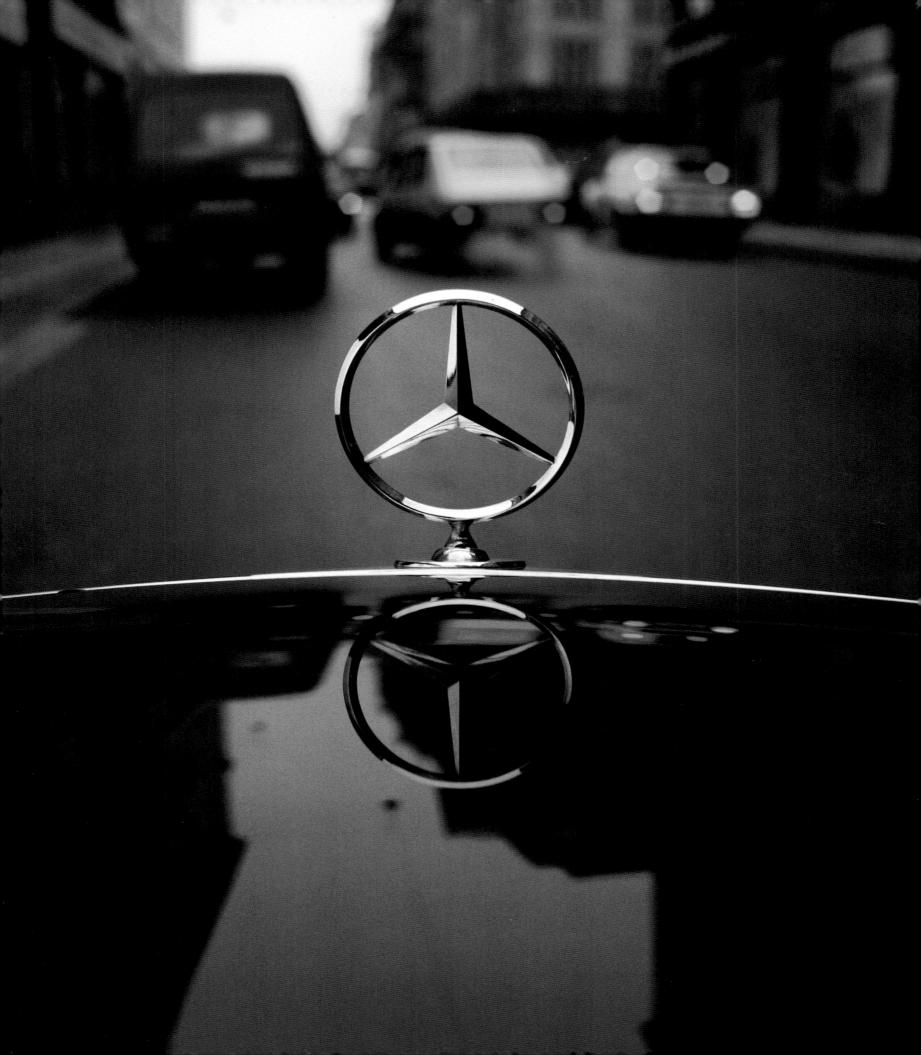

Although trademarks are almost exclusively thought of as visual phenomena, many include company names or product names which, of course, are pronounceable. Other audible aspects may also be relevant.

During the *Oktober Festspiele* in Munich, the Löwenbräu brewery featured a large lion, which roared out 'Löwenbräu' over the festival area at short intervals. In a similar way, jingles in television commercials are sometimes used so often and so consistently that they become audible trademarks.

Even so, trademarks remain almost exclusively visual phenomena. Trademarks are usually presented in printed media in a two-dimensional spatial form. Embossing and punching out are impossible or inappropriate in most print formats. Printed trademarks have no temporal dimension.

When appearing on television or on moving signs, trademarks can – in principle – have a temporal dimension. In purely spatial media, like print, a temporal dimension can sometimes be translated into spatial relationships. If Cassandre's man in the Dubonnet poster is considered a trademark, then the famous triptych can be seen as the spatial representation of a temporal relationship.

126
In his book about the poster artist A M Cassandre, Henri Mouron points out that 'according to Cassandre, the pun "dubon Dubonnet" ["good Dubonnet"] already existed; he merely extended it by adding the syllables "dubo" [reading as du beau, beautiful in French] and repeating the illustration, with variations, in three panels.'[9]
Company Dubonnet, France. Series of three lithographic posters.
Design A M Cassandre, 1932.

Linguistic functions

In 1960, Roman Jakobson presented a communication model that built on the linear model of Shannon and Weaver and applied it to linguistics.[10] This model is also relevant to non-verbal communication.

Jakobson's model includes six factors of communication:

	context	
	message	
addresser	..	addressee
	contact	
	code	

Table seven Roman Jakobson, Six factors of communication.

His model associates a function of language with each of the six factors of communication:

	referential	
	poetic	
emotive	..	conative
	phatic	
	metalingual	

Table eight Roman Jakobson, Six linguistic functions.

Any communication will include a number of Jakobson's six functions of language. These functions are not mutually exclusive, but concurrent. On the other hand, the referential and emotive functions tend to oppose each other; the more emotive a message is, the less referential it is, and vice versa.

The referential function deals with the relationship between the message and its referent, the object to which it refers. This is the basic function of communication.

The emotive function deals with the relationship between the addresser and the message or, more precisely, the way the message represents the emotions of the addresser. In contrast to the referential function, the emotive function is basically subjective. The crux of the matter is not what the object of the message is, but how the message represents the addresser's feelings about the object.

The conative function deals with the relation between the message and the addressee or, more precisely, the way the message affects the addressee. The conative function has a clear relation to Shannon and Weaver's effectiveness level. Communicators who want a specific behaviour to result from their communication will devote much of their attention to this function.

The poetic function deals with the relation between the message and itself or, more precisely, the material and formal characteristics of the message.

The phatic function is the communication-for-the-sake-of-communication function. Its only purpose is to establish and continue communication.

The metalingual function sees to it that communication is understood in the right way. Inverted commas often indicate that a word should be understood figuratively. If somebody taps a glass, it normally means that he will make a speech.

Jakobson's six linguistic functions can be usefully applied to communication by trademarks.

The fact that the trademark denotes a certain company constitutes a referential function. In addition to that, any further objective information – such as a factual reference to the trade of the company – is also embraced by the referential function. Beyond this, a trademark typically connotes the company's subjective perception about itself. This is the emotive function.

All trademarks are created to influence an audience, even if the specific result of the conative function may be difficult to measure. Designers traditionally claim that their trademarks possess great aesthetic value – and often they do. This has to do with the poetic function.

Designers and users sometimes feel tempted to claim that beautiful trademarks have greater conative impact than ugly trademarks, but this depends on the situation. In some situations, an irritating, brutal or even ugly trademark that you cannot avoid noticing may be more effective than a pleasing mark.

Trademarks are often used as visual 'small talk' – communication where communication itself is more important than what is talked about. Trademarks on high-rise buildings and in sports arenas often have no other purpose than saying 'hello'. This is the phatic function of communication.

Finally, the metalinguistic function is the function that sees to it that a trademark is understood as a trademark and not as a road sign or a piece of art. The commercial tone of voice of a trademark is a metalinguistic function that frames the message.

Linguistic functions

The referential function and the emotive function are the most important of Jakobson's six functions of language. They are fundamental functions to all communication. While the referential function is objective and cognitive, the emotive function is subjective and expressive. The referential function addresses our understanding, the emotive function addresses our feelings.

Referential and emotive functions often oppose each other and they are inversely proportional in many circumstances. The more objective a sign is, the less subjective it is, and vice versa. Linguists call this polarity between objectivity and subjectivity the 'double function' of language. The same polarity is found between science and art. It is mirrored in experiences that can be more or less intellective and correspondingly less or more affective. We understand and we feel. Logical/objective signs call for attention; expressive/subjective signs call for participation.[11]

127

127
The referential function of the masthead of the *Wall Street Journal* ensures that the newspaper is distinguished from other newspapers and that the main field of interest is recognized. The title refers to a street that has itself become symbolic of business. The emotive function drives home the intended seriousness to the reader. It is the metalinguistic function that ensures that the masthead looks like a masthead and not like a headline or anything else. Other functions of language, such as the conative function, may also exist to some degree in the title.
Company Wall Street Journal, USA.
Design Charles Dow, Edward Jones and Charles Bergstresser, 1889. (The original editors.)

128
Form follows available space. Limited space on the newsstand for masthead exposure restricts the format of newspapers' titles.

The Guardian

ndon
er

Herald INTERNATIONAL Tribune

PUBLISHED WITH THE NE

No. 35,

World's Daily News

oke

use

MONDE. Raids israéliens
**Le sud du Liban
au régime sec**

libération

ter

Frankfurter Allgemeine

Los exemplaar f 1,60

De Telegraaf

'free' dagen

België	Fr.	45,—	Gr. Brit.	£	1,60	N.A.+Aruba (N)
Canada	$	4,25	Indonesië	R.P. 7.100,—		Oostenr. O.*
Can.Eil.	P.	315,—	Israël	NIS 12,00		Polen PL
Duitsland	DM	3,30	Italië	L. 3.500,—		Portugal Es
Egypte	E.P.	9,000	Luxemb.	Fr. 42,—		Singapore S
Frankrijk	Fr.	10,—	Madeira	Esc. 365,—		Spanje P.
Griekenl.	Dr.	550,—	Moskou	U.S.$ 3,30		Thailand B

dom

CAFFÈ
HAUSBRANDT

EDIZIONE INTERNAZIONALE

** Spedizione in abbonamento
postale / 50% - Milano

il Giornale

CAFFÈ
HAUSBRANDT

Anno XXIII, N. 99, una copia L. 1500

Quotidiano

The Daily Telegraph

Signs

Peirce uses the word 'sign' with at least two meanings: he uses it in a broad sense to encompass the triadic relationship set up by a sign, and he uses it in a narrow sense to label one element in that triadic relationship.[12]

The three elements in the triadic relationship are: the *representamen* or sign in a narrow sense; the *object* for which the representamen stands; and the *interpretant*, which is the effect that the representamen creates in the mind of the user.

In Peirce's words: 'A sign or representamen, is something that stands to somebody for something in some respect or capacity. It addresses somebody, that is, creates in the mind of that person an equivalent sign, or perhaps a more developed sign. The sign that it creates I call the interpretant of the first sign. The sign stands for something, its object.'[13]

The terms can best be illustrated by a trademark on a letterhead: the trademark per se is the representamen; the effect that the trademark creates in the mind of the user is the interpretant; and the company that the trademark stands for is the object.

Decoding may differ from encoding (see p 69) and the interpretant caused by a particular representamen is not determined absolutely. The interpretant depends not only on the representamen, but also on the context in which it is used and on the culture of the user. Any user may create several interpretants in different situations. Some of the possible interpretants appear in logical chains where the interpretant itself – as suggested by Peirce – is a new sign. Peirce used logical chains to illustrate the process in an approximate series of steps. Here the chains are used to illustrate different ways of interpretation.

The Montblanc star will again serve as an example. The white star on the top of a bottle of ink is the representamen (a), the manufacturer of the ink is the object (b) (see fig 129).

The white star may just trigger a mental picture of the writing implements sold under that mark (c). However, it might also conjure up the prestige and quality of the products sold under that mark (d).

To another reader of the sign, or perhaps even the same person, simultaneously or at a different time, the white star may evoke the name of the mountain Mont Blanc (e).

The name of the ink may trigger the concept of altitude (f). Considered in connection with the specific use of the mark, this may in turn trigger the notion of mountain-high quality (g).

To still another user, or perhaps even the same user again, the white star may trigger the mental image of fountain pens (h). This image may summon up the idea of something that, under certain circumstances, causes ink blots on fingers and clothes (i).

In real life, different interpretations take place more or less simultaneously (in the mind of one user) and may be understood as one interpretation with a complex interpretant consisting of several layers – this sign denotes this and connotes that.

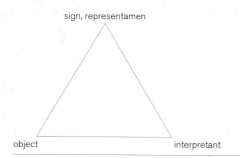

129
Peirce's triadic sign concept.

130
One sign (a) representing one object (b) may cause many different – even concurrent – interpretants (c–i).

131
Prime site exposure of Montblanc's mountaintop trademark.
Company Montblanc, Germany.
Design 1913.

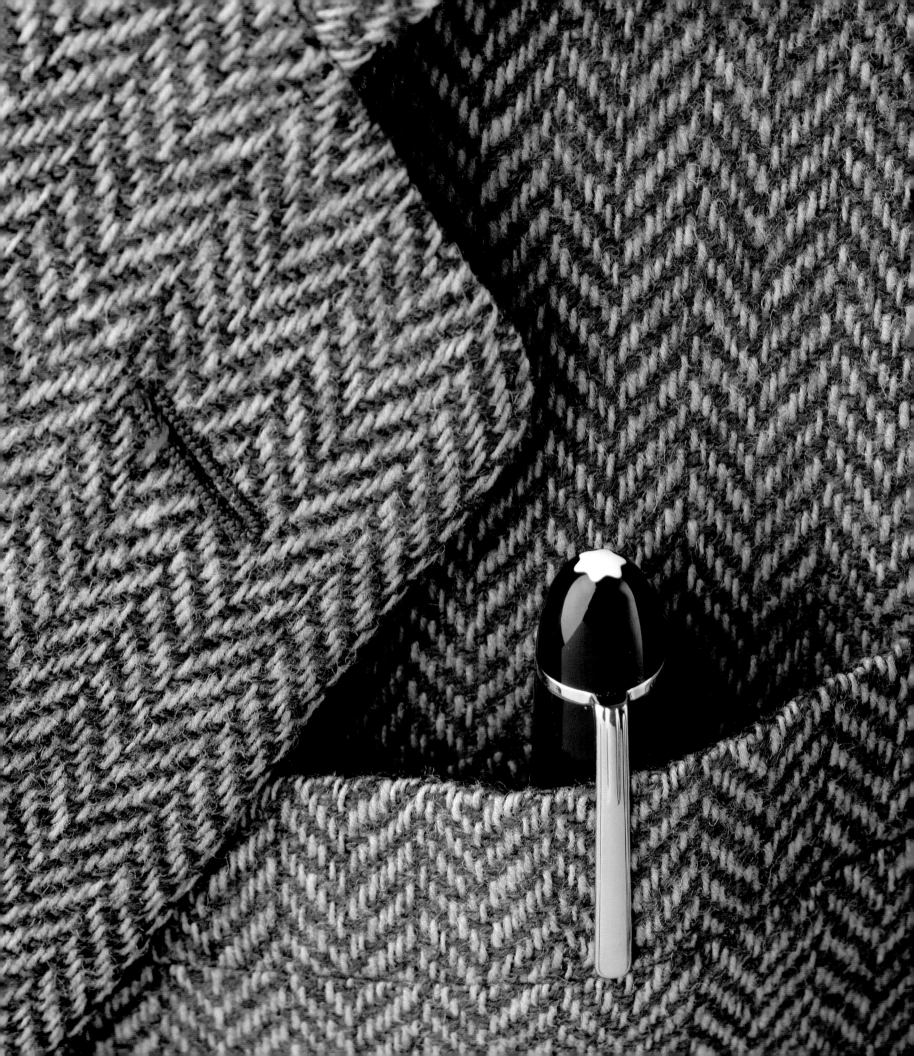

Codes

In semiotics, a 'code' is a system of signs which incorporates relations and meanings. Like signs, codes can be more or less objective and correspondingly, less or more subjective. The main distinction is between logical codes that are objective and expressive codes that are subjective.

A logical code is an objective code with a strong, usually explicit, convention. The signs of a logical code denote and call for attention. Logical codes include paralinguistic codes, practical codes and epistemological codes:

Paralinguistic codes include alphabets, the Morse code, braille, semaphore flag codes and ideograms, such as Chinese signs, which communicate ideas instead of sounds;

Practical codes are codes for instruction and co-ordination, such as traffic lights, road signs, sirens, warnings, no admission signs and programmes;

Epistemological codes deal with the relationship between epistemological systems and their description by semiological systems. All kinds of scientific codes are epistemological codes, including notation in mathematics, biology, chemistry and dentistry. The purpose of epistemological codes is classification and calculation. The taxonomy presented in chapter four is an epistemological code of trademarks.

This classification of logical codes is adapted from Pierre Guiraud's *Semiology*.[14] Guiraud also includes mantic codes (for communication with the gods) among logical codes.

While the signs of most scientific codes are arbitrary, the relation between the signs may be more or less homological, ie structurally analogical. Arbitrariness frees notation of unwanted analogies. Homology facilitates memory.

An obvious example of a homology is H_2O, the chemical formula for water: H is the arbitrary sign of hydrogen; $_2$ is the arbitrary sign of the number two, referring in this case to the number of hydrogen atoms in a molecule of water; and O is the arbitrary sign of oxygen. The combination of all three arbitrary signs into H_2O is a homology. The sum of the arbitrary signs reflects the sum of the atoms in a water molecule.

An expressive code is a subjective code with a weak, possibly implicit, convention. The signs of an expressive code connote and call for participation. If the convention is so weak that in fact it hardly exists, the message is subject to hermeneutics – interpretation through the mind of the addresser – rather than decoding.

Logical codes	Paralinguistic codes
	Practical codes
	Epistemological codes
Expressive codes	

Table nine Categorization of codes.[15]

This table shows logical and expressive codes as exclusive possibilities, but codes exist on a continuum stretching from purely logical to purely expressive codes. Trademarks have a foot in each camp. The code of trademarks is logical, in so far as trademarks facilitate orientation, and expressive as far as trademarks express the feelings of their addressers.

Modes of communication

Before discussing the logical/expressive continuum of trademarks, it is useful to divide the modes of communication, as suggested by Pierre Guiraud, into indication, injunction and representation.[16]

Indication deals with being. All kinds of social signs work in this category. Indication covers any type of sign that indicates identity. On the personal level this includes names, nicknames, modes of dress, bookplates and monograms. On a group level, social signs comprise uniforms, heraldry and insignia, shop signs and corporate identity programmes including trademarks.

Injunction deals with action and instructs the receiver of the message what to do, either by command or by suggestion.

Representation deals with knowledge in both science and art.

A combination of logical and expressive codes with these three modes of communication yields an interesting table.

	Indication *Being*	Injunction *Action*	Representation *Knowledge*
Logical/objective codes *denotation/attention*	Insignia	Signals	Science
Expressive/subjective codes *connotation/ participation*	Fashion	Rites	Arts
	Customs Behaviour	Festivals Games	Literature

Table ten Six categories of codes.[17]

This table does not include all possible types of communication. For instance, advertising is not mentioned in the subjective/injunctive field in which it primarily works.

Guiraud himself has reservations about whether his table can be applied to all systems.[18] Nevertheless, the table suggests interesting ways to look at signs. It must always be remembered that codes exist on a continuum between the purely logical and purely expressive. Indication, injunction and representation are not exclusive classes. One code may work in more than one mode. In fact the table should be understood as a classification of the areas in which codes work rather than a classification of codes per se.

Trademarks work in more than one field in this table. Primarily they work in the objective/indicative class since trademarks should always include an objective element of indication that makes it possible for the receiver to discern one company (or one product) from another.

The same trademark that works in the objective/indicative field will, however, typically express the senders' feelings about themselves and therefore also function in the subjective/indicative field.

Finally, a trademark typically includes an element of subjective injunction: 'buy me'. As well as working in the two indicative fields, trademarks also work in the subjective/injunctive field.

The typical trademark works in all three fields: the objective/indicative, the subjective/indicative and the subjective/injunctive. These areas relate to the three most fundamental functions of language in Jakobson's model: the referential, the emotive and the conative. The relative weight of the three functions varies from one trademark to another.

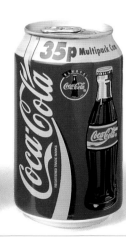

132

133

134

135

132
Pepsi-Cola has recently introduced its new blue identity, clearly differentiating itself from the red world of its strongest competitor Coca Cola.
Company Pepsico International Ltd, USA.
Design Landor Associates, 1995.

133–5
In their choice of colour, trademarks of car rental companies include a strong objective/indicative element. This makes it possible for clients to spot the companies quickly and to distinguish them at a distance in an unfamiliar location, such as an airport: Hertz is yellow, Avis is red and InterRent is blue.

133
Hertz, USA.
Redesign Susan Chait Lebowitz/Gould/Design Inc.

134
Avis, USA.

135
InterRent, USA.

Motivated and arbitrary signs

In principle, all signs are conventional. The strength of the conventions present, which determine the meaning, vary greatly from sign to sign. Conventions can also be more or less explicit and correspondingly less or more implicit. An explicit convention is established by an agreement. An implicit convention is formed by habit.

The question of convention is strongly related to the question of whether a sign is motivated (natural) or arbitrary. In terms of semiotics, a motivated mark is one that is understood without strong convention. You do not need much learning to know that a fish sign outside a shop means 'fishmonger'. The fish outside the fishmonger's shop is a natural mark. On the other hand you must learn that an owl sign outside a shop means 'bookseller'. There is no immediate relation between owls and books (we are not talking about booksellers specializing in books on ornithology).

The owl sign outside the bookseller's shop is an arbitrary sign. A strong convention is required to understand it, either by agreement or by habit. The notions of motivation and arbitrariness are not absolutes. To a scholar familiar with Greek and Roman mythology, the bookseller's owl may seem a quite natural sign; both Pallas Athene and Minerva – goddesses of wisdom in Hellas and Rome respectively – had owls as attributes. Again, the culture of the receiver plays a dominant role.

A general rule governs this situation. The more arbitrary a sign is, the more a convention, an agreement about its meaning, or a habit that forms its meaning, is needed to understand it. In science, where most signs are strongly arbitrary, conventions are explicit and strong. The + sign means addition and the x sign means multiplication. There is no doubt about it.

In advertising, where most signs are motivated, most readers can see that the Marlboro man is a sign of macho power. Conventions are quite strong, but implicit. They are read in the same way that a Western movie buff reads a film and is able to recognize immediately that a cowboy dressed in black, who comes out of a saloon and kicks a sleeping dog on the staircase, is a scoundrel, and that he will be killed by the end of the movie.

136
Marlboro was launched as a cigarette for women in 1924. In 1955, the brand was sold as a cigarette for men with the aid of cowboy symbolism. Today, Marlboro is one of the best known cigarette brands in the world.
Company Marlboro

137
Landmark advertising in the Hollywood Hills, Los Angeles. Here, Marlboro's appropriation of the cowboy and the great American outdoors is monumentally realized.

Icons, indices, symbols

While a motivated sign is a sign that shares some quality with the object to which it refers, the arbitrary sign does not have this characteristic. The arbitrary sign is established only by strong convention. As we saw in the example of the bookseller's owl, motivation and arbitrariness are not absolutes; they exist in degrees. The bookseller's sign does share some quality with the bookseller's trade, but this is not obvious to most people. To certain scholars, the owl is a motivated sign, to a mass audience the owl is an arbitrary sign.

A purely arbitrary sign is a sign that shares absolutely no quality with the object to which it refers. For instance, the signs for letters are arbitrary. The letter 'k' cannot be regarded as sharing any quality with the sound it denotes.

Peirce suggested a three-part division of signs into icons, indices and symbols.[19] While icons and indices are motivated signs, symbols are arbitrary signs. Icons and indices may be divided into subclasses.

1. *Icons* are linked to their object by similarity. An estate agent's photograph of a residence for sale is an iconic sign. Icons can be divided into images, diagrams and metaphor:[20]

1.1 Images are highly representational signs that look very much like their object. Again, we are talking about a question of degrees. The only image that is identical with the object is the object itself. The estate agent's photograph of a house for sale is an image.

1.2 Diagrams are schematic signs which show the structure of the object. The common sign on Danish electricians' shops shows a straight line and a double curved line, which denote two types of electric current: direct and alternate.

1.3 Metaphorical signs share conceptual qualities with the object. If an insurance company chooses an umbrella as its trademark, it works by metaphor. The conceptual quality that the trademark and the business share is protection. If another insurance company chooses a life belt as its trademark, the shared conceptual quality is help in an emergency. If another insurance company chooses a rock as its trademark, the shared quality is stability.

2 *Indices* are physically linked to their object. A small table with a table cloth and wine bottle seen outside a French roadside restaurant is an indexical sign. The sign draws the attention to the business. Indices may be further divided into designations and reagents:[21]

2.1 A designation acquires its meaning through its location. If a picture of a glass is placed on the outside of a parcel, it is a designation that says 'handle with care'. If a similar glass is seen outside a restaurant in an airport, it is a designation that says 'bar'.

2.2 A reagent is the effect of a causal relationship. If the wooden chips left by the cabinetmaker's plane can be seen outside in the street, they are a reagent. The workshop is the cause, the chips are the effect.

3 *Symbols* are arbitrarily linked to their object. A non-figurative trademark on the letterhead of a bank is a symbol. Its only connection with the bank – apart from its function as designation – is that the bank management has decided: this is our trademark.

138

139

140

141

142

138
This estate agent's photograph is an icon, or more precisely, an image. *Company* Per Lausen

139
The generic sign on Danish electricians' shops is an icon, or more precisely, a diagram.

140
The umbrella is a metaphor for protection.
Company Legal & General Insurance, UK.
Design c1975.
Redesign Sampson/Tyrell, 1984.

141
The lifebuoy is a metaphor for help.
Company Trygg-Hansa, Sweden.
Design Svenska Telegrambyrån, 1954.
Redesign Young & Rubicam, 1971.

142
The rock is a metaphor for stability.
Company Prudential, USA.
Design Lee & Young, 1984.

Icons, indices and symbols classify a sign's possible characteristics. The categories are in no way mutually exclusive. This can be seen with the example of a pretzel sign outside a baker's shop. As a baker's product, the pretzel is an icon. However, by drawing attention to the shop it is also an index. Positioned outside the shop, the sign is a designation. The pretzel can also be seen as a symbol, a conventional sign of the baker's trade.

The terms 'icon', 'index' and 'symbol' refer to the relationship between a sign and the object it stands for. Trademarks can be icons, indices and symbols and they can be all three at the same time. As icons, trademarks can be images, diagrams and metaphors. As indices, they can be designations and reagents. However, as a reagent, a trademark refers to its designer, which will only be relevant in our context if the trademark is the designer's own trademark or if the owner of the trademark wants to show that a certain designer has designed the mark.

Type of sign	Link to object
Icon	Similarity
Index	Physicality
Symbol	Arbitrariness

Table eleven Types of signs and their objects.[22]

Type of sign	Relation to object
Icons	Images
	Diagrams
	Metaphors
Indices	Designations
	Reagents
Symbols	

Table twelve Signs classified after their relationship to their objects

143
This sign on a parcel says 'handle with care'.

144
This similar sign outside a restaurant in an airport says 'bar'.

145
Overleaf
In Denmark and other Scandinavian countries, the pretzel is the baker's generic mark. Though few pretzels are alike, the message remains the same: the bakery is here.

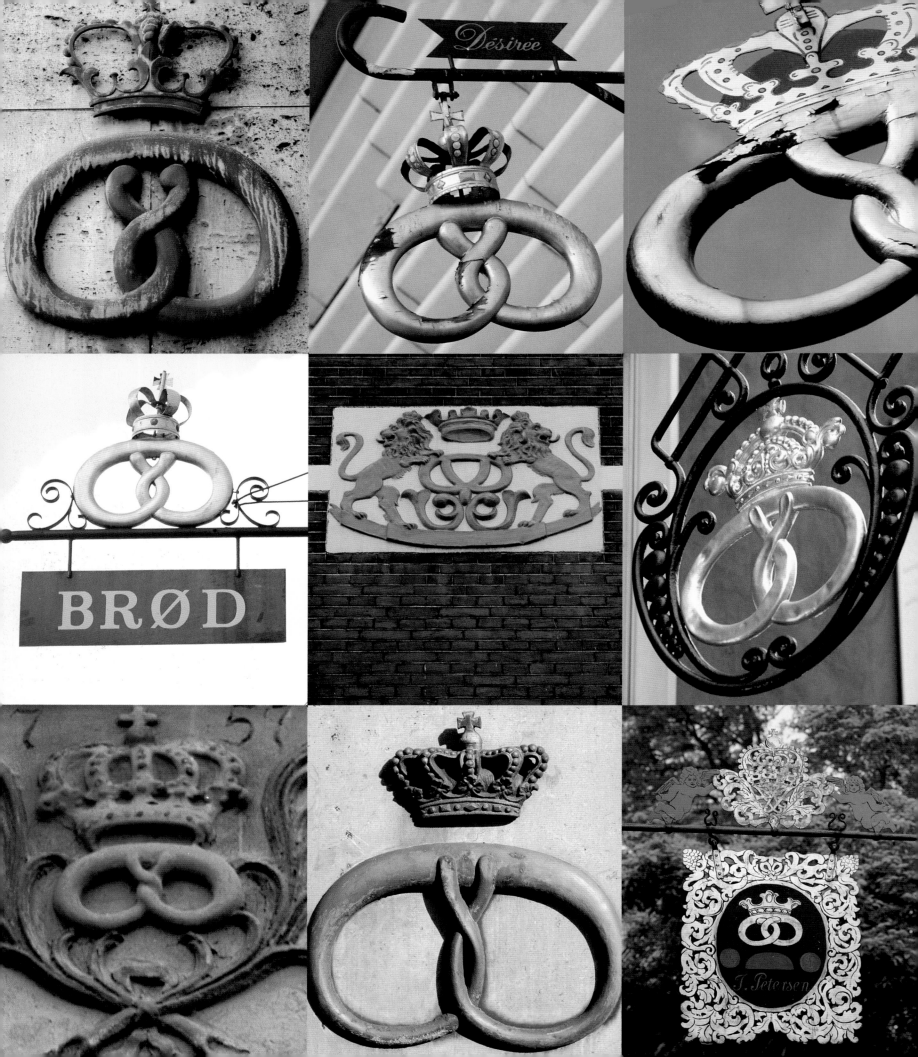

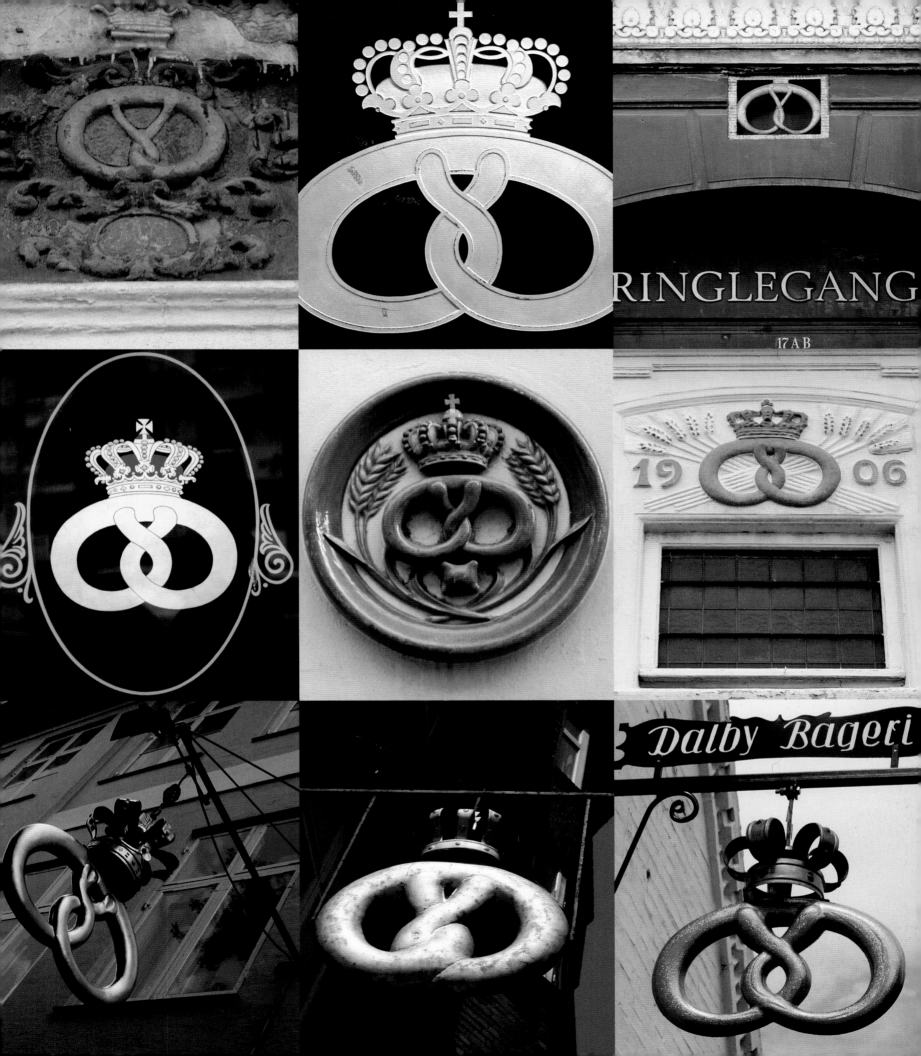

The meaning of a trademark

As we have seen, a sign can carry meanings on more than one level. The Montblanc star immediately says 'This is a Montblanc' to those who know the code. In that context, the star is an objective sign, arbitrary and conventionalized through many years of use. However, the Montblanc star can also be seen as a picture of the summit of Europe's highest mountain. This can be further seen as a metaphor of mountain-high quality. In this context, the star is a subjective sign, natural and only weakly conventionalized.

As mentioned in chapter two (p 46), trademarks often have a double meaning. On the one hand they say: 'This is the XYZ company'. On the other, they say: 'The XYZ company is such and such'. The first meaning is the result of distinction, it is about presence, it individualizes. The second meaning is the result of description, it is about competence, it qualifies. Distinction and description form the double function of trademarks.

While the aspect of distinction complies more or less with Roman Jakobson's referential function, the aspect of description is more complicated. Description can include a referential as well as an emotional function. If a trademark shows an anchor and therefore indicates that the company behind it is a shipping company, then the referential function is at work. If, on the other hand, the anchor is designed in a fashionable computerized style, then an emotional function takes over. The description of a trademark can be divided into referential categorization and emotional attribution. In this example, the category is shipping company, while the attribute is modern.

Now the double function of trademarks can be turned into the triple function of trademarks. While distinction remains distinction, description is split into categorization and attribution. Through distinction, categorization and attribution, the double function of trademarks can be precisely related to the double function of language, which consists of the referential function and the emotive function.

The double function of a trademark	The triple function of a trademark	The double function of language
Distinction	Distinction	The referential function
Description	Categorization	
	Attribution	The emotional function

Table thirteen The multiple function of a trademark in relation to the double function of language.

Trademarks more than correspond to the double function of language. They can fulfil all of Jakobson's linguistic functions.

A change of meaning often takes place during the life of a trademark. As time goes by, the public will associate it with the products and performance of the company it represents. The track record of the company replaces – to some extent, or fully – the originally intended meaning of the trademark. However well (or poorly) the intentions of the company are expressed by the graphic designer, the trademark may eventually become a symbol for the activity of the company.

'A trademark is created by a designer but made by a corporation.' In saying this, Paul Rand, designer of trademarks for IBM, ABC (broadcasting), Westinghouse, UPS, Next and others, explained why most people today dislike the swastika, note fig 146.[23] An ancient religious symbol occurring in Buddhist, Hindu and Native American cultures, it was recast in 1935 when the Nazi party officially adopted it as its symbol.

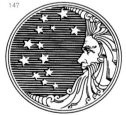

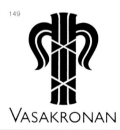

146
The swastika is an ancient symbol whose meaning for people in the West was changed as a result of its appropriation by the Nazis.

147
By wild decoding Procter & Gamble's trademark from 1882 was taken as proof of satanism a hundred years later.
Company Procter & Gamble, USA.

148
In ancient Rome, the fasces, a bundle of rods with the blade of an axe protruding, was the symbol of a magistrate's power. Later the Italian fascists adopted it, as shown here.

149
Vasakronan, a building society, has assimilated the symbol known as the crown of Vasa in its trademark.
Company Vasakronan, Sweden.
Design Lars Laurentii, 1993.

The subject matter of semiotics is the production of meaning. It should by now be clear that a trademark does not have one meaning but a complex sum of meanings. The word 'meaning' itself has more than one meaning.

Here, the meanings of a trademark will be divided into purpose, encoded meaning and aberrantly decoded meaning. Of these categories, 'encoded meaning' comes nearest to what most people in everyday language would refer to as 'the meaning of a trademark'. For reasons of expediency, the arguments deal with organizational design programmes only (in contrast to product-related design programmes that deal with brands). However, the arguments – *mutatis mutandis* – also apply to brands.

1	Purpose
1.1	Control of the company's visual identity
1.2	External identification
1.3	Internal identification
1.4	Rationalisation
1.5	Increased sales
1.6	Reduced costs
1.7	The company's overal business goals
2	Encoded meaning
2.1	Individualization
2.2	Categorization
2.3	Attribution
3	Aberrantly decoded meaning
3.1	Performance-based meaning
3.2	Wildly decoded meaning

Table fourteen The meanings of a trademark.

1 Purpose

A trademark shares goals with the design programme of which it is an element (in special cases, the trademark can be the only element of a design programme). As mentioned in the analysis of corporate identity in chapter two, the goals of a design programme can be summarized in seven parts (see p 55).

1.1 Control of the company's visual identity. The immediately apparent goal of a design programme.

1.2 External identification. Increased visibility and improved image: quantity and quality.

1.3 Internal identification
Increased employee motivation and loyalty.

1.4 Rationalization
Simplication and standardization contribute to increased cost effectiveness.

1.5 Increased sales
Increased visibility, improved image, employee motivation and loyalty can result in increased sales.

1.6 Reduced costs
Improved employee motivation and loyalty, as well as simplification and standardization, can result in reduced costs.

1.7 Increased sales, reduced costs and rationalization further the overall business goals.

2 Encoded meaning

As mentioned earlier, a trademark can be encoded with three types of signification:

2.1 Individualization
The core function of identification.

2.2 Categorization
Objective information on qualities.

2.3 Attribution
Subjective information on qualities.

3 Aberrantly decoded meaning

The general reader of the trademark will typically not search the trademark for meanings encoded by the company behind it, but may add some unintended meaning by aberrant decoding apart from, or instead of, the encoded meanings.

3.1 Performance-based meaning
As time goes by, the trademark becomes first and foremost a sign of what the company or product actually is, no matter what was originally encoded. A dirty pub named 'The White Swan' becomes 'The Mucky Duck'.

3.2 Wildly decoded meaning
Positive or negative decoding beyond the control of the company.

Practical requirements of trademarks

Louis Sullivan's dictum 'form follows function' should apply to trademarks.

The double task of a trademark is to allow immediate identification while evoking the important values of the marked organization or product. To fulfil these basic requirements in an acceptable way, other more detailed requirements must be fulfilled. Some of these requirements may conflict with each other. Others are open to debate; for instance the requirement that a trademark must be descriptive.

1 Visibility

Is the trademark visible enough?

The first practical requirement of any trademark is that it can be seen when and where it should be seen. Graphic qualities must ensure that the mark distinguishes itself from its surroundings to facilitate fast identification. The actual circumstances under which a certain trademark will be used are subject to careful analysis by the designer. The analysis will, among other things, tell how sturdy the mark must be and how small its details can be. The analysis will also provide information about the colour climate in the mark's surroundings.

2 Application

Can the trademark be used in all desirable applications?

Special interest must be devoted to the areas where the marketing battle takes place. Is the company or product going to advertise or be advertised on televised sports arenas? In such a case, a name mark will often be more potent than a picture mark because of the format it occupies. Is the most important exposure of the trademark on a concrete truck? Or is it on a letterhead, or on a small emblem for the buttonhole? Once again, form follows function.

3 Competition

Does the trademark distinguish itself from other marks?

In addition to distinguishing itself from its surroundings the trademark must also distinguish itself from trademarks and other marks used by competitors and other enterprises. The reason for this is both the necessary individualization, which is the main purpose of the identification, and the legal protection of existing marks.

4 Legal protection

Can the trademark be protected?

In order to protect the trademark against trademarks that may be developed in the future, the trademark must be eligible for legal protection, ie registration.

5 Simplicity

Is the trademark simple in its concept and therefore easy to understand?

What cannot be said simply is often not worth saying.

6 Attention value

Does the trademark have attention value?

The mark must have a certain attention value depending on the nature of the company or product to be identified. Occasionally irritation capacity is more valuable than good taste.

7 Decency

Is the trademark decent?

The mark must not include visual or linguistic elements that violate common decency. In cases where the mark is to be used in many cultures and language areas it should be tested for unintended meanings.

8 Colour reproduction

Does the trademark use standard colours?

However wealthy the holder of the trademark is, the trademark must, as a rule, fulfil certain economic requirements. In most cases that means using standard and few colours.

9 Black and white reproduction

Does the trademark work well in black and white reproduction?

Regardless of the trademark owner's preference for printing in colour, the trademark must be recognizable in black and white reproduction. Black and white photocopying equipment, newspapers and telefax transmissions do not respect colourful design ideas.

10 Vehicles

Will the trademark work on vehicles?

If the trademark is to be used on the sides of vehicles, it must be nondirectional or bidirectional, or if it is directional (unidirectional), it must be subject to mirroring. A dot is nondirectional. A horizontal double arrow is bidirectional. A running dog is directional.

11 Holding power

Does the trademark have holding power?

The trademark must, at least in some cases, have a degree of holding power, the ability to arrest the attention for more than a split second. This requirement may violate the need for fast identification.

12 Description

Is the trademark descriptive?

The image of the trademark must, at least sometimes, either describe or hint at the nature of the company or its product.

13 Tone of voice

Is the tone of voice appropriate?

The tone of voice of the mark must be compatible with the holder's marketing strategy.

14 Fashionability

Is the trademark fashionable?

Sometimes a trademark should be fashionable, even if that means that it will eventually become unfashionable.

15 Timelessness

Is the trademark durable?

Nothing is timeless, but a trademark is not intended to be completely ephemeral.

16 Graphic excellence

Is the trademark an example of graphic excellence?

The graphic design of the mark must convey the notion of managerial competence.

17 'Buy-me'

Does the trademark have 'buy-me' quality?

A trademark should encourage a decision to buy.

18 A trademark as a trademark

Does the trademark have to look like a trademark in order to function like a trademark?

A trademark should be an answer rather than a question.

19 Film/Television

Can the trademark be animated for use on film or television?

The ability to add a temporal dimension to a trademark can prove useful.

20 Three-dimensionality

Can the trademark be rendered in three dimensions?

Three-dimensional versions of a mark often make it more memorable.

21 Pronunciation

If the trademark includes a name or another type of word, can that word easily be pronounced in all relevant markets?

As well as being easily pronounced, the word should not sound like any obscene or otherwise unwanted word or sound (see 7 above).

22 Nonverbal sounds

Can the trademark be associated or connected with a sound or piece of music?

The MGM lion, for instance, can be evoked by its roar.

23 Discretion

Can the trademark be used for discreet identification?

Discretion is sometimes a characteristic attribute for a trademark.

24 Likeability

Do you like the trademark?

Appeal sometimes goes beyond the twenty-three requirements above.

150
Overleaf
The world is a theatre. The scenery truck of the English National Opera performs well seen from every side.
Company The English National Opera
Design Mike Dempsey/ CDT Design, 1992.

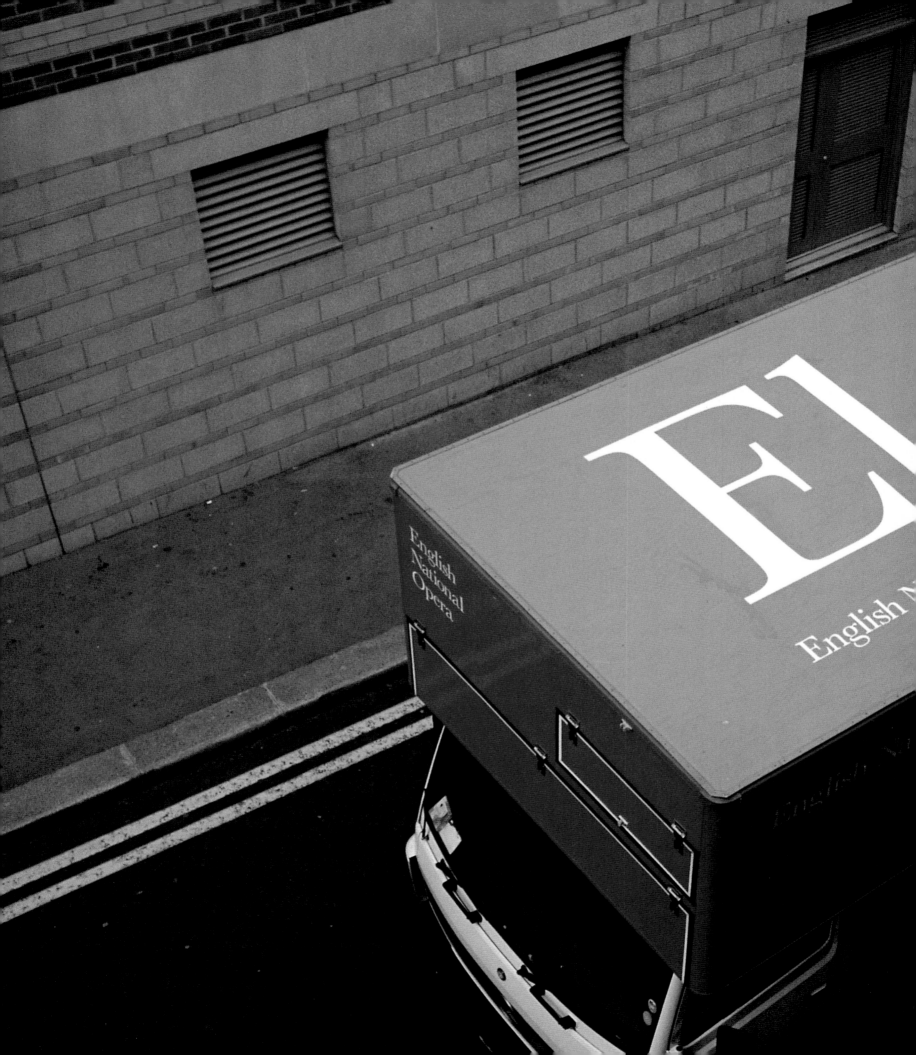

Taxonomy

Having looked at what trademarks were (history), what they should do (function) and how they perform (communication), this chapter will investigate what trademarks *are*. A new definition of trademarks and a way of classifying them according to selected qualities, is intended to expand our understanding of them by highlighting their similarities and differences.

The principles of the division, chosen to reflect characteristics of function and design, include material qualities (what the trademarks show) and referential qualities (what the trademarks mean).

A new definition of trademarks

The American legal definition of trademarks serves as a useful point of departure for developing an operational definition of trademarks:

'The term "trademark" includes any word, name, symbol or device, or any combination thereof, (1), used by a person, or (2), which a person has a bona fide intention of using in commerce and applies to register on the principal register established by this Act, to identify and distinguish his or her goods, including a unique product, from those manufactured or sold by others and to indicate the source of the goods, even if that source is unknown.'[1]

This definition includes three parts which are, respectively: the mark, the application and the purpose.

The mark: 'any word, name, symbol or device or any combination thereof'. Any word or name can be understood to cover any letter or combination of letters. Symbol can be understood to cover any pictorial sign (and should definitely not be understood in the more restrictive sense of an arbitrary sign); therefore any graphic sign that is not a letter or a combination of letters. The term 'device' can be understood to cover any non-graphic, even non-visual, sign. The definition can therefore be understood to cover all possible marks. However, this can be done more elegantly in an improved definition:

The term trademark refers to any letter or combination of letters, pictorial sign, or non-graphic – even non-visual – sign, or any combination of these.

The application: '(1) used by a person, or (2) which a person has a bona fide intention of using in commerce and applies to register on the principal register established by this Act'. This phrase can, with a view to our purpose, be rewritten as: *used by an organization*. The word organization can be understood to cover a person, a group of persons, a business and a non-profit organization. The issue of bona fide intention is irrelevant to our concerns.

The purpose: 'to identify and distinguish his or her goods, including a unique product, from those manufactured or sold by others and to indicate the source of the goods, even if that source is unknown.' This definition restricts the description of purpose to 'goods' in the literal meaning of that word. With our purpose in mind, the term 'product' can be understood to include unique products. This makes 'including a unique product' superfluous.

American legislation covers the use of trademarks in service companies by a special paragraph:

'The term "service mark" means any word, name, symbol, or device, or any combination thereof, (1) used by a person, or (2) which a person has a bona fide intention to use in commerce and applies to register on the principal register established by this Act, to identify and distinguish the services of one person, including a unique service, from the services of others and to indicate the source of the services, even if that source is unknown. Titles, character names, and other distinctive features of radio and television programs may be registered as service marks notwithstanding that they, or the programs, may advertise the goods of the sponsor.'

The term 'product' can also be understood to include services. Then one definition of purpose can be understood to cover all products and services: *to identify and distinguish his or her products from those manufactured or sold by others and to indicate the source of the products, even if that source is unknown.*

A few taxonomies of trademarks exist. In his book Trademarks & Symbols of the World, Yasaburo Kuwayama divides trademarks into four classes.[2] Kuwayama's taxonomy* only takes material qualities into consideration. The categories are neither mutually exclusive nor collectively exhaustive. In his article 'Typographer as analyst', Hans Weckerle categorizes trademarks in a 9 x 9 symmetric matrix.[3] The idea of the symmetric matrix is that a lot of trademarks belong to more than one of Weckerle's classes which, again, are neither mutually exclusive nor collectively exhaustive.**

*Kuwayama's four taxonomic classes: alphabet; concrete forms; abstract forms; symbols, numbers, and so on.

**Weckerle's 9 x 9 taxonomic classes: Verbal symbol: logotype; Verbal symbol: abbreviation; Verbal symbol: initial; Icon: product-oriented; Icon: metaphoric; Mark: figurative; Mark: coloured; Emblem: private; and Emblem: public

Trademarks are used for three immediate purposes: to mark communications, to mark property and to mark products. In order to cover all three purposes, the definition of purpose should be changed: *to identify communications, property or products and distinguish them from those of others and to indicate the source of the products, even if that source is unknown.*

To 'indicate the source of the goods, even if that source is unknown' seems self-contradictory. 'To indicate the source of the goods' can be seen as a natural part of 'to identify'. Identification can be organizational as well as branded. If the identity is organizational, the mark refers to the (known) source of the product. If the identity is branded, the mark refers to the product itself or to the class of products to which it belongs. In both cases the word 'identify' seems to include what should be included.

These changes result in the following definition:

The term 'trademark' refers to any letter or combination of letters, pictorial sign, or non-graphic, even non-visual, sign, or any combination used by an organization to identify its communications, property and products and distinguish them from those of others.

American trademark legislation identifies two other special kinds of marks that are protected by the Trademark Act: certification marks and collective marks:

'The term "certification mark" means any word, name or symbol or device, or any combination thereof, (1) used by a person other than its owner, or (2) which its owner has a bona fide intention to use in commerce and files an application to register on the principal register established by this Act, to certify regional or other origin, material, mode of manufacture, quality, accuracy, or other characteristcs of such person's goods or services or that the work or labor on the goods or services was performed by members of a union or other organization.'

'The term "collective mark" means a trademark or a service mark, (1) used by the members of a cooperative, association, or other collective group or organization, or (2) which such cooperative, association, or other collective group or organization has a bona fide intention to use in commerce and files an application to register on the principal register established by this Act, and includes marks indicating membership in a union, an association, or other organization.'

Certification marks can be included in the improved definition by adding 'or to certify products' to the purpose definition. Collective marks can also be included in the improved definition by adding 'or by its members' to the user definition. This leads to a final, comprehensive definition:

The term 'trademark' refers to any letter or combination of letters, pictorial sign, or non-graphic, even non-visual, sign, or any combination of these used by an organization or by its members to identify communications, property and products or to certify products and to distinguish them from those of others.

The taxonomic structure

In order to fulfil its purpose, a taxonomy must comply with five rules:

An ideal classification must consist of classes that are distinct. There must be sharp distinctions between classes. The classification of any single entry must be clear;

The characteristics on which the classification is based must be used consistently. Each step in the classification must be based on one principle of division;

Co-ordinate classes of the taxonomy must be mutually exclusive. There must be no overlapping between classes. No single entry must be covered by more than one class;

The co-ordinate classes must be collectively exhaustive. They must cover all possible entries;

The classes must be relevant to the purpose of the taxonomy.

For pragmatic reasons this taxonomy of trademarks is less than ideal in some respects. It has been structured in a way that includes apparent weaknesses of distinction and exclusion. The first and third rule have been violated in order to satisfy the fifth rule.

The taxonomy does not present distinct limits between all co-ordinate classes. The qualities of trademarks are not necessarily clear and discrete, and they are usually found on a continuum. The letters of a letter mark can be so special in their shape that almost nobody recognizes them as letters. The explanation that makes a trademark a descriptive mark may be almost forgotten and, to most users, leave the trademark as a found mark or even a non-figurative mark.

The characteristics are used consistently. Only one principle of division is used for each step.

Co-ordinate classes are not mutually exclusive. A trademark can contain one or more letters and a picture and can thereby belong to two co-ordinate classes. Other combinations of co-ordinate classes can appear. A name mark can contain both a proper name and a descriptive name.

To put it another way, the taxonomy works relative to exclusivity and to the isolated qualities of trademarks. In practice, the qualities described in co-ordinate classes do not all exclude each other but appear concurrently. One trademark may have qualities belonging to two or more co-ordinate classes.

One reason for the acceptance of this state of affairs is that the taxonomy would be much larger and highly unmanageable if it were to cover all possible combinations of trademark qualities by separate classes. For analytical purposes, a trademark should be classified according to all its 'split personalities'.

The co-ordinate classes are, indeed, collectively exhaustive. They include any conceivable trademark. If a trademark is not graphic, it is non-graphic, and so on.

The purpose of the taxonomy is not to enable classification beyond discussion and critique. It is to shed light on the nature and variety of trademarks and to facilitate analysis of the production of meaning in trademarks.

The divisions of the taxonomy refer to the trademark per se, that is, to the material qualities of the trademark, and to the relationship between the trademark and its object or the referential qualities of the trademark. The divisions of the taxonomy do not refer to the objects per se.

Principles of division referring to objects of the trademarks could have been related to the structure of identity: on the one side organizational or branded identity; on the other monistic, endorsed or pluralistic identity. These two sets, each with three divisions, would have demanded much space and added little to the understanding of the visual variety and production of meaning in trademarks. The interesting and rewarding phenomena in terms of formal variation and production of meaning seem to be in relation to the material and referential qualities of the trademarks.

The material qualities of a trademark will probably be understood in the same way by most sign users. The culture of the sign user and the context in which the sign is used may, however, vary from one user to another, and that will influence the interpretation of the sign, in other words the referential qualities.

That different sign users interpret the same trademark in different ways means that one trademark can be classified in more than one way. Consequently, all classifications of trademarks in this taxonomy are 'possible' classifications. Somebody else within another culture and/or in another context may – and probably will – interpret and classify at least some trademarks in another way.

Table fifteen shows in schematic form two semiotic categories (types of qualities), eight principles of division, seven intermediate and thirteen final classes of the taxonomy.

The taxonomy of trademarks is shown as a tree in table sixteen. The stem is the *summum genus*, the class in which the division begins. The thirteen branches to the right are the *infima species*, the final classes. In between are the *subaltern genera*, the intermediate classes.

Acronyms, non-acronym initial abbreviations and non-initial abbreviations could each have been further divided as name marks are, into proper names, descriptive names, metaphoric names, found names and artificial names, but that would probably be to stretch the idea too far. Most abbreviations stand for descriptive names that – in search of completeness – became too long for practical use.

Table fifteen Semiotic categories, principles of division, intermediate and final taxonomic classes. The thirteen italicized terms to the right are the final classes in the taxonomy.

Semiotic category	Principle of division	Taxonomic class
Material qualities (concerning the trademark per se): what trademarks show.	Dimensions (type and number)	Graphic marks
		Non-graphic marks
	Graphic form	Picture marks
		Letter marks
	Picture form	Figurative marks
		Non-figurative marks
	Letter combination form	Name marks
		Abbreviations
	Abbreviation form	Initial abbreviations
		Non-initial abbreviations
	Initial abbreviation form	*Acronyms*
		Non-acronym initial abbreviations
Referential qualities (concerning the relationship between the trademark and its object): what trademarks mean.	Visual reference	*Descriptive marks*
		Metaphoric marks
		Found marks
	Linguistic reference	*Proper names*
		Descriptive names
		Metaphoric names
		Found names
		Artificial names

Table sixteen Taxonomic tree of trademarks. Final classes are italicized.

Trademarks 1	Graphic marks 1.1	Picture marks 1.1.1	Figurative marks 1.1.1.1	Descriptive marks 1.1.1.1.1	
				Metaphoric marks 1.1.1.1.2	
				Found marks 1.1.1.1.3	
			Non-figurative marks 1.1.1.2		
		Letter marks 1.1.2	Name marks 1.1.2.1	*Proper names* 1.1.2.1.1	
				Descriptive names 1.1.2.1.2	
				Metaphoric names 1.1.2.1.3	
				Found names 1.1.2.1.4	
				Artificial names 1.1.2.1.5	
			Abbreviations 1.1.2.2	Initial abbreviations 1.1.2.2.1	*Acronyms* 1.1.2.2.1.1
					Non-acronym initial abbreviations 1.1.2.2.1.2
				Non-initial abbreviations 1.1.2.2.2	
	Non-graphic marks 1.2				

Trademarks

The class of trademarks is the initial class where
the division of the taxonomy begins.

The intension, the qualities implied by the class,
is given by the definition of trademarks. The
extension, the objects covered by the class, are all
the subordinate classes, partly the seven intermediate
classes, partly the thirteen final classes.

The first division in the taxonomy occurs between
graphic marks and non-graphic marks. Since the
overwhelming majority of trademarks are graphic
marks, the taxonomy divides graphic trademarks
and explores them in many classes. For the same
reason, non-graphic trademarks are not divided,
but are treated as one class.
1 *initial class*

151
Media attention on the race
track transforms the racing
driver's clothing into a
patchwork of advertising
and sponsor's marks.

Graphic marks

Graphic marks are divided into letter marks and picture marks. Letter marks consist of letters and picture marks of pictures, but that is not the complete story. Letter marks are often iconicized and then they include a pictorial element. Picture marks occasionally refer to linguistic phenomena.

Both letter marks and picture marks distinguish and describe. They do so in different ways and they produce their meaning in different ways. Some companies use both a letter mark and a picture mark.

1.1 *intermediate class*

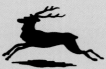

152

Although a letter mark, this trademark includes a strong pictorial element in the form of a clapperboard. The mark could also be categorized as a picture mark.
Company Danish Film Institute, Denmark.
Design Per Mollerup Designlab, 1988.

153

Although a picture mark, this trademark refers to a linguistic phenomenon. The jumping deer is a pun on the name of the factory founder, Hirschsprung. In heraldry this is referred to as a 'canting' coat of arms (see p 20).
Company AM Hirschsprung & Sønner, Denmark.
Design 1937.

154–5

Mobil Oil uses both a letter mark and a picture mark representing Pegasus. In one-colour applications, the red 'o' between the blue letters 'M' and 'bil' in the letter mark is replaced by an 'o' comprising of two concentric circles.
Company Mobil Oil, USA.
Design Chermayeff & Geismar, 1965.

Picture marks

Picture marks are divided into figurative and non-figurative marks. Figurative marks depict an object. Non-figurative marks are pictures in their own right. Figurative marks are further divided into descriptive marks, metaphoric marks and found marks.

Sometimes the nature of the object depicted in a figurative mark is forgotten and the mark will be perceived as a non-figurative mark. This has happened to the barber's pole. The original barber's pole was a three-dimensional figurative mark referring to the barber's role in medical practice. Today only a few people recall the early barber's historical function of surgery, which included bloodletting. To further the bloodletting, patients were given a pole to grip. When not in use, the pole was hung outside the barber surgeon's shop together with the bloodstained bandage that was twisted around the patient's arm.

While semiotic terms will not be used directly in the taxonomy, the study of semiotics offers a useful framework for understanding trademarks.

Picture marks that are images or diagrams are classified as descriptive marks.

Picture marks that are metaphors are classified as metaphoric marks.

Designations are not immediately covered by the taxonomy. A sign only becomes a designation through its practical use. Any trademark is a designation, when situated on the front door of the company or on the packaging of the product.

Reagents are not immediately covered by the taxonomy. The trademark's function as a reagent will normally be irrelevant as it will refer to the designer in that capacity (see p 85).

Picture marks that are symbols are classified either as found marks or as non-figurative marks.
1.1.1 *intermediate class*

Semiotic classes		Taxonomic classes	
Icons	Images	Figurative marks	Descriptive marks
	Diagrams		
	Metaphors		Metaphoric marks
Indices	Designations		Not relevant
	Reagents		Not relevant
Symbols			Found marks
		Non-figurative marks	

Table seventeen Comparison of semiotic classes and taxonomic classes of picture marks.

156
A two-dimensional picture of a three-dimensional object with an almost forgotten meaning. The barber's pole was originally adopted as a symbol of the medical practices that barbers performed, such as surgery and teeth removal.

Figurative marks

Figurative marks are depictions. In the
taxonomy, figurative marks are divided
into three classes according to the relation
between what they show and what they
represent, between the representamen and
its object: descriptive marks, metaphoric
marks and found marks.
1.1.1.1 *intermediate class*

157

158

159

157
The Black Raven restaurant
in Copenhagen's Nyhavn
has a purely found mark.
Copenhagen restaurant.
Design Bo Bonfils, 1975.

158
The shining electric bulb
is a widely recognized
metaphor for inspiration.
Apple's Newton is itself a
bright idea and facilitates
the recording of the user's
bright ideas.
Company Apple
Computers, USA.

159
The elongated cow
trademark says
straightforwardly what
the business is about:
milk production. It is
a descriptive mark.
Company Kreuzeckhof
Milkcenter.
Design Klaus Kuhn
& Kammann.

Descriptive marks

Descriptive marks are images or diagrams. A fish sign that stands for a fish restaurant is an image. So is a mask used as a trademark for a theatre. An atomic model that stands for a nuclear research agency is a diagram.

Descriptive marks refer directly to their object, the company or product in question. The relationship between the representamen and its object is motivated.

1.1.1.1.1 *final class*

a representamen	= trademark
b object	= company or product
c interpretant	= mental image of b

161

162

160
Signification, descriptive marks.

161
The Paris fish restaurant Prunier signals unspoiled quality and fresh produce with their Hergé-like *traiteur* presenting a large fish.
Company Prunier Madeleine, France.

162
The importance of water for all life on earth is the encoded meaning of this image. Pharmacia is a pharmaceutical company. The mark is perhaps more often decoded as 'a drop of medicine'. Today the mark is used by Pharmacia Biotech.
Company Pharmacia, Sweden.
Design Armin Hofmann, 1969.

Metaphoric marks

Metaphoric marks refer to their object through a shared quality. Signification takes place on two levels. In the first level, the representamen, which is the trademark, refers to the shared quality. The interpretant of the first signification is a mental picture of that quality created in the mind of the user. On the second level, that mental picture stands for the final object, the company or the product in question. Metaphoric marks are motivated on both levels of signification.

An isolated picture of a beehive does not necessarily suggest anything more than a beehive. When shown in connection with a savings bank, the beehive becomes a suggestive metaphor for sensible saving. The informed user combines the beehive and the savings bank, and detects the shared quality.

When seeing the beehive sign, the informed user may simply think 'savings bank'. The less informed user may never understand the metaphor. To him, the beehive will remain a symbol, an arbitrary sign, a found mark with one level of signification.

In this chapter, triadic chains are used to analyse the production of meaning in trademarks. Each triad stands for one level of signification. 1.1.1.1.2 *final class*

a representamen	= trademark
b intermediate object	= shared quality
c interpretant/representamen	= mental image of b
d final object	= company or product
e interpretant	= mental image of d

164

163
Signification, metaphoric marks.

164
Bikuben is Danish for beehive, a suggestive metaphor for a savings bank.
Company Bikuben, Denmark.
Design c1857.
Redesign HT/STB Reklame, 1972.

Found marks

Found marks refer directly to their object. Found marks are symbols. The relationship between the representamen and its object is arbitrary.

Found marks show something recognizable that obviously has nothing to do with the company or product which they represent.

Many trademarks, which are considered found marks today, originally had an explanation which made them motivated marks. However, if almost nobody remembers its explanation, a trademark functions as an arbitrary sign, a symbol. For example, the trademark of Shell can be considered a found mark today (see p 115). 1.1.1.1.3 *final class*

a representamen = trademark
b object = company or product
c interpretant = mental image of b

165
Signification, found marks.

166
The Shell mark shows something recognizable, a shell, that obviously has nothing to do with the product ot the company it represents (see fig 181). *Company* Shell, UK. *Design* 1900.

Non-figurative marks

Non-figurative marks refer directly to their object.
They are symbols. The relationship between the
representamen and its object is arbitrary.

Many non-figurative trademarks are presented
with much explanation and managerial fanfare
about what the mark symbolizes. Even so, if people
only see a non-figurative drawing, the mark will
simply become a symbol of a company and what
the company stands for – no more, no less.
1.1.1.2 *final class*

a representamen = trademark
b object = company or product
c interpretant = mental image of b

168

167
Signification, non-figurative
marks.

168
In 1903 a twenty-five-
year-old engineer, André
Citroën, established a gear-
wheel factory. The factory
was so successful with a
'herring bone' gear that
he made the gear-wheel
design the trademark of
the company, which later
became a manufacturer
of cars. Today few people
are aware of this, and the

mark functions as a non-
figurative mark.
Company Citroën, France.
Design André Citroën,
*c*1903.

Letter marks

The term 'logotype' and its shortened form 'logo' come from the Greek *logos*, meaning word. Logotype sometimes refers to marks that are longer and easily readable names, while logo sometimes refers to shorter names, acronyms or abbreviations. Sometimes both terms are used as synonyms for the graphic trademark, which also includes picture marks.

In this book, letter marks are divided into name marks and abbreviations. A minor weakness of this division is that acronyms and non-initial abbreviations tend to become proper names and may ultimately be confused with real name marks if their origin is forgotten.

Trademarks are primarily visual phenomena but letter marks also have a linguistic form, including a phonetic form. In fact, only the linguistic form is considered in the letter mark classes. The visual form of letter marks, however, deserves a few words.

Almost all letter marks have a definite visual form. This visual form is always symbolic when seen as a sign of sounds. When seen as a sign of a company or a product, the visual shape of the letter mark may suggest some relevant quality. A certain typeface may refer to a certain trade or may be relevant to the company or the product in question. If this reference only exists because of agreement or habit, then the typeface works as an arbitrary sign.

If the shape of the letters of a letter mark suggests a certain type of company or product because of some visual similarity or parallelism, then the letter mark – in its visual capacity – is a motivated mark. Normally this pictorial quality of a letter mark has been added by iconization, as in the name mark Golfin, where the 'o' is raised to suggest a golf ball in flight.

Letter marks have one considerable advantage over pure picture marks: onlookers say what they see and see what they should say.

169
Golfin

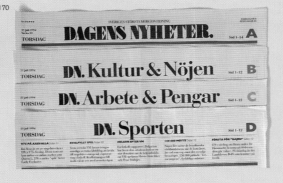

170

169
Golfin is a group of seven golf courses. The trademark spells the nature of the business and suggests it by iconization: the jumping 'o' imitates a golf ball in flight.
Company Golfin, Denmark.
Design Per Mollerup Designlab, 1994.

170
The Swedish morning paper uses its full name on the masthead and an initial abbreviation on the section heads and elsewhere. Both full name and abbreviation come complete with a full stop.
Company Dagens Nyheter, Sweden.
Design 1864.

Letter marks

Sometimes a company uses its full name
alongside various abbreviations; sometimes
only an abbreviation is used. Scandinavian
Airlines System operates with a full name
and four abbreviations: Scandinavian Airlines
System, Scandinavian Airlines, Scandinavian,
SAS and SK.
1.1.2 *intermediate class*

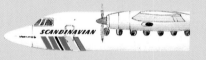

171
Scandinavian Airlines System
(SAS) was founded in 1946
when the national airlines of
Denmark, Norway and
Sweden merged to create a
single major international
airline. Here it can be seen
that the linguistic form, which
is adopted in each case to
represent the company, is
subject to the space available.

Company SAS, Denmark/
Norway/Sweden.
Design Rune Monö, 1947.
(The trademarks have been
slightly modified since then).

Name marks

Most trademarks are name marks. After all, nothing is more tempting than writing the name of a company or a product and using that name as a visual mark.

Name marks are divided into five classes: proper names, descriptive names, metaphoric names, found names and artificial names.

Name marks are – as other trademarks – signs for companies and products. A name mark can refer directly to its object through its visual shape (see p 109), but that is a pictorially and non-linguistic reference not considered here. Name marks are considered here as linguistic phenomena.

When a name mark is interpreted in its linguistic capacity, its signification can be broken down into a chain of intermediate significations.

First, a name mark is a sign for sounds. The sounds expressed by the name mark are the first intermediate object. The idea of those sounds created in the mind of the user is the first intermediate interpretant. Since there is no natural relation between the visual shape of letters and the sounds they stand for, all letter marks are arbitrary on the first level of signification.

On the second level of signification, the interpretant of the first signification is the representamen. The sounds stand for something which can either be the final object or a second intermediate object. The final object of a trademark is the company or product in question.

A second intermediate object can be a thing or a concept. There is no natural relation between the sounds of a word and the objects they stand for. Most name marks are arbitrary on their second level of interpretation. One possible exception may be onomatopoeic names, whose sound imitates the sound of the company or the product in question. A swimming pool called Splash! and a revolver called Bang! Bang! illustrate the case. Perhaps Kodak (click-clack) can also be considered an onomatopoeia.

Apart from onomatopoeic names, the relationship between the sound of a name mark and the final or intermediate object it stands for will be arbitrary. As a rule, a letter mark is arbitrary on the two first levels of signification.

To compare the signification of name marks with the signification of picture marks in a meaningful way, name marks must be classified according to their last level of signification. Then name marks can be images, metaphors or symbols.

In the analysis of picture marks (table eighteen, below), six semiotic classes were juxtaposed with the four taxonomic classes of picture marks. In table 18, the five taxonomic classes of name marks are added:

Name marks that are images are descriptive names;

Name marks that are diagrams are hardly conceivable;

Name marks that are metaphors are metaphoric names;

Designations and reagents are not relevant (see p 103);

Name marks that are symbols can be found names, proper names or artificial names.

1.1.2.1 *intermediate class*

a representamen = trademark
b intermediate object = sounds
c interpretant/representamen = mental image of b
d intermediate or final object = thing or concept or company or product
e interpretant = mental image of d

Signification, name marks, two first levels of signification.

Table eighteen Comparison of semiotic and taxonomic classes of picture marks and name marks.

Semiotic classes			Taxonomic classes		
			Picture marks		Name marks
Icons	Images		Figurative marks	Descriptive marks	Descriptive names
	Diagrams				Not possible
	Metaphors			Metaphoric marks	Metaphoric names
Indices	Designations			Not relevant	Not relevant
	Reagents			Not relevant	Not relevant
Symbols				Found marks	Found names
			Non-figurative marks		Proper names
					Artificial names

Proper names

A founder's or owner's proper name used as a
trademark signals both pride and responsibility.
It says: 'We guarantee this product. We are
proud of it.'

 The interpretation of proper names is
debatable. In principle, a proper name does
not say whether a person with that name is
the founder, the owner, a relative (Mercedes)
or something else. Hansen as a product name
does not say what kind of product we are
talking about. If the name were to be Hansen
Rum, however, it would be a descriptive name,
and a different matter. Proper names will be
classified as symbols. Proper names have two
levels of signification. They are arbitrary signs
on both levels. It could be argued that the
interpretation has three levels if the proper name
already has a meaning, eg a rocket manufacturer
(Wernher) Von Braun.
1.1.2.1.1 *final class*

a representamen = trademark
b intermediate object = sounds
c interpretant/representamen = mental image of b
d final object = company or product
e interpretant = mental image of d

173
Signification, proper names.

174
The current Braun letter
mark with the characteristic
tall 'A' succeeded an earlier
letter mark with a tall 'A'.
Company Braun, Germany.
Design 1935.
Redesign Wolfgang
Schmittel, 1952.

Descriptive names

In contrast to proper names, descriptive names describe the nature of the business or product. The name may be dull but helpful to new clients. Newspaper and magazine mastheads often fall into this category.

In descriptive name marks, the interpretant of the second interpretation is a mental image of something that explains the final object. The relationship between the third representamen and the final object is motivated.

In the case of the Swiss newspaper, *Neue Zürcher Zeitung* (New Zurich Newspaper), the mental picture that is the interpretant of the second signification and the representamen of the third signification, is a fair description of the nature of the object (see p 109).

In the case of a supermarket chain called BEST (see fig 177), the name is less descriptive. The name refers to only one quality of the object, namely that of superiority. Descriptive names are motivated on their third level of signification. Sometimes name-givers are so eager to find the correct descriptive name that the name becomes too long to be practical. Then it will probably be replaced by an abbreviation that does not explain so much. The National Aeronautics and Space Administration, the Federal Bureau of Investigation and Columbia Broadcasting System are descriptive names that are better known by their abbreviations, NASA, FBI and CBS respectively.

1.1.2.1.2 *final class*

a representamen	= trademark
b intermediate object	= sounds
c interpretant/representamen	= mental image of b
d intermediate object	= the literal meaning of the proper name
e interpretant/representamen	= mental image of d
f final object	= company or product
g interpretant	= mental image of f

176

177

175
Signification, descriptive names.

176
The descriptive name of the newspaper *Neue Zürcher Zeitung* (New Zurich Newspaper) is often abbreviated to NZZ. *Company* Neue Zürcher Zeitung, Switzerland. *Design* 1878 or earlier with later adaptions.

177
A descriptive name that only refers to quality. Pictorially this trademark reinforces what is said linguistically. *Company* BEST, USA. *Design* Chermayeff & Geismar, 1979.

Metaphoric names

While descriptive names straightforwardly describe what the business is all about, metaphoric names reveal the nature of the business indirectly. A metaphoric name refers to its object through a shared quality. Mustang cars are supposed to be fast and elegant like mustang horses. Speed and hardiness are the shared qualities. Metaphoric names work by association.

In metaphoric name marks, the second interpretant, the result of the second level of signification, is a mental picture of the metaphor which indirectly explains what the final object is all about. The object of the third signification, the third intermediate object, is a quality which its representamen shares with the final object. The third interpretant is a mental picture of that quality. On the fourth and final level of signification, the object is the final object and the interpretant is a mental picture of that object. Metaphoric names are motivated both on their third and fourth level of signification.

On its first level of signification, the name mark Jaguar stands for the sound of that word. On the second level of signification the sound stands for that animal. When used to name a car, the animal becomes a metaphor. The jaguar shares the metaphorical qualities of speed and elegance with the car. On the third level of signification, the representamen, the mental picture of a jaguar, creates an interpretant which is a mental

picture of speed and elegance. On the fourth and final level of signification, the representamen is speed and elegance and the interpretant is the mental picture of the car. On its two first levels of signification, the name mark Jaguar is arbitrary. On the third and the fourth levels of signification the name mark Jaguar is motivated. If the name mark Jaguar is supported by the famous picture mark showing a leaping jaguar, it doubles the metaphor.
1.1.2.1.3 *final class*

a	representamen	= trademark
b	intermediate object	= sounds
c	interpretant/representamen	= mental image of b
d	intermediate	= metaphor object
e	interpretant/representamen	= mental image of d
f	intermediate object	= shared quality
g	interpretant/representamen	= mental image of f
h	final object	= company or product
i	interpretant	= mental image of h

179

178
Signification, metaphoric names.

179
Metaphoric names often come with metaphoric marks. The Danish savings bank Bikuben (beehive) has both a metaphoric mark (see p 106) and a metaphoric name.
Company Bikuben, Denmark.
Design 1957.
Redesign HT/STB Reklame, 1972.

Found names

A found name is an already known word which has no natural relation to the company or product it stands for.

An insurance company called Zebra has a found name. When the name-givers have had a reference in mind that others have forgotten or have perhaps never known, the name may be considered found.

On the third level of signification, the representamen is a mental picture (eg, that of a zebra) and the object is the final object. A found name is arbitrary on all three levels of signification.

1.1.2.1.4 *final class*

a representamen	= trademark
b intermediate object	= sounds
c interpretant/representamen	= mental image of b
d intermediate found name	= the idea of the object
e interpretant/representamen	= mental image of d
f final object	= company or product
g interpretant	= mental image of f

181

182

180
Signification, found names.

181
What comes first, the name or the picture? In the case of Shell, the name came first. When Marcus Samuel formed the Shell Transport and Trading Company in 1897, he selected the company name in memory of his father's business – a small, London antique shop that also dealt in decorative oriental sea shells. Few people know the origin of the mark, which can therefore be considered a found name. The shell business behind the name mark has absolutely nothing to do with the company's field of operation.
Company Shell, UK.
Design 1900.
Redesign Raymond Loewy, 1971.

182
Several years after Paul Rand designed the IBM trademark, he designed this name mark for Next, the computer company founded by Steven Jobs after he left Apple.
Company Next, USA.
Design Paul Rand, 1986.

Artificial names

While proper names, descriptive names, metaphoric names and found names consist of existing words, artificial names are neologisms, completely new words coined for the company or product they represent.

Artificial names have only two levels of signification. They are arbitrary on both levels. 1.1.2.1.5 *final class*

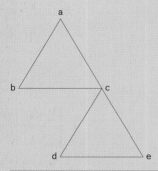

a representamen	= trademark
b intermediate object	= sounds
c interpretant/representamen	= mental image of b
d final object	= company or product
e interpretant	= mental image of d

184

185

183
Signification, artificial names.

184
It can be argued that Kodak is not an artificial name but a descriptive name as its sound imitates the sound of a camera shutter. The Kodak name could be considered an example of an onomatopoeia (see p 111).
Company Kodak, USA.
Design Peter J Oestreich, 1972.

185
The name of the petrol company Elf was generated by computer and chosen from among 8,253,000 three-, four- and five-letter combinations.
Company Elf, France.
Design Jean-Roger Rioux, 1966.

Abbreviations

When company names become too long, there will always be a strong urge to introduce abbreviations. Abbreviations are of one of two types or a combination of both. In a suspension, the last part of a word or name is dropped. Scandinavian Airlines and Scandinavian are suspensions of Scandinavian Airlines System. In a contraction, the first and last part are retained, while something in the middle is dropped: Jr, for example, is a contraction of junior.

As far as company names are concerned, a combination of suspension and contraction is the most familiar way of abbreviation. All initial abbreviations (with more than one letter) such as ABC, BBC, CBN, CNN, ITV and MTV are of that type. Metropolitan Life Insurance abridged to MetLife is also the result of combined suspension and contraction.

To keep the taxonomy operational, suspension and contraction are not used as principles of division. Instead, the first division of abbreviations separates initial abbreviations and non-initial abbreviations.

1.1.2.2 *intermediate class*

186
NY means New York. NE means New England and X stands for excellence, says the telephone company that serves the north-eastern part of the USA. This combines suspension and contraction. A non-initial abbreviation.
Company NYNEX, USA.
Design Lippincott & Margulies 1984.

187
When MetLife took over the PanAm building in New York from the defunct airline, one combined suspension and contraction abbreviation followed another. A non-initial abbreviation.
Company MetLife, USA.
Design Anspach, Grossman and Portugal, 1991.

Initial abbreviations

Most abbreviations are made up of initials. As such they are the result of combined suspensions and contractions.

Some initial abbreviations look unfriendly and bureaucratic. Some are difficult to remember. Some initial abbreviations seem to provide more anonymity than identity and sometimes the same abbreviation is used by more than one organization. Huge companies such as IBM and GM did not grow big because of initial abbreviations. They can afford abbreviations because they are big.

Initial abbreviations are divided into acronyms and non-acronym initial abbreviations.
1.1.2.2.1 *intermediate class*

188

188
Agfa is an anagram of an acronym, AGAF, which stands for Aktien-Gesellschaft für Anilin-Fabrikation. The rhomboid form of the mark has – with a number of variations – been in use since 1923.
Company Agfa, Germany.
Design 1923.

Acronyms

Acronyms are initial abbreviations that form new pronounceable words such as NASA. When people forget that acronyms are abbreviations, the acronyms become names in their own right. Acronyms are more friendly and easier to remember than non-acronym initial abbreviations. Acronyms are arbitrary signs, unless they create new, motivated words.
1.1.2.2.1.1 *final class*

189

190

191

189
The NASA acronym stands for National Aeronautics and Space Administration.
Company NASA, USA.
Design Danne & Blackburn, 1976.

190
The AGA acronym stands for Aktiebolaget Gasaccumulator.
Company AGA, Sweden.
Design AGA, 1955.

191
IKEA is one of those acronyms whose origin is almost forgotten because of the success of the name. IKEA stands for Ingvar Kamprad Elmtaryd Agunnaryd, which is the name of the company's founder and of his birthplace in the county of Småland in southern Sweden.

Company IKEA, Sweden.
Design 1943.

Non-acronym initial abbreviations

Most initial abbreviations are pronounced as the sum of the individual letters and are therefore not acronyms. Non-acronym initial abbreviations are arbitrary signs.

Monograms used by individuals are a special kind of non-acronym initial abbreviation. Royal monograms are usually pronounced as the full, unabridged name (see p 26).
1.1.2.2.1.2 *final class*

(see p 26)

192
Paul Rand designed IBM's name mark twice. In 1956, he made a solid three letter name mark based on the typeface City. In 1960, he added the stripes to make the name mark still more distinctive. The striped name mark exists in an eight-line as well as a thirteen-line version. Today only the eight-line version is seen.

Company IBM, USA.
Design Paul Rand, 1956/1960.

Non-initial abbreviations

Non-initial abbreviations are arbitrary signs
unless they form a new word which is a
motivated sign.

Sometimes a company's name is determined
by the phonetic content of an abbreviation of
the original name. This is the case with Esso,
ERCO and ESSELTE.
1.1.2.2.2 *final class*

193

194

195

193
Esso is a phonetic
abbreviation of Standard Oil.
Company Esso, USA.
Design 1923.

194
ERCO is a phonetic
abbreviation of Reininghaus
und Co. The logotype with
four capitals of descending
thickness is intended
to evoke the end product
of the German lamp
manufacturer – light.
Company ERCO, Germany.
Design Otl Aicher, 1974.

195
ESSELTE is a phonetic
abbreviation of the initials
of Sveriges Lithografiska
Tryckerier. The helm has
been used as a trademark
since 1918, when it
was introduced by Uno
Dunér, inspired by Swedish
Petterson motorboats.
Company ESSELTE, Sweden.
Design Rolf Andersson, 1970.

Non-graphic marks

'Non-graphic – even non-visual – signs', as
stated in the definition of trademarks used
here, is a broad category. It includes the shape
of a Coca-Cola bottle and of the Pizza Hut
roof and almost any form which is characteristic
and essential to a business. In principle,
the mark can be non-visual (see pp 96–7).

Non-graphic marks can be motivated as
well as arbitrary.

Many practical examples of non-graphic
trademarks are covered by the concept of the
fifth element (see p 216), which stands for all
trademarks which are not 'real' trademarks in
the normal sense of that word. The fifth element,
however, also includes graphic marks such as
the Adidas stripes and the Coca-Cola Dynamic
Ribbon, and para-graphic elements such as
the BMW double kidney radiator grille.
1.2 *final class*

196
197
198

196–7
In 1881, when Tuborg
began sales of its own
beer, painter Carl Lund
was commissioned to
design a special Tuborg
parasol. Since then the
parasol has been mounted
on horse-drawn drays,
trucks, train carriages and
beer pumps; the portico
to the main entrance to

the former Tuborg
administration building is
even formed in its shape.
Company Tuborg, Denmark.
Design Carl Lund, 1881.

198
The parasol has also
entered the Danish
language, where a printer's
bracket is called 'a Tuborg'.

The production of meaning in trademarks

Meaning is produced in different ways within different classes of trademarks.

Descriptive marks have one level of signification: the relationship between the representamen and the object is motivated.

Metaphoric marks have two levels of signification: the relationship between the representamen and the object is motivated on both levels.

Found marks have one level of signification: the relationship between the representamen and the object is arbitrary.

Non-figurative marks have one level of signification: the relationship between the representamen and the object is arbitrary.

Proper names have two levels of signification (see p 112): the relationship between the representamen and the object is arbitrary on both levels.

Descriptive names have three levels of signification: the relationship between the representamen and the object is arbitrary on the two first levels and motivated on the third level.

Metaphoric names have four levels of signification: the relationship between the representamen and the object is arbitrary on the two first levels and motivated on the third and fourth level.

Found names have three levels of signification: the relationship between the representamen and the object is arbitrary on all three levels.

Artificial names have two levels of signification: the relationship between the representamen and the object is arbitrary on both levels.

Abbreviations work in two ways. If people understand what an abbreviation stands for, they work as other name marks do, but with an extra initial level of signification where the abbreviation is decoded into the name it represents – probably a descriptive name.

If the abbreviation is not understood, the interpretation depends on whether the abbreviation forms a new recognizable word with meaning, or is merely an abbreviation. In the former case, interpretation will take place according to the nature of the word formed by the abbreviation. In the latter case, interpretation takes place in the same way as in artificial names.

Level of signification	first	second	third	fourth
Trademark class				
Descriptive marks	motivated			
Metaphoric marks	motivated	motivated		
Found marks	arbitrary			
Non-figurative marks	arbitrary			
Proper names	arbitrary	arbitrary		
Descriptive names	arbitrary	arbitrary	motivated	
Metaphoric names	arbitrary	arbitrary	motivated	motivated
Found names	arbitrary	arbitrary	arbitrary	
Artificial names	arbitrary	arbitrary		

Table nineteen Production of meaning in trademarks.

199
Overleaf
Though trademarks are generally designed to be shown in full colour, they can also work without that design element. At tennis tournaments, such as the French Open, there is a tradition of restricting advertising to green, black and white.

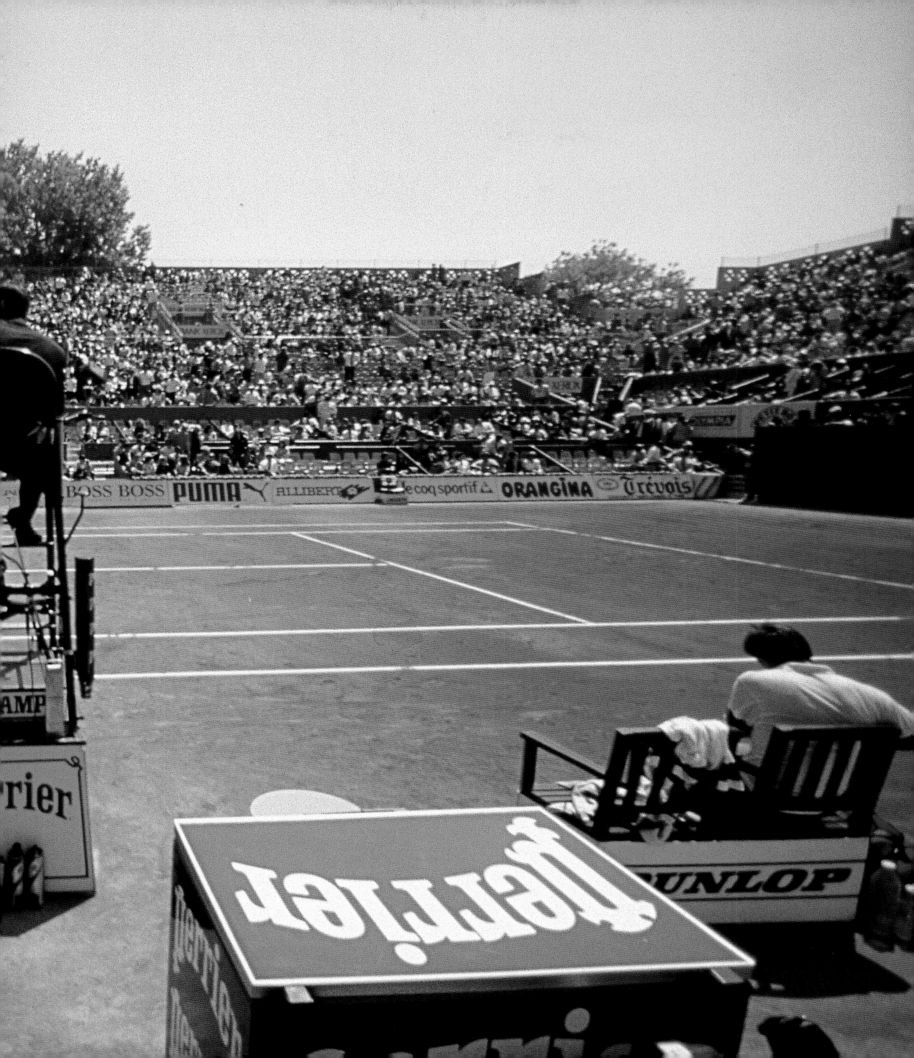

Motifs

This chapter groups trademarks according to the motifs used in their design. Each trademark is also given a possible classification according to the taxonomy presented in the previous chapter.

These classifications are 'possible' because one trademark does not necessarily have the same meaning to all users at all times. In fact, all trademarks shown here can – in different contexts or by users with different cultures – be understood and classified in other ways.

The trademarks selected were chosen as individual examples rather than as a representative cross section of marks. The main aim has been to illustrate possible rather than typical variations in trademark themes and to show marks that tell a story.

There are two aspects to the selection, which should be noted when looking at the choice of marks. The examples are not essential to the thesis of the book; similar trademarks could make the same point. The trademarks are also not exclusive to the group they appear in. They could, for instance, illustrate different headings: Apple's apple, Alfa Romeo's serpent and the Red Cross cross could have been grouped together under 'biblical themes'.

The symbol * throughout this chapter denotes 'possible classification'.

Animals

Given that animals are often attributed with noble qualities, it is not surprising that many trademarks have animal motifs. Sometimes animals are given human characteristics. Most of the time, however, they are chosen for the qualities associated with them. A tiger can stand for strength while an elephant can represent reliability. (Marks based on birds, dogs, lions and serpents have been given their own categories.)

Animal trademarks are figurative marks. They show something recognizable. The animal trademarks shown here may be classified as descriptive, metaphoric and found marks.

200
The Playboy rabbit is not like the one featured in Bambi, or in any other children's book for that matter. It serves as a metaphor to remind the *Playboy* reader of the magazine's uninhibited interest in sexuality. The bow tie and the attentive ears suggest that the rabbit is both elegant and alert.
Company Playboy, USA.
Design Arthur Paul, 1953.
* A metaphoric mark.

201
Many metaphoric trademarks include an element of hyperbole – in this case comparing toothpicks with an elephant's tusks.
Company Toothpicks, Greece.
* A metaphoric mark.

202
The Hellesens tiger was a metaphor of raw power; as was the tiger mark of Humble Oil and Esso three decades later.
Company Hellesens, batteries, Denmark.
Design Knud V Engelhardt and Gunnar Biilmann Petersen, 1937.
* A metaphoric mark.

203
Countless cars are named after fast running, elegant animals. Sometimes it is a single model or a product line that is named. Sometimes – as in the case of Jaguar – it is both the name of the company and the make that have adopted a big cat metaphor.
Company Jaguar Cars, UK.
Design Norman Wittington Davies, 1982.
* Pictorially, a metaphoric mark. Linguistically, a metaphoric name.

200

![Playboy magazine cover, January 1995, Holiday Anniversary Issue, featuring Drew Barrymore "In the Flesh". Cover lines include Playboy Interview "Wham! Bam! Jean-Claude Van Damme", "Sex and Prozac the Untold Story", "Tom Snyder Late Night's Big Mouth", "A Riotous Year in Sex", "Clarence Thomas Rage Stalks the Justice", and "Plus Bruce Jay Friedman, Danny Glover, Robert James Waller, Playmate Review, College Hoops Preview and Much Much More".]

PLAYBOY
ENTERTAINMENT FOR MEN
JANUARY 1995 • $5.95

HOLIDAY ANNIVERSARY ISSUE

Drew BARRYMORE IN THE FLESH

PLAYBOY INTERVIEW
Wham! Bam!
JEAN-CLAUDE VAN DAMME

SEX AND PROZAC THE UNTOLD STORY

TOM SNYDER LATE NIGHT'S BIG MOUTH

A RIOTOUS YEAR IN SEX

CLARENCE THOMAS RAGE STALKS THE JUSTICE

PLUS BRUCE JAY FRIEDMAN DANNY GLOVER ROBERT JAMES WALLER PLAYMATE REVIEW COLLEGE HOOPS PREVIEW AND MUCH MUCH MORE

201

202

HELLESENS TØRELEMENT 1887-1937

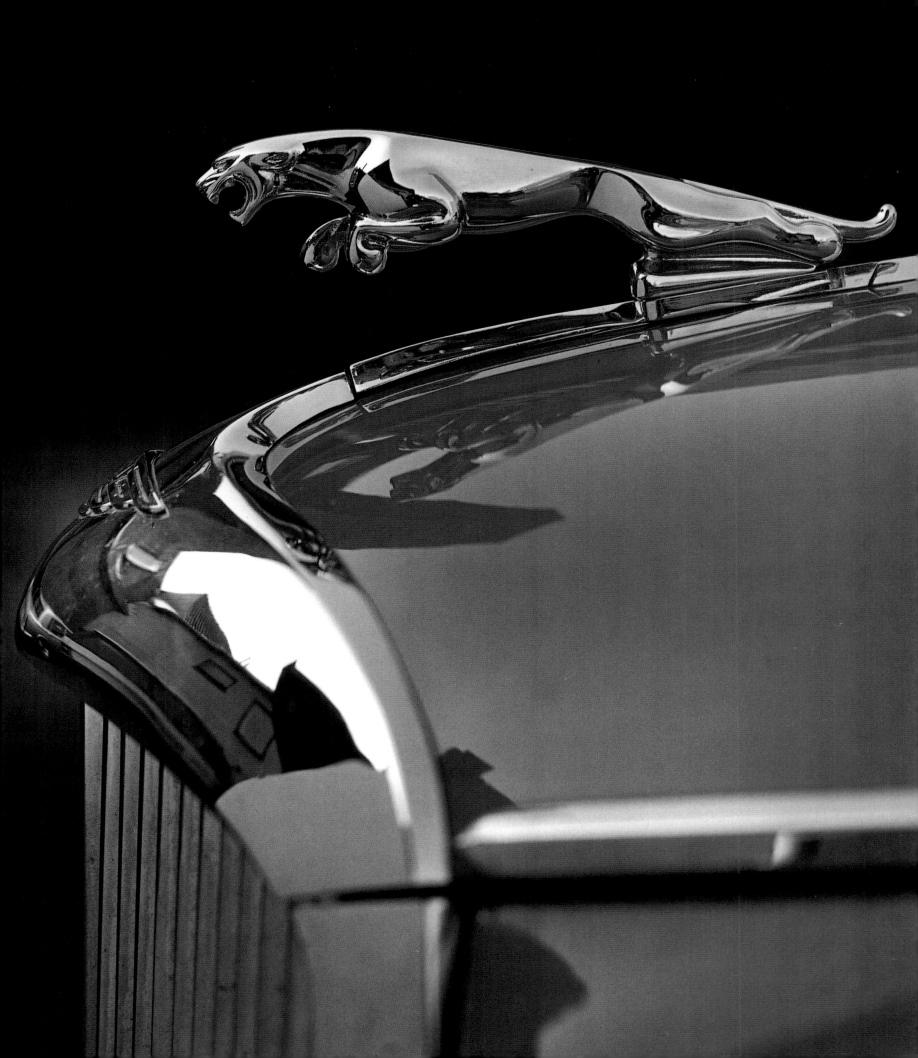

204

With any amount of visual improvisation, the camel remains the same. The original one-humped dromedary was drawn by the company's founder R J Reynolds after a photograph of 'Old Joe', a camel from the Barnum & Bailey Circus that came to town on Monday 29 September 1913. Today R J Reynolds Tobacco Co calls the macho, jazz-playing spokes-camel in their advertisements 'New Joe'. The unusual camel packagings are from a special anniversary series sold in Italy in 1996.
Company R J Reynolds Tobacco Co, USA.
Design R J Reynolds, 1913.
* A metaphoric mark.

205
Maximum impact is created by stretching the Slazenger big cat across the head of the tennis racket.
Company Slazenger, UK.
Design Slazenger, 1912.
* A symbol, a found mark.

206
No obvious link seems to associate a fox with a paint and chemical manufacturer. This particular fox, however, has become integral to Hadfields's identity.
Company Hadfields, UK.
Design Wolff Olins, 1966.
* A symbol, a found mark.

207
This jaguar provides a strong pictorial symbol for a cement company.
Company Arabian Bulk Trade, Saudi Arabia.
Design Lock/Pettersen, 1984.
* A symbol, a found mark.

208
Here, a dog's paw print rather than the dog itself is adopted as a motif.
Company Lewisville Humane Society, USA.
Design RBMM, 1986.
* A symbol, a found mark.

209
'Fjällräven' is Swedish for 'mountain fox'. Fjällräven manufactures clothing and rucksacks. The Fjällräven mark suggests that the animal and the piece of clothing or rucksack and its owner have something in common: they belong to nature.
Company Fjällräven, Sweden.
Design Fjällräven *c*1974.
* A metaphoric mark.

210
The people at Frogdesign do not know why they have a frog as their mascot. One explanation is that 'frog' is an acronym of 'Federal Republic of Germany'.
Company Frogdesign, Germany.
Design Frogdesign, 1975.
* A symbol, a found mark.

211
The kangaroo represents both Australia and movement. It is the perfect trademark motif for the down-under airline.
Company Qantas, Australia.
Design 1984.
* A metaphoric mark.

212
The long form of the crocodile curves around to create a neat circle.
Company Cooper Union for the Advancement of Science and Art, USA.
Design Herb Lubalin, 1972.
* A symbol, a found mark.

213
Sonofon has chosen the dolphin for its association with boundless communication. There are two dolphins because communication implies at least two parties.
Company Sonofon, GSM mobile telephone network, Denmark.
Design Johan Adam Linneballe/Eleven Design, 1993.
* In spite of the above explanation the dolphins must be considered a symbol, a found mark. Linguistically, a descriptive name.

206

207

208

209

210

211

212

213

214

The Panda trademark was designed by ornithologist, artist and WWF founder Sir Peter Scott. Of his choice, Scott said: 'We wanted an animal that is beautiful, is endangered, and one loved by many people in the world for its appealing qualities. We also wanted an animal that had impact with black and white printing to save money on printing costs.' The Panda goes right to the point.
Company World Wide Fund For Nature, Switzerland.
Design Sir Peter Scott, 1961.
Redesign Landor Associates, 1986.
* An image, a descriptive mark.

215

A 'toy' animal adopted for a range of toys.
Company House of Fraser, UK.
Design Minale Tattersfield, 1968.
* An image, a descriptive mark.

216

There is no natural relationship between the name and the figure. Silja is neither Finnish nor Swedish for seal – it is Finnish for Cecilia. Silja Line runs ferries between Finland and Sweden and Germany. Painted on the ship's hull the company seal appears to emerge from the water.
Company Silja Line, Finland.
Design Viki Kaltala, Janne Sjöström, c1970.
* Linguistically, partly a proper name, partly a descriptive name. Pictorially, a metaphoric mark.

217

Since Nordisk Film – one of the oldest film companies in the world – first used its polar bear trademark, the mark has been adjusted a number of times. The reason for this choice was probably one of the company's early film successes, *The Great*

Polar Bear Hunt, made in 1907. In 1909 the legendary founder of the company, Ole Olsen, got the idea of showing a living bear in the titles preceding his films.
Company Nordisk Film, Denmark.
Design 1909/1978.
* However good the explanation may be, the mark must today be considered a symbol, a found mark.

218

In the late 1920s, tennis pro Jean René Lacoste, a real fighter, was given the nickname 'the Crocodile'. Later, in co-founding a company for sports clothes, he capitalized on his fame in a most professional way.
Company Lacoste, France.
Design Robert George, 1933.
* Today the crocodile must be considered a symbol. Pictorially, a found mark. Linguistically, a proper name.

219

For a company that specializes in financial services the bull can have connotations of being 'bullish' as well as the 'bull-market'.
Company Merrill Lynch Capital Market, financial services, USA.
Design King-Casey, 1973.
* A symbol, a found mark.

220

The Apis bull was a sacred animal in ancient Egypt. Shortly after founding the medical factory, Novo adopted the Apis bull and thereby followed a pharmacy tradition of using animal symbols.
Company Novo Nordisk, pharmaceuticals and chemicals, Denmark.
Design 1925.
* A symbol, a found mark.

214

215

216

217

218

219

220

Arrows

The arrow indicates movement and direction. Both meanings are relevant for a trademark used by a transport company. For this reason, the double arrow has become an almost generic trademark theme for transportation companies.

When used as a directional sign, the arrow is an index. However when designed as a trademark, it becomes something else.

Later it can also be used as an index that says, 'This belongs to …'. The arrow trademarks shown here may be classified as descriptive marks and as found marks.

221

The official British Rail interpretation of their trademark is that they are 'Two-way traffic arrows on parallel lines representing tracks'. Arrow trademarks for transportation companies are diagrams. They show the structure of the service.
Company British Rail, UK.
Design Design Research Unit, 1965.
* A diagram, a descriptive mark.

222
Company Nederlandse Spoorwegen, railways, Netherlands.
Design Tel Graphic Design, 1967.
* A diagram, a descriptive mark.

223
'A motion-oriented' service mark in red, white and blue, is how Amtrak, the railway company, describes its American flag-coloured arrow. Amtrak is a contraction and a blending of the concepts 'American' and 'track'.
Company Amtrak, USA.
Design Lippincott & Margulies, 1971.
* Linguistically, a non-initial abbreviation. Pictorially, a diagram, a descriptive mark.

224
Company Renfe, Spanish State Railways, Spain.
* A diagram, a descriptive mark.

225
Company Seatrain Lines Inc, shipping company, USA.
Design Tom Geismar, Chermayeff & Geismar, 1965.
* Linguistically, a non-acronym initial abbreviation. Pictorially, a diagram, a descriptive mark.

226
Company Metro São Paolo, Brazil.
Design Unimark Bob Noorda, 1974.
* Pictorially, a diagram, a descriptive mark. Linguistically, a descriptive name.

227
Another transport trademark which promises to take you away and bring you back again.
Company Helsinki City Transport, Finland.
Design Studio Esko Miettinen, 1974.
* A diagram, a descriptive mark.

228
This seemingly simple arrow mark has evolved through a series of redesigns. Hans Hartmann designed the double arrow for the Swiss rail company. Uli Huber placed it in the black block, and added German, French and Italian initials. Josef Müller-Brockmann and Peter Spalinger finalized it.
Company SBB, Switzerland.
Design Hans Hartmann, 1972.
Redesign Uli Huber, 1976. Josef Müller-Brockmann and Peter Spalinger, 1978.
* Linguistically, a non-acronym initial abbreviation. Pictorially, a diagram, a descriptive mark.

221

222

223

224

225

226

227

228
SBB CFF FFS

Birds

There is great diversity and even disparity in the meanings attached to birds and their individual species. Though their association with flight means that they often represent physical flight and flight of thought, since ancient times they have symbolized political power. In the United States Congress, doves and hawks discuss national and world affairs under the figurative eye of the American eagle. Peacocks have appeared in Christian art as symbols of both spiritual immortality and the vanity of man.

The adoption of birds in commerce is often more straightforward. They have proved popular as trademarks for airlines and publishers.

The bird trademarks shown here may be classified as metaphoric marks and found marks.

229
Nothing could be more appropriate than a bird as the trademark of an airline. This bird was the result of a competition held in 1919. It was first used on an aircraft in 1920 and has never been grounded!
Company Lufthansa, airline, Germany.
Design Otto Firle in co-operation with Walther Mackenthun, 1919.
* A metaphoric mark.

230
Company Ving, travel agency, Sweden.
Design Hans Brindfors/ Lowe Brindfors, 1993.
* Pictorially, a metaphoric mark.
Linguistically, a metaphoric name.

231
This highly suggestive eagle was sadly replaced in 1993 by a poor trademark. Saturday Night Live news anchorman Kevin Nealon, described the new mark as 'a special breed known for its incompetence, slow flight and sudden bursts of violent behavior against former co-eagles'.
Company United States Postal Service, USA.
Design Raymond Loewy, 1970.
* Linguistically, a descriptive name.
Pictorially, a metaphoric mark.

232
The NBC peacock signals the pluralism of a great broadcasting network in a colourful way.
Company National Broadcasting Corporation, USA.
Design Chermayeff & Geismar, 1986.
* A metaphoric mark.

233
This highly stylized owl was originally designed for the Danish booksellers' association. It was later adapted by Norwegian, Swedish and Swiss booksellers.
Company Booksellers, Denmark.
Design Erik Ellegaard Frederiksen, 1955.
* A symbol, a found mark.

234
Since 1945 Bantam has had bantam roosters as its trademark.
Company Bantam, publishers, USA.
Design 1945.
Redesign 1992.
* A symbol, a found mark.

235
The three ducks are evocative of freshwater life, making this trademark unforgettable for a company with lakes in its title.
Company Tipton Lakes Corporation, USA.
Design Paul Rand, 1980.
* Initial and metaphoric mark combined.

229
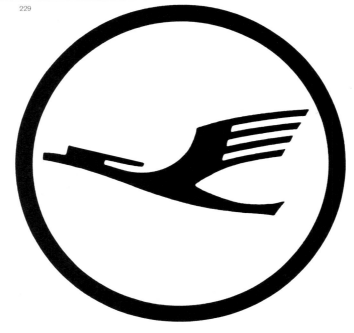

230

231

232

233

234

235

236
The Penguin trademark was a prominent feature of the publisher's classic paperback series.
Company Penguin, UK.
Design Edward Young, 1934.
Redesign Jan Tscichold, 1949.

237
The first Penguin trademark was designed by a twenty-one-year-old office employee, Edward Young, whom Allan Lane, the publisher, sent to London Zoo to do some sketches of a penguin. Fifteen years later, Jan Tschichold designed the penguin we know today.
Company Penguin, UK.
Redesign
Jan Tschichold, 1949.
* A symbol, a found mark.

238
Gyldendal adopted its first crane trademark in 1770. The bird was a symbol for the area of Copenhagen where the publishing firm was and is still based.
Company
Gyldendal, Denmark.
Design 1770.
Redesign
Austin Grandjean, 1975.
* A symbol, a found mark.

239
A few years after the introduction of this mark, the Copenhagen department store changed its name (back) to 'Illum' with no apostrophe or letter 's'.
Company Illum's, Denmark.
Design Peter Hiort, 1989.
* Pictorially, a symbol, a found mark. Linguistically, a proper name.

240
The mark of the Danish jewellers Georg Jensen depicts two weaver birds, which represent the craft involved in producing Jensen's designs.
Company Georg Jensen Damaskvæveriet, Denmark.
Design C Svane, early 1920s.
Redesign
Knud V Engelhardt, 1925.
* A metaphoric mark.

236

237

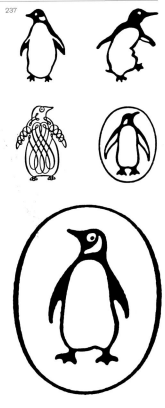

238

239

240

Botanical motifs

Plants are said to symbolize death and resurrection, while fruit most often stands for immortality. As trademarks, they can represent anything: computers, products made from plants, even banks. The botanical trademarks shown here may be classified as descriptive marks and found marks.

241
The highly successful apple of Apple Computers brings together a number of references. Though the apple can represent knowledge, the bite out of it makes an obvious biblical allusion to sin. The stripes set up a playful comparison with one of its major competitors IBM. Apple Computers itself gives three reasons for choosing the apple as a trademark:

1 The name begins with an 'A'; it therefore appears at the front of most directories.

2 The fact that nobody will normally associate an apple with computers will make it memorable.

3 The apple gives a positive feeling. It is non-threatening. It has a 'healthy' connotation – an apple a day keeps the doctor away. It connotes a warm, personal image.[1]

Company Apple Computers, USA.
Design Rob Janoff/Regis McKenna Advertising, 1977.
* A symbol, a found mark.

242
A round tree with an 'r' for a stem evokes the manufacturer's name in more ways than one.
Company Rowntree, UK.
Design Smith & Milton, 1989.
* Pictorially, a symbol, a found mark. Linguistically a non-acronym initial abbreviation

243
This symbol designed for a company of architects and landscape designers reflects the firm's two interests. Reciprocal shapes and figureground, however, make both house and tree a single graphic image.
Company Cedric Lisney & Associates, UK.
Design David Hillman/

Pentagram, 1980.
* An image, a descriptive mark.

244
Here, the branches of a tree not only swirl to create the initial 'S' for Surrey, but also to suggest the verdant English Home County.
Company Surrey Institute of Art & Design.
Design The Partners, 1994.
* Pictorially, a symbol, a found mark. Linguistically, a non-acronym initial abbreviation.

245
The Atheneum Hotel is planned for the 'Greek Town' area of Detroit. Its trademark combines classic typography with an illustrated olive branch – a Greek symbol.
Company Atheneum Hotel, USA.
Design Colin Forbes/ Pentagram, 1990.
* Initial and metaphoric mark.

246
Lantmännen is the Swedish national organization of farmers. Their trademark depicts an embryo.
Company Lantmännen, Sweden.
Design Plan, 1970.
* An image, a descriptive mark.

247
Golden Grove is a publishing house specializing in Welsh literature. The design for the company symbol is a grove of trees derived from a printers' traditional leaf motif.
Company Golden Grove, UK.
Design David Hillman/ Pentagram, 1987.
* A symbol, a found mark.

241

242

243

244

245

246

247

248
Today the Danish sugar factories are part of Danisco Sugar. A stylized sugar-beet represents sugar.
Company De Danske Sukkerfabrikker, Denmark.
Design Henry Anton Knudsen, 1972.
* An image, a descriptive mark.

249
Perhaps an oriental metaphor ties tomatoes and banks together.
Company Tomato Bank, Japan.
Design Shigeo Katsuoka, 1989.
* (Western) A symbol, a found mark.

250
Pileprodukter (products from willow) is the collective mark of a number of protected workshops in Malmöhus County in Scania, Sweden. Among their products are baskets. This, and the fact that the willow is a typical tree in this region of Sweden, explains the choice of motif.
Company Pileprodukter, Sweden.
Design Robert Weiss, 1972.
* An image, a descriptive mark.

251
Here a plant means a plant. From its *piano nobile* shop in a backyard in Milan's Brera quarter, Centro Botanico sells all kinds of products related to gardening, including plants, seeds, books and honey.
Company Centro Botanico, garden shop, Italy.
* An image, a descriptive mark.

252
In terms of American legislation, this mark is a certification mark. It is used to identify 'good quality branded products in 100% cotton'.
Company Pure Cotton, UK.
Design Walter Thompson, mid-1950s.
* An image, a descriptive mark.

253–5
Tormod Olesen took his inspiration for this mark from a Chinese ideogram (fig 253) meaning 'tree'.
Company GORI, wood protection, Denmark.
Design Tormod Olesen (fig 254) 1960s.
Redesign Niels Hartmann (fig 255) 1970.
* An image, a descriptive mark.

248

249

250

251

252

253

254

255

Buildings

Years ago, merchants and other businesses spoke of their own company as 'the house', for example the house of Buddenbrooks, as described by Thomas Mann in his novel of that title. Today producers of commodities, from haute couture to newspapers and computer software, refer to their companies as 'houses'. A good French wine comes from a château and a lot of wine growers feature a château – real or imaginary – on their labels. The label is not something extra, it is an integrated part of the product. The building trademarks shown here may be classified as descriptive and metaphoric marks.

256
The most exciting feature of the Pompidou Centre designed by Renzo Piano and Richard Rogers is its unconcealed structure. Both the structural parts and the service elements of the building are on view. The trademark for the centre celebrates this aspect of the building.
Company Centre Georges Pompidou, exhibition centre, France.
Design Jean Widmer, 1975.
* An image, a descriptive mark.

257
Company
Krak, publisher, Denmark.
Design 1899.
Redesign Erik Ellegaard Frederiksen, 1989.

258
The Tower and the river Thames lend the nearby property development project an identity.
Company London Docklands Development Corporation, UK.
Design John McConnell/ Pentagram, 1981.
* An image, a descriptive mark.

259
Figure/ground rooftop design.
Company Workhouse, UK.
Design The Partners, 1990.
* An image, a descriptive mark.

260
Moathouse is a company set up to export Fortnum & Mason products to the American market.
Company Moathouse, UK.
Design David Hillman and Lydia Thornley/ Pentagram, 1985.
* A metaphoric mark.

261
Gleerups is an academic bookshop that faces the Cathedral of Lund in one of Europe's old university towns.
Company Gleerups, Sweden.
Design Erik Lindegren, 1976.
* Pictorially, an image, a descriptive mark. Linguistically, a proper name.

262
The best-known building in the north German city of Lübeck is Lübecker Tor (Lübeck Gate). Lübeck's most famous product is marzipan.
Company G Niederegger, marzipan, Germany.
Design Attributed to Alfred Mahlau, 1921.
* Pictorially, an image, a descriptive mark. Linguistically, a proper/descriptive name.

263
A cathedral more than 400 years old and the Rhine river are the main features of Cologne. Both sights can be enjoyed from the Köln Messe fairground and in the Köln Messe trademark.
Company Köln Messe, trade fair company, Germany.
Design
Coord von Mannstein, 1981.
* Pictorially, an image, a descriptive mark. Linguistically, a descriptive name.

264
The mark on the back of this plate is for Bing & Grøndahl, now part of the Royal Copenhagen Group. Like Krak's trademark it features the three towers of the Danish capital. Anywhere in the world the companies' products go they are identified with their home city.
Company Bing & Grøndahl, porcelain factory, Denmark.
Design Bo Bonfils, 1970.
* Images, descriptive marks.

256

257

258

259

260

261

262

263

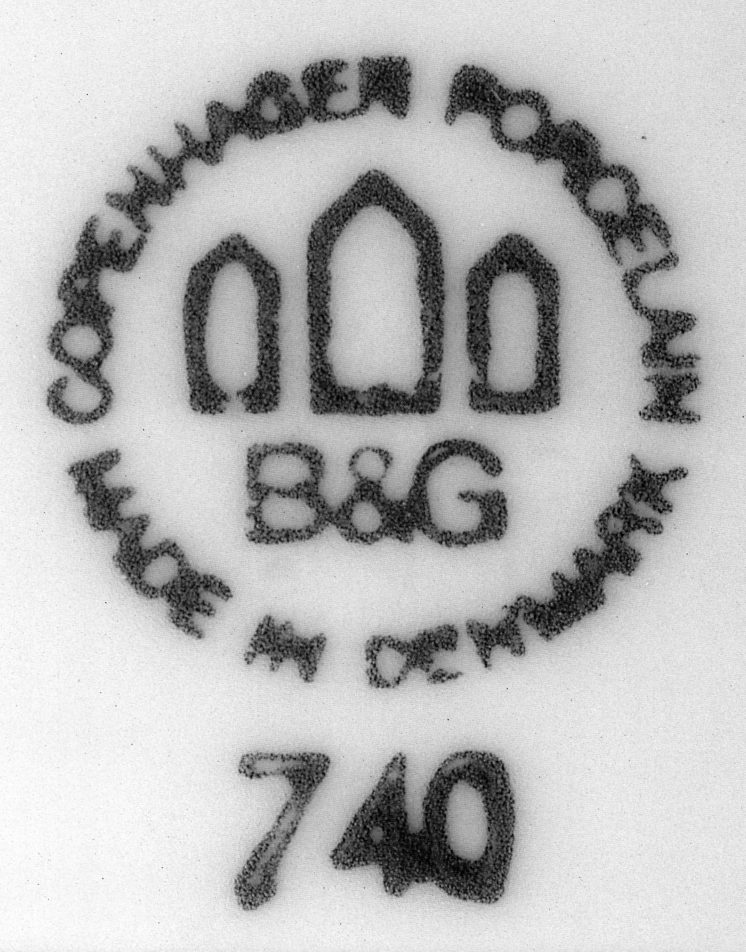

Crosses

The cross is not exclusive to the Christian faith. In the Western world, it preceded Christianity. In fact Christians did not adopt the cross as a religious symbol until Emperor Constantine abolished crucifixion in 315 AD. When a sign has strong emotional value, it can also generate strong feelings in groups who do not identify with it. For this reason, the Christian cross is not unanimously popular (see p 70, figs 120–1).

The cross trademarks shown here may be classified as non-figurative marks.

265
Historically a white cloth has symbolized truce or suspension of hostilities in battle. Embellished with a red cross (the reverse of the Swiss national flag), it suggests respect for the wounded and for medical personnel. The mark is used today both by the army medical corps and the International Red Cross established after the Geneva Convention of 1864.
Company International Red Cross and Red Crescent Movement, Switzerland.
Design Henri Dunant, 1863.
* A symbol, a non-figurative mark.

266
A symbol within a symbol.
Company The Herman Trust, UK.
Design Lowell Williams/ Pentagram, 1989.
* Linguistically, a non-acronym initial abbreviation. Pictorially, a symbol, a non-figurative mark.

267
In the 1850s and early 1860s, the shipowners Koch & Henderson used the Maltese cross on their company flag. In 1866 they merged with two other shipping companies to form DFDS, which took over the Maltese cross. The man behind the new company, C F Tietgen, must have liked the symbol. He used it again and again. The shape of the DFDS cross today is, strictly speaking, not a Maltese cross, but something in between what heraldry calls a Maltese cross and a Pattée cross.
Company DFDS, Denmark.
Design c1850.
Redesign Niels Hartmann, 1978.
* A symbol, a non-figurative mark.

268
The Maltese cross formerly worn by the Knights of Malta was adapted here for a trademark.
Company Air Malta.
* A symbol, a non-figurative mark.

269
When Mr Tietgen turned Em Z Svitzers Salvage Company into a limited company in 1872, he gave it a blue Maltese cross on a white background.
Company Em Z Svitzers Salvage Company, Denmark.
Design 1872.
* A symbol, a non-figurative mark.

270–1
De Danske Spritfabrikker, manufacturers of Danish aquavit, has a Maltese cross in an oval form following the colour of the label: red, blue or brown. Since 1912, the Maltese cross has always been red on a white background. Today, the company is part of Danisco Distillers.
Company De Danske Spritfabrikker, Denmark.
Design 1881.
* A symbol, a non-figurative mark.

272
The vermilion parallelogram with the white cross says both 'aviation' and 'Switzerland'.
Company Swissair, Switzerland.
Design Karl Gerstner, 1974.
* Linguistically, a descriptive name. Pictorially, an image (aircraft tail), a descriptive mark and a symbol (cross), a non-figurative mark.

265
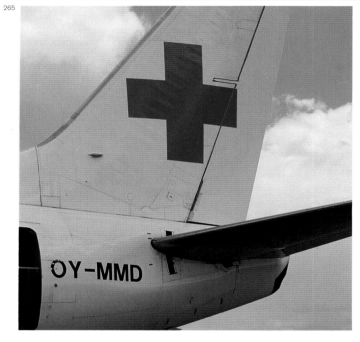

266

267

268

269

270

271
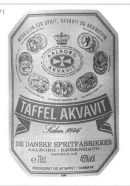

273

This animation is a birthday celebration.
Company PTT Switzerland, National Post Office.
Design Rüttiman + Haas, 1971.
* A symbol, a non-figurative mark.

274

A charity that brings health care to people – the crosses evolve into human figures.
Company Health Unlimited, UK.
Design The Partners, 1992.
* A descriptive mark.

275

This is one of the best cross trademarks. Almost timeless, clinically clean, it is equally suitable whether embossed on aspirins or lighting the night sky at the company headquarters in Leverkusen.
Company Bayer, pharmaceuticals, Germany.
Design Hans Schneider, 1900.
* Linguistically, a proper name. Pictorially, a symbol, a non-figurative mark.

276

The Cross used by the Union Bank of Switzerland incorporates abbreviations of both the German name, Schweizerische Bankgesellschaft, and the French, Italian and English names.
Company Union Bank of Switzerland, Switzerland.
Design Y&R and Company, 1981.
* Linguistically, two non-acronym initial abbreviations. Pictorially, a symbol, a non-figurative mark.

277

In Switzerland, a great many companies and institutions use the cross as a trademark. In 1933, Swiss legislation imposed certain restrictions on the use of marks similar to the Swiss flag. The cross of Emmental,

represents two wheels of Swiss Emmental cheese and complies with the law.
Company Emmental, cheese exporters, Switzerland.
Design Herbert Auchli, 1960.
* An image (cheese), a descriptive mark, and a symbol (cross), a non-figurative mark.

278

Since 1928, the Cross of Lorraine has been used as a mark of victory in the crusade against tuberculosis.
Company International Union against Tuberculosis and Lung Disease.
Design 1928.
* A symbol, a non-figurative mark.

279

It is simple. It is Swiss. It works equally well in poster or stamp format.
Company Swiss National Exhibition Expo, Lausanne 1964, Switzerland.
Design Armin Hofmann, 1964.
* Linguistically, a non-acronym initial abbreviation. Pictorially, a symbol, a non-figurative mark.

280

This cross stands for tradition and progress, as well as security, stability, strength, significance and calm, according to the bank.
Company Schweizerische Kreditanstalt, Switzerland.
Design Willi Wermelinger, 1967.
* A symbol, a non-figurative mark.

281

Company Beekman Downtown Hospital, USA.
Design Philip Gips, 1970.
* A symbol, a non-figurative mark.

282

Company Richman's Zipper Hospital, USA.
Design Steven Snider, 1984.
* An image, a descriptive mark, and a symbol, a non-figurative mark.

272

swissair

273

I 700 anni Confœderatio Helvetica

274

275

276

277

278

279

280

281

282

NATIONALFORENINGEN
TIL BEKÆMPELSE AF
LUNGESYGDOMME

Crowns

A crown has no practical function. Even in its three-dimensional form it is nothing but a symbol. A crown can stand for an emperor, royalty or nobility, as well as authorization by any of these powers, or simply quality. Companies that are purveyors to royalty often show the royal warrant together with their trademark. Both Carlsberg and Tuborg, for instance, changed their labels when they were appointed purveyors to the King of Denmark. Tuborg introduced its 'watchmaker' label. Carlsberg named its normal lager beer Hof, Danish for 'court'. Crowns that stand for royalty can be more or less exact depictions of a real crown. The trademarks of government offices and enterprises owned by the state may depict the crown of the monarch. Purveyors to the British Royal Court have the right to display a royal warrant, representing the crown. The trademark crowns may be classified as found marks.

283
Drawing from *Den Danske Vitruvius* of Danish coronets. In order to prevent people from showing a crown to which they had no right, Christian V introduced coronets, a system of crowns that precisely signified the user's status.
At the top is the crown of the King and Queen, below are those of the Crown Prince and Crown Princess, the Princes and the Princesses, next down are the Gyldenløve family (surname given to the illegitimate children of Danish kings Christian IV, Frederik III, Christian V and Frederik IV), and then the counts and the barons, and finally, the crowns of the untitled nobility. Only the king's crown exists – or has existed – in real life.

284
The Tuborg lager 'watchmaker' label declares its association with the Royal Court.
Company Tuborg, Denmark.
Label design Kristian Kongstad, 1914.
Redesign Plan Design, 1972.

285
The labels of the Carlsberg lager. Hof (court) on the neck, royal warrant on the chest.
Company Carlsberg, Denmark.
Label design Thorvold Bindesbøll, 1904.

286
In London, the Royal Parks are administered by the Crown. This is conveyed literally by their royal symbol, which is made up of the sorts of leaves that you would find in an English park.
Company Royal Parks, UK.
Design Moon Communications, 1994.
* Pictorially, a symbol, a found mark.

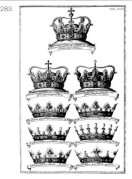

Ever since Queen Juliane of Denmark founded the Royal Copenhagen Porcelain Manufactory in 1775 the company has had a crown as part of its trademark. Today the Royal Copenhagen Porcelain Manufactory, together with Bing & Grøndahl Porcelain Factory, Holmegaard Glassworks and Georg Jensen Silversmithy have been brought together to form the Royal Copenhagen Group.
Company Royal Copenhagen Porcelain Manufactory, Denmark.
Design Unknown, 1775.
Redesign: Unknown, 1898 (in use from 1898 until about 1922).

* Pictorially, both the crown and the waves are symbols, found marks. Linguistically, a descriptive name.

288

Company Forsknings-ministeriet, the Danish Ministry of Research and Communication.
Design Per Mollerup Designlab, 1996.

* A symbol, a found mark.

289

This trademark for the Swedish glassworks has been refined to an elegant simplicity.
Company Kosta, Sweden.
Design H C Ericson, 1992.

* Linguistically, a proper name (Kosta is a place). Pictorially, a symbol, a found mark.

290

Company Riksgäldskontoret, the Swedish National Debt Office, Sweden.
Design Sven Höglin and Göran Österlund, 1984.

* Pictorially, a symbol, a found mark. Linguistically, a descriptive name.

291

The Dutch airline KLM, Koninklijke Luchtvaart Maatschappij, has had the three letter abbreviation and a royal crown as its mark since 1919. The airline accepted the new mark only after long consideration: it seemed too advanced.
Company KLM, Netherlands.
Design F H K Henrion, 1961.

* Pictorially, a symbol, a found mark. Linguistically, a non-acronym initial abbreviation.

292

Company Operan, The Swedish State Opera House, Sweden.
Design Unknown, 1964.

* Pictorially, a symbol, a found mark. Linguistically, a descriptive name.

287

288

289

290

RIKSGÄLDS KONTORET

291

292

Dogs

Man's best friend also serves as a motif for some of the best-known trademarks. A huge variety of breeds are drawn on, all giving very different associations. The dog trademarks shown here may be classified as descriptive, metaphoric and found marks.

293
Though the trademark is contained in the name mark here, it is also characterized by the dog that accompanies it on the stationery's packaging depicted in various pursuits by the American illustrator Charles Barsotti.
Company Niceday, UK.
Design Newell & Sorrell, 1992.
* Proper name.

294
NETTO, a chain of hundreds of discount supermarkets in Britain, Denmark and Germany, chose a Scottish terrier to symbolize its stores where great savings are available. It later proved that the dog could also bark at competitors.
Company NETTO, Denmark.
Design Peter Hiort, 1991.
* An image, a descriptive mark (as a dog helping to carry the groceries home), or a symbol, a found mark (as a moneysaving Scot).

295
Since 1980 the outline of the Jack Russell 'Nipper' has been used for HMV's European music shops.
Company HMV record shops, UK.
Design Adapted from Francis Barraud, 1889.
* Pictorially an image, a descriptive mark. Linguistically, a non-acronym initial abbreviation.

296
Here the name and the product (dog food) are represented in a single image.
Company Spratts, UK.
Design Max Field-Bush, 1936.
* Pictorially an image, a descriptive mark. Linguistically, a proper name.

297
The greyhound is a fast runner and a great metaphor for a bus service.
Company Greyhound, USA.
Design Raymond Loewy, mid-1950s.
* A metaphoric mark.

298
The truck manufacturer's choice of metaphor is quite obvious. A bulldog is a very strong and sympathetic dog.
Company Mack Trucks, USA.
Design Early 1920s.
Redesign Mack Trucks 1948.

299
The HMV – His Master's Voice – 'Nipper' is probably the best-known canine trademark in the world. It was originally acquired by The Gramophone Company, which later became part of EMI. In 1901, the slogan was registered as a name mark itself. When the company tried to break away from the dog some years ago, there were strong protests.
Company EMI, UK.
Design Francis Barraud, 1889.
* An image, a descriptive mark.

293

294

295

296

297 298

Eyes

Sun gods, omniscience, all-seeing divinity, light, enlightenment, knowledge, mind, vigilance and protection are some of the symbolic meanings that have been assigned to the eye. The eye trademarks shown here are descriptive marks and found marks.

300

300
The CBS eye, the television news trademark par excellence, is still unequalled after three decades. Television is about seeing; the TV news sees for the television viewer.
Company CBS, Columbia Broadcasting System, USA.
Design William Golden, 1951.
* An image, a descriptive mark.

301
This hand and eye marked the inclusion of volume II of *Icographic* in *Mobilia* design magazine. *Icographic* is the journal of Icograda, the International Organization of Graphic Design Organizations. It shows the eye that sees and the hand that draws.
Company Icographic, Denmark.
Design Wolfgang Schmidt, 1982.
* An image, a descriptive mark.

302
Pinkerton Security Service is the oldest in the business. Its old police-like shield has been replaced by a vigilant eye forming an initial P.
Company Pinkerton Security Service, USA.
Design Selame Design, 1979.
* Pictorially, an image, a descriptive mark. Linguistically, a proper name.

301

302

303

Rebuses – images that can be read as words or letters – embrace the linguistic and pictorial functions of trademarks. The image of the eye is one of the most effective of these visual puns. Paul Rand has adopted it on at least two occasions (also see below).
Company IBM, International Business Machines, USA.
Design Paul Rand, 1970.
* Pictorially, three symbols, found marks. Linguistically, a non-acronym initial abbreviation which stands for a descriptive name.

304

Company AIGA, American Institute of Graphic Design Agencies, USA.
Design Paul Rand, 1981.
* The AIGA eye works in two ways. It is a sign for a sound and a sign of the metiér of graphic designers. In the first capacity, the eye is a symbol, a found mark. In the second capacity it is an image, a descriptive mark.

305

Company Sight Care, opticians, UK.
Design Mervyn Kurlansky/ Pentagram, 1984.
* An image, a descriptive mark.

306

Exclusivity is essential to any real club. Not everyone can enter; someone has to keep an eye on the entrance.
Company
The Speakeasy Club, UK.
Design Alan Fletcher/ Pentagram, 1965.
* An image, a descriptive mark.

307–8

Visual information with a direction is what the Sign Group cares about. The crowned mark is used in connection with awards.
Company Sign Group, promotional body, UK.
Design
Quentin Newark, 1992.
* An image, a descriptive mark.

309

Symbol for an Anglo-Russian creative consortium.
Company The Association.
Design Mike Dempsey/CDT Design, 1987.
* Linguistically, a non-acronym initial abbreviation. Pictorially, a metaphoric mark.

310

Company Cambridge Contact Lenses, UK.
Design The Partners, 1987.
* An image, a descriptive mark.

311

This mark combines eye and ear, sight and sound.
Company Time Warner, USA.
Design Steff Geissbuhler/ Chermayeff & Geismar, 1992.
* An image, a descriptive mark.

312

Symbol for visionary record label dedicated to new forms of classical recording. Here the 'e's become eyes.
Company Eye Records Ltd.
Design Barbaro Ohlson/ CDT Design, 1988.
* Linguistically, a non-acronym initial abbreviation. Pictorially, a symbol, a found mark.

303

304 305 306

307 308 309

310 311 312

Flags

A flag is a means of communication. Used as a trademark, it can represent communication. The flag trademarks shown here may be classified as metaphoric and non-figurative marks.

313
This logo was devised for a British regional TV channel that previously had a silver knight as its emblem. The heraldic associations were carried over into the new design applied to a flag.
Company Anglia Television, UK.
Design Lambie-Nairn & Company, 1987.
* A symbol, a non-figurative mark.

314–5
Flags are traditional for shipping companies. P&O's flag, in the royal colours of Spain and Portugal, recalls its trade routes of the 1830s. P&O is meant to have been granted the right to use these colours after it came to the Spanish and Portuguese monarchs' aid during their civil wars.
Company The Peninsular & Oriental Steam Navigation Company, UK.
Design 1830s.
Redesign Wolff Olins, 1975.
* A symbol, a non-figurative mark.

316
This is the logo for a visual communications company communicating communication.
Company Viscom, UK.
Design David Hillman/ Pentagram, 1980.
* A metaphoric mark.

317
German federal state Schleswig-Holstein has both a flag and a trademark showing the flag in motion.
Company Schleswig-Holstein, Germany.
Design Michael Päpke, Klaus Glöckner, 1990.
* A symbol, a non-figurative mark.

318
Here a naval image is suggested by the flags that are joined up to form a 'P'.
Company Flagship Portsmouth Trust, UK.
Design Alan Fletcher, 1994.
* Linguistically, a non-acronym initial abbreviation. Pictorially, a number of symbols, non-figurative marks.

313

ANGLIA

314

315

316

VISCOM

317

WHY SAIL ACROSS THE CHANNEL WHEN YOU CAN CRUISE ACROSS?

P&O European Ferries

Fragments

A fragment is often more exciting than a
motif in its entirety. The intelligent reduction
of graphical means increases attention value,
holding power and, probably, memorability.
It urges the viewer to solve a riddle, to fill in
the answer and to remember it. In terms of
our classification, a fragment trademark will
be whatever it was before fragmentation.

319–20
The unicorn is a time-
honoured fabulous
creature and trademark.
In Søndergaard's version,
the unicorn is so strong
visually that the bank only
shows half of the trademark
half of the time.
Company Unibank, Denmark.
Design Ole Søndergaard/
Eleven Design, 1990.
* A symbol, a found mark.

321
An informed (Swedish) reader
cannot help reconstructing
the dismembered logotype
of the Viking Line.
Company
Viking Line, Sweden.
Design Lasse Liljedahl/
Rönnbergs Reklambyrå, 1985.
* Partly a metaphoric name that says that
the company shares something with the
Vikings. Partly a descriptive name that
says that the company is a ferry line.

322–3
The Musée d'Orsay in Paris,
devoted to the art of the
Second Republic, has both
a full lettermark and a
fragmented one.
Company Musée d'Orsay,
France.
Design Jean Widmer and
Bruno Monguzzi, 1986.
* A non-acronym initial abbreviation.

324
Company Royal National
Theatre, UK.
Design FHK Henrion and
Ian Dennis, 1976.
* A non-acronym initial abbreviation.

325
Sweden Next is the name
of an export campaign
initiated to increase the
sale of Swedish furniture
in international markets.
The lack of the 'E' is
nothing less than a plus.
Company Sweden Next,
Sweden.
Design John Melin, 1991.
* A descriptive name.

326
'V&A' has long since been
the colloquial abbreviation
of the Victoria & Albert
Museum. Alan Fletcher has
continued the subtraction
and amputated the left
leg of the A.
Company Victoria & Albert
Museum, UK.
Design Alan Fletcher/
Pentagram, 1988.
* A non-acronym initial abbreviation.

319

320

321

Årskort till Åland för 100:-
Ålandskortet gäller under 12 månader räknat från inköpsdagen och berättigar till
obegränsat antal tur- och returresor Kapellskär–Mariehamn. Du köper Ålandskortet
i någon av Viking Lines resebutiker eller på din resebyrå.

NG LI

Tala med din resebyrå eller Viking Line, tel. 08-714 56 00
(Resebutiken vid SJ Centralstation), 08-644 07 65, 0176-441 00.

322

323

324

325

Geometric figures

Some of the best trademarks – and legions of bad ones – are geometric figures. The best are simple and well treated by repetition and reputation. The geometric marks shown here may be classified as descriptive and non-figurative marks.

327

328

329

330

331

332

World famous, the map of
the London Underground
railway system has become
an unofficial trademark.
Company London
Underground, UK.
Design Harry Beck, 1933.
Constantly updated since.

333

The trademark for London
Underground takes its
form from the train wheel.
Its designer was also
responsible for the
London Transport sans
serif type face, designed
for quick reading.
Company London
Underground, UK.
Design Edward Johnston,
1933.
Constantly updated since.
* If you see it as a wheel, then it is an
image, a descriptive mark. If you do not,
it is a symbol, a non-figurative mark.

334

Two colours are entwined
in a ring in this symbol for
an association representing
Islamic Solidarity.
Company Islamic Solidarity,
Saudia Arabia.
Design Alan Fletcher/
Fletcher Forbes Gill, 1968.
* Metaphoric mark.

335

This symbol is for an
advertising agency whose
initials 'A' and 'M' are based
on a triangular structure.
Company Abbott
Mead/BBDO, UK.
Design Mike Dempsey/
CDT Design, 1988.
* A symbol, a found mark.

336

Company
DG Bank, Germany.
Design Nacke & Flink, 1976.
* A symbol, a non-figurative mark.

337

Company Blue Circle,
cement, UK.
Design F H K Henrion, 1970.
* A symbol, a non-figurative mark.

332

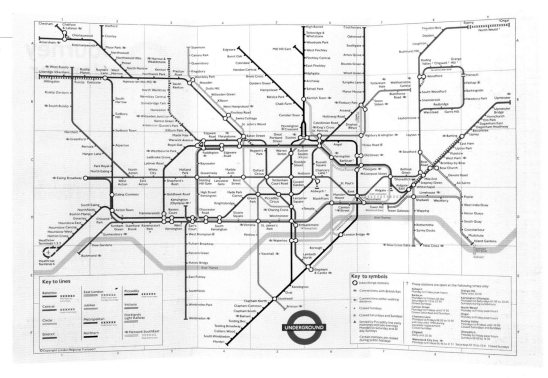

333

334

335

336

337

Globes

The globe as a trademark obviously proclaims:
'We cover the world: the whole world is our
natural province.' When it clearly carries this
meaning, a globe trademark may be classified
as an image, a descriptive mark. However, when
this interpretation cannot be applied, the globe
trademark may be considered a found mark.

338
Saul Bass was first with
this type of striped globe
trademark. Since then
many graphic designers
throughout the world have
helped to turn Bass globes
into a design category.
Company AT&T,
American Telephone
& Telegraph, USA.
Design Saul Bass, 1984.
* Pictorially, an image, a descriptive
mark. Linguistically, a non-acronym
initial abbreviation that stands for
a descriptive name.

339
Company Statkraft,
power work, Norway.
Design Anisdahl/
Christensen, 1985.
* A symbol, a found mark.

340
Company Den Norske Bank,
Norway.
Design Skaara & Partners,
1990.
* A symbol, a found mark.

341
The American daily is
distributed worldwide.
Its trademark is a globe
showing the Western
hemisphere.
Company USA Today, USA.
Design Mutsuo Yasumura,
1982.
* Pictorially, an image, a descriptive mark.
Liguistically, a descriptive name.

342
Coloplast sells health
care products to colostomy
patients and others.
Company Coloplast,
Denmark.
Design Hans Due, 1988.
* Pictorially, a symbol, a found mark.
Linguistically, a descriptive name.

343
Scanticon has partly
based its globe design on
Piet Hein's superellipse
a hybrid of a rectangle
and an ellipse.
Company Scanticon,
conference centres, Denmark.
Design Peter Jensen/Pind
Marketing, 1989.
* A symbol, a non-figurative mark.

344
A company that wires
the world.
Company Cable & Wireless,
communication cables, UK.
Design Lock/Pettersen,
1992.
* Pictorially, an image, a descriptive mark.
Linguistically, a descriptive name.

338

339

340

341

342

Coloplast

343

Scanticon

344

Greek alphabet

The Greek alphabet has twenty-four letters. Though alpha and omega are *principium et finis,* the most well known, many others are used as trademarks. Like Latin letters, Greek letters are symbols.[2] The Greek alphabet trademarks shown here may be classified as found marks and names.

345
Phaidon was a pupil of Socrates and a speaker in Plato's dialogue on the immortality of the soul. Dr Horovitz, the founder of Phaidon Press, chose the name out of his love of antiquity. The letter 'phi' is the initial of Phaidon written in Greek.
Company Phaidon Press, UK.
Design c1945.
Redesign David Hillman/ Pentagram, 1991.
* Pictorially, a symbol, a found mark. Linguistically, a proper name.

346–7
Alfa-Laval was introduced as the name of the 1890 model of De Laval's centrifugal separator manufactured by the Oscar Lamm Jr company. The company name was later changed to Separator and still later to Alfa-Laval. In 1970, the Greek letter was introduced as a trademark. After the merger of Tetra-Pak and Alfa-Laval, the new company stuck to the alpha.
Company Alfa-Laval, food appliances, Sweden.
Design Sigvard Bernadotte, 1970.
Redesign Toni Manhart & Jörgen Haglind, 1992.
* A symbol, a found mark.

348
The Greek letter 'psi' spelled in English is an acronym of the company name, Paper Sources International.
Company PSI, USA.
Design Bradbury Thompson, 1981.
* Pictorially, a symbol, a found mark. Linguistically, a non-acronym initial abbreviation.

349
EUREKA is a European initiative in which nineteen countries are taking part. Its aim is to strengthen Europe's position in the world market by facilitating technological development through the cooperation of industrial and scientific bodies. To mathematicians 'sigma' means sum.
Company EUREKA, Belgium.
Design Pedro Torrents, 1987.
* A symbol, a found mark.

350
'Omega' is the brand name of watches manufactured by SMH. The omega mark was already in use in the nineteenth century and was registered in Switzerland in 1904.
Company Omega, Switzerland.
Design Eugène Patkévitch, 1978.
* Pictorially, a symbol, a found mark. Linguistically, a found name.

351
Company Purup Graphic, printers of forms, Denmark.
Design Purup Graphic, 1989.
* A symbol, a found mark.

352
The name of the popular Greek ice-cream spells the name of the fourth letter of the Greek alphabet: delta.
Company Delta, Greece.
* A found name.

345

346 347 348 349

350 351 352

Leica

D.R.P.

Ernst Leitz
Wetzlar

№ 198967

Handwriting

A logotype in the form of a handwritten signature signals guarantee, responsibility, pride and quality. Most handwriting trademarks are proper names, but they can also be descriptive names like Coca-Cola, non-initial abbreviations like Leica and probably metaphoric names, found names and artificial names as well as abbreviations.

353
'Leica' is a combined contraction and suspension of 'Leitz Camera'. Ernst Leitz is the former name of the company.
Company Leica Cameras, Germany.
Design 1910.
* A non-initial abbreviation.

354
Zino Davidoff, the Geneva-based tobacconist, made it his business to upgrade cigar smoking. Originally all Davidoff cigars came from Havana. Today the product comes from the Dominican Republic. Every cigar from Davidoff carries a label with Zino Davidoff's signature.
Company Davidoff, Switzerland.
Design Zino Davidoff, 1968–9.
* A proper name.

355
Ford's first chief engineer and designer, Childe Harold Wills, probably developed the stylized Ford script. The typeface was a standard typeface known as 'Heavy Script No 9'. In 1912 the oval was added, and since 1928 there has been virtually no change to the name mark.
Company Ford, USA.
Design Attributed to Childe Harold Wills, 1903.
Redesign 1912, 1928.
* A proper name.

356
In 1984 the famous department store added 'Knightsbridge', its salubrious London address, to its name mark.
Company Harrods, UK.
Design Minale Tattersfield and Partners, 1967.
Redesign Minale Tattersfield and Partners, 1984.
* A proper name.

357
Originally jewellers and watchmakers, Cartier today lends its name to a long line of prestigious products.
Company Cartier, France.
Design Before 1888.
* A proper name.

358
A handwritten trademark need not be an authentic signature. Paul Smith's trademark was written by a friend, Zena.
Company Paul Smith, fashion, UK.
Redesign Alan Aboud/ Aboud Sodano, 1990.
* A proper name.

354

355

356

357

358

Hearts

A heart is often used to symbolize love; however, it also refers to the heart and health in a medical context. In the first case, a heart may be classified as a symbol, a found mark. In the second case, a heart may be classified as an image, a descriptive mark.

359–60
The Danish architect and graphic designer Knud V Engelhardt was outspoken in his weakness for hearts. His own name means 'angel's heart'. Wherever possible, Engelhardt included hearts in his designs, sometimes as a heart with his initials, sometimes to replace the dot in the letter 'i'.

359
Company Tobe, gas cookers, Denmark.
Design Knud V Engelhardt, 1919.
* A found name or a proper name that includes a symbol, a found mark.

360
Engelhardt's own heart mark.
Design Knud V Engelhardt.
* A symbol, a found mark.

361
Company Copenhagen Airport Shopping Centre, Denmark.
Design Brindfors, 1986.
* Linguistically, a descriptive name. Pictorially, a symbol, a found mark.

362
By choosing a heart this Japanese tele-communications company emhasizes the human aspect of the business.
Company NTT, Japan.
Design Yasaku Kamekura, 1985.
* A symbol, a found mark.

363
Kaffee HAG coffee is decaffeinated and thus spares the heart.
Company Kaffee HAG, coffee, Germany.
Design Alfred Hunge and Eduard Scotland, 1911.
*Redesign c*1928.
* Pictorially, an image, a descriptive mark. Linguistically, an acronym for Handels-Aktien-Gesellschaft.

364
Company Heart Center Clinic for Cardiological Disorders, USA.
Design Woody Pirtle/ Pentagram, 1979.
* An image, a descriptive mark.

365
The horizontal lines in this heart design give the illusion of three dimensions.
Company The International Society for Heart Research, UK.
Design Alan Fletcher, 1995.
* A descriptive mark.

366
Probably the most copied graphic statement in the world. Hardly a trademark!
Design Milton Glaser, 1975.
* Linguistically, an acronym. Pictorially, a metaphor.

359

360

361

362

363

364

365

366

Illusions

Illusions are a means of attracting attention. They make you look again at something that you know you are not seeing – if it did not make you realize the deception, you would not recognize it as an illusion. The illusory trademarks shown here may be classified as descriptive and non-figurative marks.

367
Zanotta chose an impossible construction, the Penrose triangle, to symbolize the revolutionary character of its furniture.
Company Zanotta, Italy.
Design Marcello Minale, Michele Provinciali, 1968.
* If the mark works as intended, it is a diagram, a descriptive mark, if not, it is a symbol, a non-figurative mark.

368
Contradictory three-dimensional design.
Company Oslobanken, Norway.
Design Anisdahl/Christensen, 1984.
* A symbol, a non-figurative mark.

369
The students at a modern business school must learn that problems are not always what they appear. The idea that this H is an illusion is in itself an illusion. It is perfectly possible to show the letter in three dimensions.
Company Handelshøjskolen i København, The Copenhagen Business School, Denmark.
Design Designlab, 1989.
* Linguistically, a non-acronym initial abbreviation. Pictorially, a symbol, a found mark.

370
More than an illusion, this 'Z' in fact depicts a diecasting mould. This is more than an appropriate mark for the Zinc Development Association.
Company Zinc Development Association, UK.
Design Alan Fletcher, Fletcher Forbes Gill, 1967.

371–2
Company Renault, France.
Design (fig 371) Victor Vasarely, 1972.
Redesign (fig 372) Style Marque, 1989.
* Symbols, non-figurative marks.

367

368 369 370

371 372

Initials

As linguistic and visual abbreviations, initials provide designers with a valuable short cut which allows them to dispose with the full company name. For practical reasons, most items under this heading are single initial marks. Production of meaning takes place in two ways: by the linguistic capacity of initials and by their possible picture content. Linguistically, initials refer firstly to a name. If the name is revealed, then the production of meaning takes place as in a name mark of the type in question. If the name behind the initial is not revealed then the production of meaning takes place through an artificial name. Pictorially, the initial can include a reference which can be any type of picture mark: descriptive, metaphoric, found or non-figurative. The production of linguistic and pictorial meaning takes place simultaneously and one may support the other.

373
No roads, no trucking. For Adams trucking, a road formed out of the initial 'A' is a most appropriate trademark.
Company Adams Trucking, USA.
Design Almanac Advertising, 1981.
* Linguistically, a non-acronym initial abbreviation. Pictorially, an image, a descriptive mark.

374
The 'A' that Chwast chose for Artone is in a heavy nineteenth-century type. It succinctly communicates 'artistic' for a company of art suppliers.
Company Artone, USA.
Design Seymour Chwast/ Push Pin Studios, 1961.
* Linguistically, a non-acronym initial abbreviation that stands for a descriptive name. Pictorially, an image, a descriptive mark.

375–8
Armin Hofmann's series of single initial abbreviations for cultural institutions and other organizations in Basel is a gala performance of outstanding graphic design. Linguistically, all four marks are non-acronym initial abbreviations.

375
Company Basel Tourist Office, Switzerland.
Design Armin Hofmann, 1989.
* Pictorially, a symbol, a found mark.

376
Company Basel Bach Choir, Switzerland.
Design Armin Hofmann, 1981.
* Pictorially, a symbol, a found mark.

377
The negative pattern in this and the next mark depicts a 'Baseler Stabli', a bishop's staff, which is the motif of the coat of arms of Basel.
Company Hotel Hilton Basel, Switzerland.
Design Armin Hofmann, 1971.
* Pictorially, a symbol, a found mark.

378
Company Basel Museums, Switzerland.
Design Armin Hofmann, 1960.
* Pictorially, an image, a descriptive mark.

379
Company Canadian National Railways, Canada.
Design Alan Fleming, 1959
* A non-acronym initial abbreviation that stands for a proper and descriptive name.

380
Company Japanese National Railways, Japan.
Design Yoji Yamamoto, Nippon Design Center, 1987.
* A non-acronym initial abbreviation that stands for a proper and descriptive name.

381
The sense of order suggested by this mark reassures the airline's passengers of its organization and efficiency.
Company United Airlines, USA.
Design Saul Bass, 1976.
* A non-acronym initial abbreviation that stands for a descriptive name.

382
A rough combination of initials mark clothing for sailors and others exposed to the elements.
Company Helly Hansen.
Design Ole Søndergaard/ Eleven Design, 1988.
* A non-acronym initial abbreviation that stands for a proper name, partly a descriptive name.

373

374

375

376

377

378

379

380

381

UNITED

383
The McDonald's golden arches 'M has become a worldwide synonym for hamburger meals.
Company McDonald's, USA.
Design Jim Schindler and others, 1962.
Redesign 1968.
* A non-acronym initial abbreviation that stands for a proper name.

384
The Warner 'W' gives the appearance of being punched out.
Company Warner Communications, USA.
Design Saul Bass, 1972.
* A non-acronym initial abbreviation that stands for a proper or descriptive name.

385
Company H+H Industri, building materials, Denmark.
Design Jørgen Johansen, early 1960s.
* Partly a non-acronym initial abbreviation that stands for a proper name, partly a descriptive name.

386
Company International Harvester, agricultural machinery, USA.
Design Raymond Loewy, 1960.
* A non-acronym initial abbreviation that stands for a descriptive name.

387
Company Metropolitana Milanese, Italy.
Design Bob Noorda, 1963.
* Linguistically, a non-acronym initial abbreviation that stands for a descriptive name. Pictorially, a diagram, a descriptive mark.

388
Company Electrolux, electric household appliances, Sweden.
Design Carlo L Vivarelli, 1963.
* A non-acronym initial abbreviation that stands for a descriptive name.

389
Company Tecno, contract furniture, Italy.
Design Osvaldo Borsani, Roberto Mango, 1953.
* A non-acronym initial abbreviation that stands for a descriptive name.

390
Volkswagen has two theories about the origin of the famous trademark. One theory says that Franz Xaver Reimspiess, an employee of Dr Porsche, designed the mark. Another theory says that Martin Freyer designed the trademark for a competition organized by DAF. Neither of the theories can be verified today.
Company Volkswagen, automobiles, Germany.
Design 1938.
* A non-acronym initial abbreviation that stands for a descriptive name.

391
'O' is for olive here, pictorially as well as linguistically.
Company Katsouns Brothers, UK.
Design Carter Wong, 1987.
* Linguistically, a non-acronym initial that stands for a product. Pictorially, an image a descriptive mark.

392
Company Ocean Oil, Britain.
Design Minale Tattersfield & Partners 1965.
* Linguistically, a non-acronym initial abbreviation that stands for a proper or descriptive name. Pictorially, an image, a descriptive mark.

393
Jysk Teknologisk, the Danish technological service institute, disappeared in a merger in the early 1990s. The gear wheel motif is based on an earlier trademark consisting of two gear wheels.
Company Jysk Teknologisk, Denmark.
Design Henry Anton Knudsen and Per Mollerup, Designlab, 1985.
* Linguistically, a non-acronym initial abbreviation that stands for a descriptive name. Pictorially, an image, a descriptive mark.

383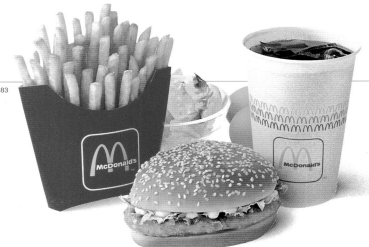

384

385

386

INDUSTRI A/S

387

388

Electrolux

389

Tecno

390

391

392

393

Kandinsky-inspired motifs

As part of his research at the Weimar Bauhaus, Wassily Kandinsky in 1923 presented a questionnaire to all Bauhäuslers – students and fellow faculty members – about the associations between the triangle, square and circle and the colours yellow, red and blue. The forms were shown and the colours mentioned in that order, and the majority of respondents painted the triangle yellow, the square red and the circle blue.

Since then, the differently-coloured basic geometric forms have been used in many trademarks, but for one reason or another, almost never in the combinations devised by the Bauhäuslers. The Kandinsky marks shown here are non-figurative marks.

394
Wassily Kandinsky's questionnaire exploring associations between shapes and colours.

395
Company IDZ Berlin, International Design Centre, Germany.
Design Pierre Mendell, Mendell & Oberer, 1986.
* A symbol, a non-figurative mark.

396
Company Haseko Group, construction company, Japan.
Design Kazumasa Nagai, 1988.
* A symbol, a non-figurative mark.

397
Company Museum of Contemporary Art, Los Angeles, USA.
Design Chermayeff & Geismar, 1984.
* Linguistically, an acronym of a descriptive name. Pictorially, a symbol, a non-figurative mark.

398
The logotype of the exhibition centre, La Villette, in Paris is, in fact, a family of logotypes. A triangle, a square and a circle make the 'V' and the background for the first and second 'e' in the name. the colours of the geometric figures change according to the mark's application: if the triangle is green, the square is red and the circle is black, then the logotype stands for the establishment, as such, including its three institutions. If the triangle is green and the square and the circle are black, then the logotype stands for the park. If the square is red and the triangle and the circle are black, then the logotype stands for la Cité des Sciences et de l'Industrie. If the triangle and the square are black and the

circle is blue, then the logotype stands for la Cité de la Musique.
Company La Villette, France.
Design Grapus, 1986.
* Linguistically, a proper name. Pictorially, a symbol, a non-figurative mark.

399
The trademark of this upmarket food hall is by design colourless, but nevertheless a genuine homage to Kandinsky.
Company Kokkenes Torvehal, Denmark.
Design Peter Bysted, 1988.
* Linguistically, a descriptive name. Pictorially, a symbol, a non-figurative mark.

400
Company UPN, United Paramount Network, USA.
* A symbol, a non-figurative mark.

394

Fachgebiet (Beruf):
Geschlecht:
Staatsangehörigkeit:

Zu Untersuchungszwecken bittet die Werkstatt für Wandmalerei des Bauhauses Weimar, folgende Aufgaben zu lösen:
1. Füllen Sie diese drei Formen mit den drei Farben Gelb, Rot und Blau aus. Die Farbe sollte die jeweilige Form ganz ausfüllen.
2. Geben Sie, wenn möglich, eine Erklärung für Ihre Farbverteilung.
Erklärung:

395

396

397

398

399

400

UNITED PARAMOUNT NETWORK

Keys

One, two or three keys have been attributed to Saint Peter. Two keys stand for absolution when the door is opened, and excommunication when the door is closed. Three keys stand for heaven, earth and hell. Hotel porters throughout the world carry two crossed keys on the lapel, the symbol of their organization, Les Clefs d'Or. The key trademarks chosen may be classified as metaphoric and found marks.

401

401
Keys represented on a hotel porter's badge.
Design 1922.

402
Company Key Coffee, Japan.
Design Hoi Ling Chu, 1989.
* Pictorially, a found mark. Linguistically, partly a found, partly a descriptive name.

403
Company Corum, watches, Switzerland.
Design René Baunwart, 1958.
* A symbol, a found mark.

404
Company KeyBank, USA.
Design Landor Associates, 1995.
* Pictorially, a metaphoric mark. Linguistically, a metaphoric/descriptive name

405
Company Estland Bank, USA.
Design Crawford Dunn, 1978.
* A metaphoric mark.

406
Company Caja Laboral Popular, bank, Spain.
Design CLP Dept, Publicity.
* A metaphoric mark.

407
The meaning is clear: we keep your valuables safe.
Company Swiss Bank Corporation, Switzerland.
Design Warja Honegger-Lavater, 1937.
* A metaphoric mark.

408
Company Ålandsbanken, bank, Finland.
Design Tapio Vallioja
* A metaphoric mark.

402

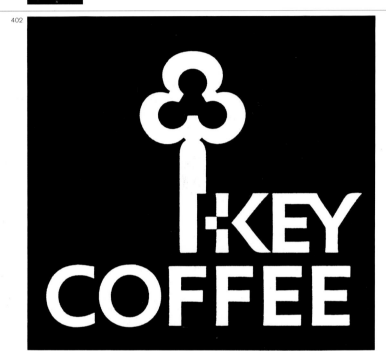

403

404

405

406

407

408

Lightning

Power and speed are the obvious meanings of a lightning bolt. A car, a telecommunications company and a power plant all subscribe to this meaning. The lightning trademarks shown here may be classified as descriptive and metaphoric marks.

409
A metaphor suggesting a fast vehicle.
Company Adam Opel, Germany.
Design c1930.
Redesign 1987
· A metaphoric mark.

410
Company Quebec Hydro-Electric, power plant, Canada.
Design Gagnon, Valkus, 1960.
· A metaphoric mark.

411
Company The New Brunswick Telephone Co, USA.
Design Ernst Roch, 1966.
· A metaphoric mark.

412
Company Bernische Kraftwerke, power supply, Switzerland.
Design Erich Hänzi, 1970.
· A metaphoric mark.

413
Company Televerket, telecommunications, Norway.
Design Carl Tørris Christensen, 1979.
· Linguistically, a descriptive name. Pictorially, a metaphoric mark.

414
Company Salev, truck manufacturers, France.
Design Bucher Cromières, 1969.
· A metaphoric mark.

415
A trademark for a company that designs electronic systems for home security.
Company Itanaco, USA.
Design Rattan Design, 1992.
· Descriptive mark.

409

410

411

412

413

414

415

Lions

Regarded as king of the beasts, the lion is often used as a trademark motif. The lion trademarks shown here may be classified as metaphoric marks and found marks.

416–7
Among the companies that use lions as symbols, the German brewery Löwenbräu must be one of the oldest. Löwenbräu has been around for more than 600 years. The first documented reference to an inn known as 'Zum Löwen' dates from 1383. The present Löwenbräu brewery has grown substantially since the early days of the inn-keeper's home brew.
Company Löwenbräu, Germany.
* An image, a descriptive mark and a metaphoric mark.

418
Peugeot's lion dates back to 1858 when Industries Peugeot registered the trademark to mark its saw blades and hand tools. The lion was chosen to symbolize strength, flexibility and speed. When Peugeot started manufacturing cars in 1910, it adopted the lion. Since then the beast has been redesigned many times.
Company Peugeot, France.
Design 1858.
Redesign Signe & Fonction, 1979.
* A metaphoric mark.

419
The painter Asta Rink originally designed this Assyrian lion for Københavns Løveapotek, the Copenhagen pharmacy owned by her brother A Kongsted. When Mr. Kongsted established a pharmaceutical factory in 1908, the lion followed. The pharmacy no longer exists.
Company Løvens Kemiske Fabrik, Denmark.
Design Asta Rink, 1905–7.
* A symbol, a found mark.

420
The lion that symbolizes the film company MGM evolved from an idea by song-writer Howard Dietz.
Company MGM, USA.
Design Howard Dietz, 1927.
* A symbol, a found mark.

421
Company Hutschenreuther, porcelain, Germany.
Design 1917.
Redesign 1970.
* A symbol, a found mark.

416–7

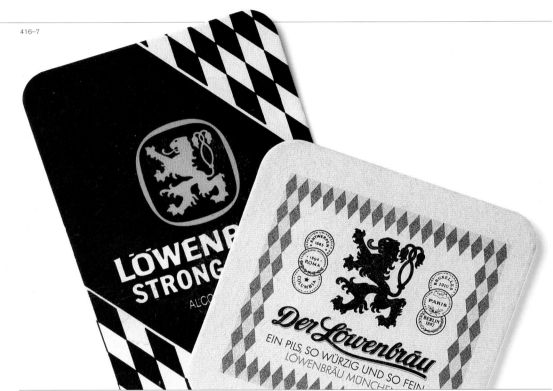

418

419

420

421

Maritime

Maritime motifs can range from anchors and life buoys, representing safety, to a ship depicted on the high seas more often associated with travel and adventure. The maritime trademarks shown here may be classified as descriptive, metaphoric and found marks.

422
The simplified life buoy is almost a natural sign for the insurance company Trygg-Hansa. The firm has placed life buoys at lakes and beaches throughout Sweden, a sympathetic way of making a trademark known.
Company Trygg-Hansa, Sweden.
Design Svenska Telegrambyrån, 1954.
Redesign Y&R, 1971.
* A metaphoric mark.

423
A light blue sea, a square yellow sun, and a dark blue trident represent holidays.
Company Club Méditerranée, France.
Design Style Marque, 1986.
* Pictorially, a metaphoric mark. Linguistically, a non-initial abbreviation that stands for a descriptive name.

424
Company Abra Export, clothing export, USA.
Design Paul M Levy, 1965.
* A symbol, a found mark.

425
Frames of a ship's hull make a relevant mark for a shipyard.
Company B&W, Denmark.
Design Flemming Ljørring, 1971.
* An image, a descriptive mark.

426
Company Hydro, petrochemicals and energy, Norway.
Design Anisdahl/ Christensen, 1971.
* Pictorially, a symbol, a found mark. Linguistically, a found name.

427
Company CS First Boston, bank, USA.
Design 1930s
Redesign Salit and Moriber, 1993.
* A symbol, a found mark.

428
Company Banque Scandinave, Switzerland.
* A metaphoric mark.

429
This mark was used from 1969 to 1993 by three shipping groups.
Company Scan Service, Scan Dutch, EAC Ben, Denmark and other countries.
Design Niels Hartmann, 1969.
* An image, a descriptive mark.

430
Company Det Norske Veritas, classification and certification of ships, Norway.
Design Leif Anisdahl, 1991–2.
* Pictorially, a metaphoric mark. Linguistically, a non-acronym initial abbreviation.

431
Gustavsberg, the porcelain factory, first used an anchor in its trademark in 1839. Nobody knows why. Perhaps it was because of the import of material and expertise from Britain, where an anchor was a common motif on ceramics. Or perhaps it was because of Gustavsberg's situation on an island in the archipelago of Stockholm.
Company Gustavsberg, porcelain, Sweden.
Design Karl-Erik Forsberg, 1978.
* A symbol, a found mark.

432
Company Atlantica, insurance, Sweden.
* Pictorially, a symbol, a found mark. Linguistically, a found name.

433
Company Nedlloyd, shipping line, Netherlands.
Design AM+D, 1970.
* A metaphoric mark.

422

423
Club Med'

424

425

426
HYDRO

427

428

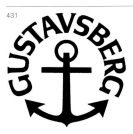
429

430
DNV

431

432
ATLANTICA

433
Nedlloyd

Möbius strips

A Möbius strip is a shape that has only one
side and one edge, but looks at first glance, as
if it has two of each. The confusing construction
is named after the German mathematician and
astronomer who discovered it, A F Möbius.
The Möbius trademarks shown here include
non-figurative marks and descriptive marks.

434–5
These two certification
marks depict balls of wool.
* Two images, two descriptive marks.

434
Woolmark.
Company The International
Wool Secretariat.
Design Francesco Seraglio,
1964.

435
Woolblendmark.
Company The International
Wool Secretariat.
Design In-house, 1971.

436–7
Company FDB, co-op,
Denmark.
Design Gunnar Biilmann
Petersen, 1948.
Redesign 1994.
* Two symbols, two non-figurative marks.

434

435

436

437

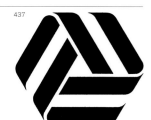

Music

Musical marks stand for music and almost anything else. The musical trademarks shown here may be classified as descriptive marks and found marks.

438
The Guinness harp is the O'Neill (or Brian Boru) harp. The original 1862 version featured twenty-seven strings. For graphic reasons the number of strings was reduced to eighteen and then ten strings in the 1950s and 1960s. In 1922, when Ireland was declared an independent nation, the O'Neill harp was chosen as its official symbol. For copyright reasons, Ireland had to reverse the harp. The Guinness signature was introduced alongside the harp in 1862.
Company Guinness, Ireland.
Design 1862.
Redesign 1950s, 1960s.
* A symbol, a found mark.

439–40
The Guinness breweries started brewing Harp lager in 1960 and for obvious reasons used the well-known Guinness harp both as a picture mark and as inspiration for a name mark.
Company Harp, Ireland.
Design 1862, mid-1960s.
* Pictorially, a symbol, a found mark. Linguistically, a found name.

441
Event Stravinsky Festival, UK.
Design Alan Fletcher and Paul Anthony/Pentagram, 1979.
* Linguistically, a non-acronym initial abbreviation referring to a proper name. Pictorially, a symbol, a non-figurative mark.

442
A trademark designed by Wolfgang Amadeus Mozart! This motif was chosen from a piece of musical notation by the famous composer for the Endymion Ensemble, a group of fifteen musicians who perform internationally.
Company Endymion Ensemble.
Design John Rushworth/ Pentagram, 1991.
* A symbol, a non-figurative mark..

443
Lurmærket, the mark of the lure horn, has been the quality mark of Danish butter since 1899. The mark was suggested by Danish farmer Rasmus Rasmussen of Højrupgård.
Company Lurmærket, dairy products, Denmark.
Design Harald Faber, 1899.
* A symbol, a found mark.

444
Years ago, the postman would announce his arrival with a blast on his horn. Today, the mark functions as a symbol.
Company Posten, the post office, Sweden.
Design Martin Gavler and Tommy Säflund, 1984.
* A symbol, a found mark.

445
Pan was the god of goat shepherds in Greek mythology. He fell in love with the nymph Syrinx who – in order to escape – changed into a rush with which Pan made his pipe, or syrinx. Here the Pan flute stands for PAN, which in turn stands for P A Norstedt, the publisher.
Company PAN, publishers, Sweden.
Design Leif Zetterling 1965.
* A symbol, a found mark that refers to an acronym that stands for a proper name.

438

439

440

441

442

443

444

445

Mythology

Mythology – Greek, Roman and that of other cultures – provides a rich repertoire of signs ready to be adapted and revitalized for commercial and other uses. The mythological marks shown here may be classified as found marks.

446
Nike was the goddess of victory in Greek mythology. She had wings, an appropriate symbol for runners' shoes.
Company Nike, USA.
Design Carolyn Davidson, 1971.
* A symbol, a found mark.

447
A griffin is a fabulous creature with the body of a lion and the head and wings of an eagle. The griffin head in Saab-Scania's trademark refers to the part of Sweden called Scania where Scania trucks are manufactured, and which has the griffin in its coat of arms.
Company Saab-Scania, Sweden.
Design Carl Fredrik Reuterswärd, 1984.
* A symbol, a found mark.

448
Pegasus, the winged horse, grew from the blood of Medusa when Perseus decapitated her. As a symbol, it represents artistic inspiration, speed, strength and immortality. The Mobil Oil Corporation has used Pegasus as a symbol for many years. In 1911, a white Pegasus was used by the Vacuum Oil Company in South Africa. In 1925, the Standard Oil Company of New York used a Pegasus mark in Japan, and in 1933, when Vacuum and Socony were merged, the new company adopted the Pegasus as its trademark. Since 1966, Mobil Oil has used the Mobil logotype (see p 102) as its primary trademark and the Pegasus as its secondary trademark.
Company Mobil Oil, USA.
Redesign (bottom) Chermayeff & Geismar, 1965.
* A symbol, a found mark.

449
Mercury is to Roman mythology what Hermes is to Greek mythology. He is remembered as the speedy messenger of the gods. and was himself the god of roads and boundaries as well as commerce, trickery and theft. No wonder that Mercury has become trademark motif for many kinds of businesses. Interflora, the florists' delivery service, has used Mercury as their mark since 1917. The mark has been redesigned a number of times, most recently in 1989. The illustration shows the mark with the Danish version of the company motto, 'Say it with flowers'.
Company Interflora, USA.
Design Ernest Beach Smit, 1917.
* A symbol, a found mark.

450
Company Deutsche Messe, commercial fair company, Germany.
Design Ernst Rademacher, 1947.
* A symbol, a found mark.

451
Company Hermes, credit insurance, Germany.
Design 1917.
Redesign 1982.
* A symbol, a found mark.

452–3
The founder of Goodyear, Frank A Seiberling, chose the Wingfoot symbol as the company's trademark. The source of inspiration was a statue of Mercury in the Seiberling family home.
Company Goodyear, USA.
Design Frank A Seiberling, 1900.
* A symbol, a found mark.

446
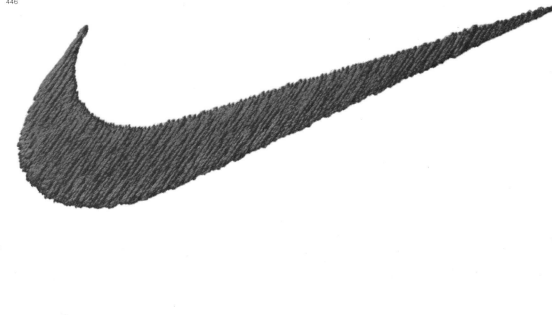

447
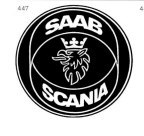

448

449

450

451
452

Name descriptions

A proper name used as a company name reflects responsibility and pride. If the proper name describes an object, the object can sometimes serve as a motif for a trademark and identify the company. The name description trademarks shown here may be classified as symbols or found marks.

454–5
The modern Bell symbol was designed to unify the twenty-three regional companies that comprised the Bell System at that time. Today, the mark is jointly owned by a number of companies. The bell in the picture refers to Alexander Graham Bell, the inventor of the telephone, not to the bell that was once a part of his invention.
Company The Bell System, telephone communication, USA.
Redesign (fig 454) Saul Bass, 1969.
˙ A symbol, a found mark.

456
A M Hirschsprung & Sønner is one of Denmark's finest cigar factories. Not surprisingly, they chose a graphic representation of the founder's name as their trademark.
Company A M Hirschsprung & Sønner, Denmark.
Design 1883.
Redesign 1949.
˙ A symbol, a found mark.

457
John Deere's name calls for a picture mark. The yellow jumping deer on a green background is seen in the countryside around the world.
Company John Deere, agricultural machinery, USA.
Design 1876.
Redesign John Dreyfuss, 1968.
˙ Pictorially, a symbol, a found mark. Linguistically, a proper name.

458
The mark for this publisher is a pun on the company name, Fischer.
Company Fischer Bücherei, Germany.
Design c1952.
˙ A symbol, a found mark.

459
Henri Nestlé, founder of the company and a pioneer in the field of infant nutrition, showed considerable foresight when he chose a nest with a mother bird feeding three small birds. The most dramatic alteration of the mark from 1875 took place in 1985 when the number of baby birds was reduced from three to two.
Company Nestlé, foods and chocolate, Switzerland.
Design 1875.
Redesign 1985.
˙ Pictorially, a symbol, a found mark. Linguistically, a proper name.

460
'Falck' is Danish for 'falcon'.
Company Falck, salvage company, Denmark.
Design 1931.
Redesign Peter Bysted, 1993.
˙ A symbol, a found mark.

461
Kay Bojesen was a silversmith and a designer of toys, cutlery, pots and pans. In Danish, 'Boje' means buoy. This decorated keystone, incorporating a buoy, effectively signposts Bojesen's workshop in Nybrogade, Copenhagen.
Company Kay Bojesen, Denmark.
Design Kay Bojesen (1886–1958)
˙ A symbol, a found mark.

454
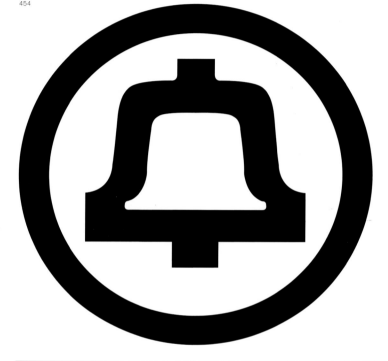

455

456
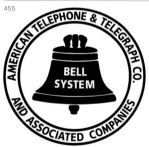

457

458

459

460

Numbers

Numbers – like letters Q, X and Z – have a special attention value both in organizational marks and in branding. Some confusion may occur when a company name begins with a digit – for instance, when the customer looks for it in the phone book: will the number appear in the front of the alphabetical listing, will it be spelled, or will it appear at the end? Numbers as trademarks may be written abbreviations, abbreviations of abbreviations, such as 3M and 4K, or phonetic abbreviations, such as Q8. They may refer to practical circumstances, such as the opening hours of a chain store or the official number of a television channel. Sometimes trademarks such as 4711 refer to a fact that is not known or has been forgotten by its customers. The number trademarks shown here may be classified as abbreviations, found names and descriptive names.

462
Company Phase One, electronic camera backs, Denmark.
Design Per Mollerup Designlab, 1993.
* A found name.

463
2tal is a pun. In Danish it means both 'figure of two' and 'total'. 2tal is the result of a merger between two chains of radio/TV retailers.
Company 2tal Radio/TV, Denmark.
Design Per Mollerup Designlab, 1991.
* A found name.

464
3M represents a fundamental type of initial abbreviation.
Company 3M, Minnesota Mining & Manufacturing, USA.
Design 1906.
Redesign Siegel & Gale, 1978.
* Initial abbreviation.

465 & 467
The number names of TV stations TV4 and Channel 4 clearly have a practical aspect. They relate to the number names of the respective television stations and therefore help to orientate the viewer in distinguishing between different channels.
* Non-initial abbreviations.

465
Company TV4, television station, Sweden.
Design Sydow, Nyberg & Belvert, 1990.

466
4K stands for Københavns Kul og Koks Kompagni (The Copenhagen Coal and Coke Company).
Company 4K, Denmark.
Design Kjeld Asrild.
* Non-initial abbreviations of non-acronym initial abbreviations of descriptive name.

467
Company Channel 4, television station, UK.
Design Martin Lambie-Nairn/Robinson Lambie-Nairn, 1982.

462

463

464

465

466

467

468
One of the most elegant
name numbers ever. It
competes with Chanel
No 19 and other line
extensions with more
or less the same design.
Company Chanel No 5,
perfume, France.
Design Coco Chanel, *c*1925.
* A found or proper name.

469
7-Eleven stands for the
original opening hours of
the shops in this chain.
Company 7-Eleven,
convenience stores, USA.
Design Allan Dodd,
1945 or 1946.
Redesign Fran Gianninoto
and Associates, 1968.
* A descriptive name (that in some
places should be '24-twenty-four').

470
Company 7-UP,
soft drinks, USA.
* A symbol, a found mark.

471
Q8 is a phonetic
abbreviation of Kuwait (Oil).
Company Q8, UK.
Design Wolff Olins, 1986.
* A (phonetic) non-initial abbreviation
of a proper and descriptive name.

472
4711 is the house number
given by decree of the
French commandant in
Cologne, General Daurier,
to the house where
'water from Cologne'
was produced. In 1881,
the name 'Eau de Cologne
& Parfümerie Fabrik
Glockengasse 4711
gegenüber der Pferdepost
von Ferdinand Mühlens'
was registered.
Company 4711, Germany.
Design 1881.
* Originally a descriptive name. Today
a found name.

468

469

470

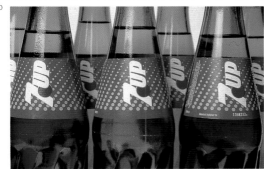

471

472

Products

The trademarks featuring products shown here are all organizational marks. Product-related trademarks do not tend to depict products but suggest them in other ways. If a trademark does show the product (or service) of its owner, it is an image, a descriptive mark.

473–4
No lamp (or other) design is timeless, but Poul Henningsen's PH lamps come close. Danish lamp manufacturer Louis Poulsen has turned Poul Henningsen's basic lamp design into a monogram with the company's initials, LP. This design was the result of a competition for a new trademark.
Company Louis Poulsen & Co, Denmark.
Design Johan Pedersen, 1942.
* An image, a descriptive mark.

475
If you sell electricity, it is easier to show the delivery structure than to show the product itself.
Company The National Grid, UK.
Design John McConnell and Justus Oehler/Pentagram, 1990.
* An image, a descriptive mark.

476
The trademark of United Parcel Service shows a specially desirable kind of parcel: a gift.
Company United Parcel Service, USA.
Design Paul Rand, 1961.
* An image, a descriptive mark.

477
A precise trademark for a company selling textiles for interior furnishings.
Company Jack Lenor Larsen, USA.
Design Arnold Saks & James S Ward, 1962.
* An image, a descriptive mark.

478
A descriptive trademark for a process engraver.
Company Schwitter, Switzerland.
Design Karl Gerstner, c1957.
* An image, a descriptive mark.

479
Originally, the Bavarian Motor Works manufactured motors for aircraft. Aviation inspired the propeller trademark.
Company BMW, Bavarian Motor Works, Germany.
Design Franz Josef Popp, 1917.
* A symbol, a found mark.

480
Overleaf (left)
This template for the Carl Zeiss trademark (fig 483) provides printers and others with exact proportional information and dimensions.

481
Overleaf (right)
The Watneys red barrel house mark was the result of a competition held in 1930 in the London evening papers. Some 26,000 entries were received, but the £500 prize was won by Mr E W Rankin of Alperton, Middlesex. As a pub sign it makes the most immediate of statements: beer can be bought here.
Company Watneys, UK.
Design E W Rankin, 1930.

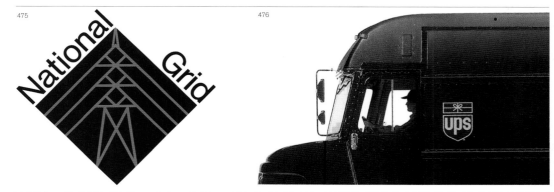

Bezeichnung eines Warenzeichens a = 100 mm :
Wazei 100 mm

Maßeinheit 0,1 mm, mm oder cm

a	b	c	d	e	r₁	r₂	r₃	h₁	h₂	h₃	Strichstärke s
10	5,2	8,6	3	1,7	10,5	42	18,5	1,2	0,3	0,5	0,2
12,5	6,5	10,8	3,8	2,1	13,5	53	23	1,5	0,4	0,6	0,25
16	8,3	13,8	4,8	2,7	17	68	29	1,9	0,5	0,8	0,32
20	10,4	17,2	6	3,4	21	85	37	2,4	0,6	1	0,4

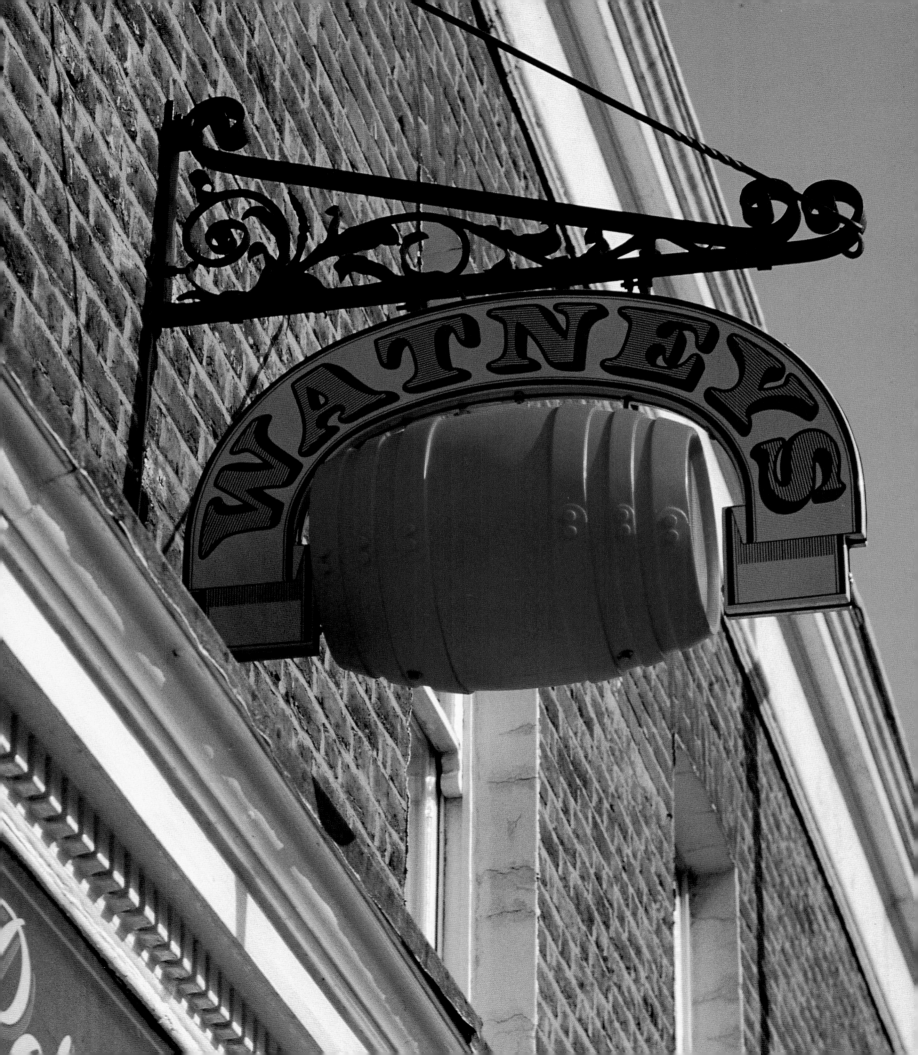

482

The original Watneys red
barrel house mark of 1930
was transformed into a
classic trademark by this
redesign.
Company Watneys, UK.
Design John McConnell/
Pentagram, 1980.
˙ Linguistically a proper name.
Pictorially, a descriptive mark.

483

Precise graphics for
precision optics.
Company Carl Zeiss,
optical instruments, Germany.
Design 1923.
˙ An image, a descriptive mark.

484

This witty bus poster for
Pirelli tyres plays on the
familiarity of a well-
established trademark.
Company Pirelli Ltd, UK.
Design Fletcher Forbes
Gill, 1962.

485

The Pirelli logotype does
not show the product per
se, but the product's most
important quality, elasticity.
Company Pirelli, Italy.
Design 1908.
˙ An image, a descriptive mark.

482

483

484

485

Road signs

To use a road sign or a paraphrase of a road sign as a trademark creates a visual double take which makes you look a second time and probably remember it better. The road signs-cum-trademarks shown here may be classified as descriptive marks.

486
Company Bull Signs, UK.
Design (adaptation from the Highway Code):
Quentin Newark, 1989.
* An image, a descriptive mark.

487
Company Crossroads Films, USA.
Design Woody Pirtle and Jennifer Long/ Pentagram, 1989.
* An image, a descriptive mark.

488
The trademark shows that SEGD members are occupied with direction signage.
Company Society of Environmental Graphic Designers, SEGD, USA.
Design Doug Akagi, 1980.
* An image, a descriptive mark.

489
Company Street Shoes, shoe shop, UK.
Design Colin Forbes, Dan Friedman/ Pentagram, 1979.
* An image, a descriptive mark including a descriptive name.

486

487 488 489

Science

Scientific symbols have been adapted in the trademarks below. Also included under this heading are the para-scientific symbols of alchemy and astronomy. The alchemic symbols of the metals mercury, iron, copper, pewter/zinc and lead are the same as the astronomical symbols of the planets Mercury, Mars, Venus, Jupiter and Saturn. As Mars and Venus were the prominent gods of masculine and feminine qualities in Roman mythology (Ares and

Aphrodite in Greek mythology) the symbols of Mars and Venus also represent man and woman. Signs of science are symbols, non-figurative marks and found names.

490
Today, Volvo almost exclusively uses an Egyptienne logotype designed in 1959 by K E Forsberg:

VOLVO

However, an old iron symbol is still used together with a diagonal on the front of Volvo's transportation products.
Company Volvo, automobiles and trucks, Sweden.
Design K E Forsberg, 1959.
* Linguistically, a descriptive name.
Pictorially, a symbol, a non-figurative mark.

491
The full name of this company, which is more than 700 years old, is 'Stora Kopparbergs Bergslags Aktiebolag', which translates into 'The Great Copper Mountain Owner Group Limited'. What used to be a company excavating copper is today a conglomerate with highly diversified interests. From the end of the 1800s until 1985, the sign of copper played a significant role in the corporate design programme. In 1985, the size of the copper sign was diminished in order to de-emphasize other meanings, such as Venus and the feminist movement.
Company Stora, Sweden.
Design Jan Olof Lygner, 1985.
* Linguistically, a non-initial abbreviation.
Pictorially, a symbol, a non-figurative mark.

492
In some countries, the ironmongers' and iron merchants' mark has been in use since 1926. Today it is in use in Australia, Austria, Belgium, Canada, Denmark, Finland, France, Germany, Iceland, Ireland, Italy, Liechtenstein, Luxembourg, the Netherlands, Norway, Spain, Sweden, Switzerland, the UK and the USA.
Company Ironmongers generally.
* A symbol, a non-figurative mark.

493
Company Robeco Group, financial group, Netherlands.
Design Casperi de Geus, 1980.
Redesign Casperi de Geus, 1990.
* Linguistically, a non-initial abbreviation for Rotterdam Beleggings Consortium.
Pictorially, a symbol, a non-figurative mark.

494
The sci-square-root-m mark is a visual paraphrase of a mathematical formula. Although it consists mainly of letters, it works as much as a pictorial mark as a letter mark.
Company Science Museum, UK.
Design Peter Leonard, 1988.
* Linguistically, a non-initial abbreviation.
Pictorially, a symbol, a non-figurative mark.

490

491

492

493

494

495

In choosing a name,
Cubic Metre took advantage
of the fact that metric
measurements had just
been introduced in Britain.
Company Cubic Metre,
furniture, UK.
Design Minale Tattersfield
& Partners, 1966.
˙ A found name.

496

This leisure clothing
company has taken a
chemical abbreviation for its
name, which is both verbally
and visually memorable.
Company H_2O, Denmark.
Design Kaj Lynnerup 1983.
˙ A found name.

497

Company Ecko-Alcoa
Containers, USA.
Design Don Marvine,
Latham Tyler Jensen, 1957.
˙ A symbol, a non-figurative mark.

498

The sign of infinity used for
the Swedish co-op suggests
no easy explanation.
Company Konsum, Sweden.
Design
Bjarne Petterson, 1968.
˙ A symbol, a non-figurative mark.

499

International classification
mark for Perma Paper.
Design ANSI, 1984.
˙ A symbol, a non-figurative mark.

495

496

497

498

499

ISO 9706

Serpents

The serpent is an ancient sign of healing. Aesculapius, god of medicine, had a serpent as his emblem. Most of these trademarks could equally well have been grouped under 'mythology'. The serpent trademarks shown here may be classified as found marks.

500–3
These serpents symbolize medicine, and also present the initials of the company name.

500
Company Apoteksbolaget, pharmacies, Sweden.
Design Apoteksbolaget, 1972.
* Pictorially, a symbol, a found mark and an image, a descriptive mark. Linguistically, a non-acronym initial abbreviation.

501
Company Superior Scientific, pharmaceuticals, USA.
Design Hoi L Chu, 1983.
* Pictorially, a symbol, a found mark. Linguistically, a non-acronym initial abbreviation.

502
Company Clay Adams, pharmaceuticals, USA.
Design Chermayeff & Geismar, 1970.
* Pictorially, a symbol, a found mark. Linguistically, a non-acronym initial abbreviation.

503
Company Chicago Pharmaceutical, USA.
Design John Massey, 1965.
* Pictorially, a symbol, a found mark. Linguistically, a non-acronym initial abbreviation.

501

502 503

Stars

A star stands for hope, happiness and immortality. In contrast to reality, graphic stars are pointed. If the star is five-pointed and used on a flag, it stands for freedom, as it first did when the colonies in North America declared independence and designed a flag with thirteen five-pointed stars and thirteen stripes. Stars were later used by communist nations, Central and South American countries, the European Council and the European Union. Enterprises that use a star as their trademark invent their own interpretation.

504
The star represents Citicorp, which is part of a financial conglomerate.
Company Citicorp, USA.
Design Anspach, Grossman and Portugal, 1976.
* A symbol, a found mark.

505
Company Texaco, gasoline, USA.
Design Anspach, Grossman and Portugal, 1981.
* Pictorially, a symbol, a found mark. Linguistically, a non-acronym initial abbreviation.

506
Star Semen sells semen from star bulls.
Company Star Semen, bull farm, USA.
Design Steven Sessions.
* A symbol, a found mark.

507
Company Montblanc, writing implements, Germany.
Design 1913.
Redesign Herbert Lindinger, 1965.
* Linguistically, a metaphoric name. Pictorially, a metaphoric mark.

508
This seven-pointed star was originally devised by the company's founder, Captain P M Møller, for use on the funnel of his first ship, SS Laura, in 1886. Captain Møller reportedly chose the star for religious reasons. Today, company folklore tells us that it was chosen because of the number of working days in a week. The current version of the star is carefully shown in the appropriate colours, with a white figure on bright blue ground.
Company A P Møller, shipping line and industrial group, Denmark.
Design Acton Bjørn, 1971.
* A symbol, a found mark.

509
This star for the Commercial Bank of Kuwait is constructed out of two words in Kufic, an Arabic script, which means 'commercial' and 'bank'. Though Arab speakers can read the mark, the star is also a distinctive symbol for its Western customers.
Company Commercial Bank of Kuwait.
Design Alan Fletcher/ Pentagram, 1980.
* Linguistically (to Arabs) a descriptive name. Pictorially (to Westerners) a symbol, a found mark.

510–13
Company Converse, sports footwear, USA.
Design 1992.
* A symbol, a found mark.

514
A Mercedes star represents *Spitzenklasse,* top class. This criteria embraces heavy-duty vehicles, such as Unimogs and trucks, as well as very expensive private cars, such as those in the 'S' series.
Company Mercedes-Benz, Germany.
Design Gottlieb Daimler, 1911.
* A symbol, a found mark.

504

505

506

507

508

509

510 511 512 513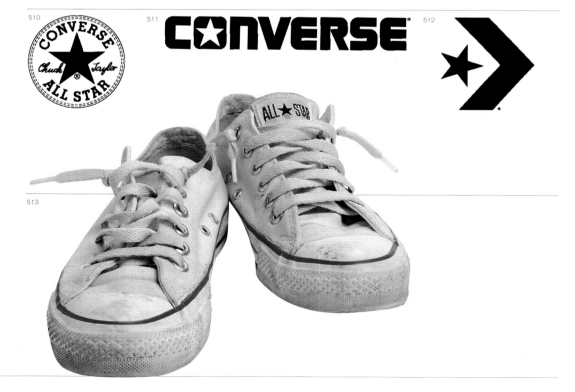

Waves

There are many kinds of waves. The wave trademarks shown here stand for seas, for liquids or for radio waves. These trademarks may be classified as images, descriptive marks and symbols, found marks.

515
The three waves refer to the three Danish straits: Øresund, Storebælt and Lillebælt.
Company Royal Copenhagen Porcelain, Manufactory, Denmark.
Design 1775
˙ A symbol, a found mark.

516
Company Philips, radios, TVs and electric household appliances, Netherlands.
Design 1938.
˙ An image, a descriptive mark.

517
When ICI was created out of the merger of four other companies in 1925, it took over the 1923 trademark of Nobel Industries where the waves were shock waves from an explosion. Today, the same waves can represent liquids.
Company ICI, chemicals, UK.
Design 1925.
Redesign Wolff Olins, 1987.
˙ An image, a descriptive mark.

518
This trademark is for a public swimming baths. The 'G' is for 'Geroldswil', the name of the Swiss town, and the waves represent those of the pool.
Company Hallenbad Geroldswil, Switzerland.
Design Rosmarie Tissi, 1976.
˙ Linguistically, a non-acronym initial abbreviation. Pictorially, an image, a descriptive mark.

515

517

516

517

518

X, and other conspicuous letters

Letters Q, X and Z have a special attention value. So have Æ, Ø and Å in the Danish and Norwegian alphabet and Ä, Ö and Å in the Swedish alphabet. This is perhaps because of their shape, or because of their relatively low frequency. (Q is little used in the Nordic languages, it is far more common in English). The trademarks shown here may be classified as descriptive names, artificial names, abbreviations and proper names.

519
Company Zürich, insurance, Sweden.
Design Rolf Weiersmüller/ B+P Design.
* A proper name.

520
Company Quality Food, UK.
Design John Powner, 1991.
* Linguistically, a non-acronym initial abbreviation. Pictorially, an image, a descriptive mark.

521
Company Exxon, oil, USA.
Design Raymond Loewy, 1971.
* An artificial name.

522
Company USX, oil, USA.
Design Siegel & Gale, 1986.
* Partly a non-acronym initial abbreviation, partly a found name.

523
Company Röhsska, Museum of Applied Art, Sweden.
Design H C Ericson, 1991.
* A proper and descriptive name.

524
Rødby is Danish for 'red town'.
Community Rødby, town, Denmark.
Design Per Mollerup/ Designlab, 1992.
* A proper and descriptive name.

525
Overleaf
X Bus runs a long distance network of extra fast and luxurious coaches across Jutland, the part of Denmark joined geographically to the Continent.
Company XBus, Denmark.
Design Per Mollerup/ Designlab, 1995.
* Partly a found, partly a descriptive name.

519

520

521

522

523

R**Ö**hss
R**Ö**hsska
R**Ö**hsska *Museet*
G**Ö**teborg

524

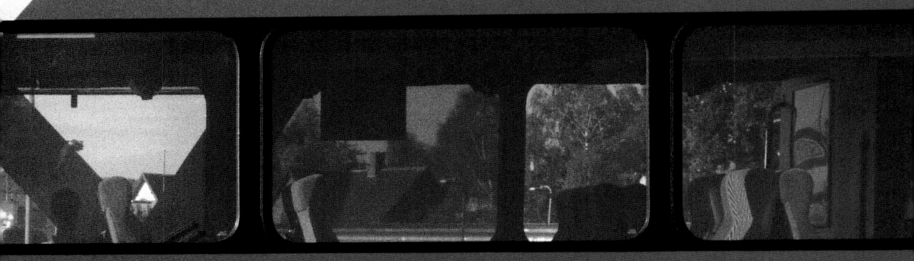

Development

Graphic design for corporate identity, like design of any kind, is both an ongoing process and the result of this process. Every design programme needs to be adjusted to meet changing conditions. This chapter describes some of the developments that occur within design programmes and the changes that have been made to various trademarks over time.

Evolution

While society tends to become more complicated, trademarks seem to have become simpler. Whether this is because of changes in taste, or the increasing pace of life, which makes fast identification essential, it seems that design and corporate professionals increasingly recognize that simplicity is a virtue, and that sometimes less is more.

The early Danish functionalist designer, Knud V Engelhardt, noticed that if designed objects have edges that are too sharp, these will be rounded off as time goes by. Speaking figuratively, the same can be said about trademarks. If trademarks begin with elements that hinder communication without adding anything useful, these elements will be smoothed off in time.

528

529

530 **BENNETT**

526–7
Previous pages
At very different petrol stations, and even though the trademark has been refined over time, the message remains the same: Texaco.

528
Rolls Royce was founded in 1904 by Henry Royce and CS Rolls. The double red 'R' monogram was designed in 1905. In 1930, the lettering changed from red to black. This was three years before Sir Henry Royce died, and so the change was not introduced as a mark of respect following his death as was once widely believed.

The mark used today is slightly broader than that of the original.
Company Rolls Royce, UK.
Design 1905.
Redesign 1939, 1967.

529
A handle on a Copenhagen tram. Knud V Engelhardt literally rounded off his designs in three dimensions, as well as those in his graphic work (see figs 359–60, p 160).
Design Knud V Engelhardt, 1910.

530
All letter forms are smooth in this trademark.
Company Bennett, travel agents, Denmark.
Design Knud V Engelhardt, 1917.

531–32
Everything goes faster and
faster, but not necessarily
the development of
trademarks. When they are
simplified to the bone,
they last.

Company 3M, USA.
Design 1906
Redesign Piet Mondrian,
1961 (fig 531, fourth right,
bottom line).
Redesign Siegel & Gale,
1978 (fig 532).

533

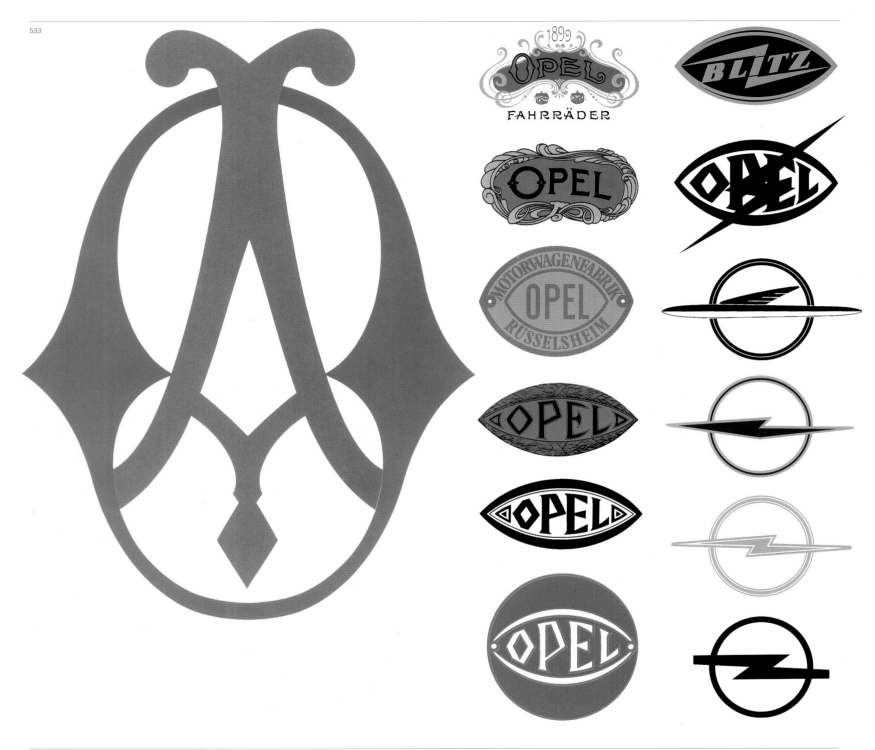

533
A good trademark does not last for ever: it must be adjusted when circumstances dictate. The history of the Opel trademark illustrates the point. Adam Opel founded his company in 1862, producing sewing machines. The first A and O monogramme was in the fashion of the day. With the

manufacture of bicycles at the turn of the century, an Art Nouveau trademark stressed the family name. In 1902 the first Opel car was manufactured and furnished with a clearly visible 'eye' sign, updated in 1910. The lettering later became more aggressive and, with the production of motorbikes, the 'eye' was encircled in the mid-twenties. The

lightning flash symbol soon became the most important part of the trademark, used in various styles. The 1985 version is an extreme simplification. History tells us that extremely simplified marks often last longer.

534
Since 1900, the Shell trademark has become more and more stylized and simplified. Today, the symbol would hardly be recognized as a shell if the company did not carry the name.
Company Shell, UK.
Design 1900.
Redesign Raymond Loewy, 1971.

535
The trademark for the Bing Grøndahl Porcelain factory has evolved from an early descriptive simplicity to a sophisticated simplicity via a surfeit of detailing.

534

535

B&G

Danish China Works
COPENHAGEN
B. & G.

B&G
COPENHAGEN
DANISH CHINA WORKS
B & G

B&G
KJØBENHAVN
DANISH CHINA WORKS
B & G

B&G
KJØBENHAVN
MADE IN DENMARK
B & G

B&G
KJØBENHAVN
COPENHAGEN
B&G

536

537

538
Agfa
PHOTO-ARTIKEL

„Agfa"

„Agfa"

"AGFA"
PHOTO-ARTIKEL

„Agfa"

539

A E G

AEG

AEG

536
The Westinghouse mark has had a steady development over time. The 'W', the bar and the circle have been redefined a number of times. Most changes were simplifications. No previous mark has enjoyed the longevity of Paul Rand's design (bottom).
Company Westinghouse, USA.
Design 1900–53.
Redesign Paul Rand, 1960.

537
Less is much more.
Company Bayer, Germany.
Design Hans Schneider, 1900.

538
The development of the Agfa trademark belies eighty years of increasing simplification.
Company Agfa, Germany
Design 1903–28.

539
The original trademark for the Allgemeine Elektricitats Gesellschaft (General Electricity Company) was designed as a sign for the employees' entrance to the offices. It was still in use in 1907 when the first Peter Behrens design (second from top) was produced.

Company AEG, Germany
Design Franz Schwetchten, 1886.
Redesign Otto Eckmann, 1900 and Peter Behrens, 1907–8.

Family

The double function of a trademark is to signify differentiation and relationship, a mixture of distinction and description. Sometimes an additional function of trademarks is to connect the individual parts of an organization or to relate products to each other.

In heraldry, father/son relationships can be shown in a number of ways. One is with the use of cadency marks (see p 20). A cadency mark relates and differentiates at the same time by denoting a man's position within the male line. Other ways to show cadency in heraldry are by changing the colour or motif of the arms.

In the business world, one common way to show that an organizational unit is an integrated part of an organization is by adding a prefix or a suffix to the parent company's trademark. BP has done that with market-sector names Air BP and BP Marine.

BP marine

air BP

BP farm service

BP heat

BP detergents

Corporate kinship may also be shown by 'endorsed identity', where two apparently independent entities are bound together. An endorsed identity can be either organizational, as expressed by the suffix A Gulf + Western Company, or it can be product related, as expressed by Citroën Xantia (see p 59).

However, other ways of showing family relationships exist. Products themselves may bear offspring through the process of 'brand stretching'. Line extension takes place if a family of products, such as Colgate toothpaste with its various package sizes, is augmented by Colgate mouthwash. Cross branding comes about when a prestigious name, like that of Rolls Royce, is lent by licence to a manufacturer who produces another product, such as eyewear.

When Railfreight, the deregulated freight operation of British Rail, established a new design programme, they kept the British Rail typography to show the intension, the upstream relationship. To show the extension, the downstream relationship, they developed a family of heraldic marks constructed on one grid.

Organizational unit	Signs
Railfreight (parent company)	bars
Distribution	lozenges
Petroleum	waves
Metals	chevrons
Coal	diagonal checkers
Construction	checkers

Table twenty Railfreight units and their signs.

All marks contain/conceal an 'F' for freight. The marks – not the 'F's – are designed with a view to conspicuous use on moving locomotives.

A vertical strip variation of the marks is used to supplement the real thing, but it may also be applied by itself. The relationship between divisions and parent company is obvious; the nature of the relationship is not.

The Alpha BP Bold typeface was introduced exclusively for the display of family relations: market-sector names, branded facilities and product names. *Typeface* Alpha BP, UK. *Design* Colin Forbes and Adrian Frutiger/Crosby Fletcher Forbes, 1970.

540

541
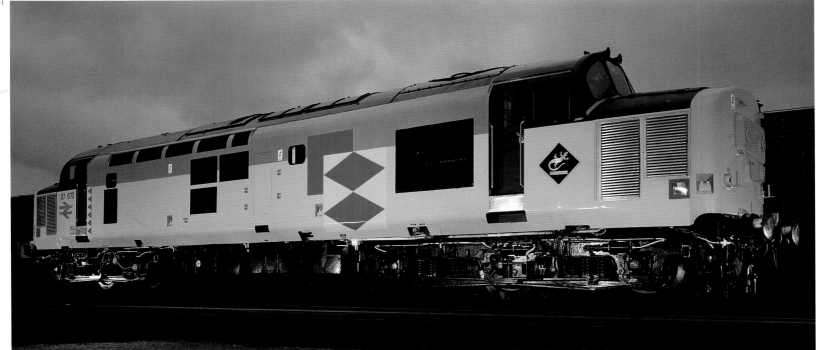

542

540
Railfreight's corporate image is made up of the parent symbol, which is the first in the series, and five related sub-sector symbols: Railfreight Distribution, Metals, Petroleum, Coal and Construction. Each symbol contains the letter 'F' made up from the top left-hand corner of the framing square and one of the adjoining horizontal shapes.
Company Railfreight, UK.
Design Roundel Design Group, 1987.

541
With Railfreight's identification marks it is possible to read a locomotive at a glance. This engine has the double diamond distribution sign painted on its side.

542
These depot plates depict the mascots of major distribution depots. The motifs were developed from proposals by staff. Their popularity has since led to them being applied to badges, overalls and sports kits.

543
Overleaf
The livery on Railfreight's locomotives maintains a distinction between the transporter and the freight.

Trade convergence

Corporate identity represents both what a
company is and what it is not, in relation to
other businesses. Companies use their corporate
design programmes to position themselves in
a conceptual relationship with colleagues and
competitors. A company's identity is, to a certain
degree, implicitly defined by the visual identity
of other companies. It is differentially conditioned.

Sometimes the relationship between one
company's visual identity and that of another
company is marked by an explicit visual
reference. For example: Apple's polychrome
stripes may be seen as a playful reference
to IBM's time-honoured monochrome stripes;
and the fox trademark created for J C Penney's
polo shirt would not have existed without the
prior existence of the Lacoste crocodile.

544

548

545

546

547

544–5
When the Danish
newspaper *Information*
computerized its systems
using Apple Computers,
Apple Center Promaq
celebrated the deal
by 'applefying' the
newspaper's masthead
'i' in an advertisement.

544
Newspaper advertisement,
1992.
Company Promaq, Denmark.

545–6
Company Information,
newspaper, Denmark.
Design 1945.

547
The multi-coloured Apple
symbol (see also fig 241,
p 138).
Company Apple Computers,
USA.
Design Rob Janoff, Regis
McKenna Advertising, 1977.

548
How J C Penney tried
to outfox Lacoste.
Magazine advertisement,
late 1980s.
Company J C Penney, USA.

Frequently the coexistence of companies in a certain trade is visualized by an apparent convergence between corporate identities. For a long time, certain motifs have been identified with particular trades, such as masks for theatre and anchors for shipping. However, the convergence we deal with here goes beyond those motivated marks, it deals with arbitrary marks and with style.

An international example of trademark convergence is provided by banks. In many countries they choose non-figurative trademarks. Many of these trademarks are similar to the Chase Manhattan trademark designed by Chermayeff & Geismar in 1960. Today this type of trademark is almost generic with banking.

A national example of trademark trade convergence is provided by German automobile manufacturers; they all seem to prefer logos based around circles.

549
Company Chase Manhattan, USA.
Design Tom Geismar, Chermayeff & Geismar, 1960.

550
Company Jyske Bank, Denmark.
Design Jyske Bank, 1967.

551
Company Bankers Trust, USA.
Design Michael Vanderbyl.

552
Company Development Co-operative Bank, India.
Design Yeshwant Chaudhary.

553
Company National Westminster Bank, UK.
Design HSAG, 1969.

554
Company São Paolo Development Bank, Brazil.
Design Alexandre Wollner.

555
Company Dresdner Bank, Germany.
Design Jürgen Hampel, 1970.

556
Company Senbank, South Korea.

557–61
Why do VW, Opel, Mercedes, BMW and AUDI all have circular trademarks?

557
Company VW, Germany.
Design 1938.

558
Company Opel, Germany.
Design c1930.
Redesign 1987

559
Company Mercedes-Benz, Germany.
Design Gottlieb Daimler, 1911.

560
Company BMW, Germany.
Design Franz Josef Popp, 1917.

561
Company AUDI, Germany.
Design Horch, 1932.

Private brands

Trademarks are a strong weapon in the battle for the consumer's mind. The power of trademarks, however, can occasionally be so overwhelming that consumers choose to reject them. Some consumers feel better if they buy unbranded merchandise. When businesses capitalize on that feeling they encourage mutiny against ordinary brands.

MUJI, a chain of retail clothing and accessories shops with almost a hundred outlets in Japan and the UK, has specialized in unbranded goods. The name MUJI means 'No brand goods'. Ironically, MUJI has itself become a powerful brand, in much the same way as nudity can be regarded as an expressive way of dressing.

Other retail chains and department stores have noticed the desire for no brands and have created generic brands – a shop's own brand. Generic goods are packaged to look alike – apparently for protection only; they convey frugality and a clear message: 'This is for your basic needs. We don't waste your money on silly marketing games. You are too clever for that.' Even so, generic brands do not imply that retailers have become saints or that they have forgotten that making money is the purpose of their business. The trick is that the apparent absence of persuasion is highly persuasive to some customers. On top of that, shops achieve a stronger buying position when they are not forced to rely on branded goods. This can mean a larger profit margin.

However, not all customers prefer unbranded merchandise or generic brands. Or more precisely, not all customers prefer unbranded goods or generic brands all the time. There are times when we want to be persuaded. In fact, there are times we feel a little cheated if we are not a little deceived. Who wants to celebrate with a generic champagne?

Generic brands are only one type of private brand. Private brands or own labels exist on a continuum. At one end are naked generic brands with nothing but protective packaging and the strictly necessary identifying text; at the other end are private brands that often rival other branded goods in terms of suggestive packaging. The private-brand food packages of Harvey Nichols, the London department store, belong to the latter category.

562
Generic brand goods
from the Swedish co-op,
Konsum. Dog food, cleaner,
toothpaste and ketchup all
look alike.
Company Konsum, Sweden.
Design Svea Annonsbyrå,
1978–9.

563–4
Private brand goods from
Harvey Nichols are no less
evocative than other brands.
Company Harvey Nichols, UK.
Design Michael Nash, 1992.

HARVEY NICHOLS

OLIVE OIL

750ml e 25.3fl oz

HARVEY NICHOLS

EXTRA VIRGIN

OLIVE OIL

0.5lt e 16.9fl oz

HARVEY NICHOLS

PROVENCE
HERB
VINEGAR

6°

net
ct. 8½fl oz 25cl e

Identity versus variation

The immediate purpose of all trademarks and the design programmes, of which they are a vital part, is identification. Most of the time, identification is achieved by recognition. Recognition implies repetition, preferably frequent repetition. However, repetition is not the answer to all corporate identity problems. It can become too much. The repeated message can be so monotonous that it becomes difficult to catch the full attention of target groups.

'Two completely opposite phenomena occupy us – habit and change', said the seventeenth-century French philosopher, Jean de la Bruyère. The challenge for the designer and the client is to develop a design programme that provides both identity and enough room for variation.

One way of solving this is to create a mark as versatile as Michelin's Bibendum. You meet him in a great number of different postures, but you always recognize him. Variation has become part of the identity. Change has come to stay. Perhaps because so many trademarks are so cool, perhaps because they are so static, many companies supplement their corporate imagery with a kind of graphic pet, which is much more versatile than the trademark itself and which supposedly communicates more kindness and humour. Esso's tiger in the 1960s and 1970s and IBM's pink panther in the 1990s are examples of this high-tech/high-touch compensation. Sometimes, the graphic pet is just another example of repair design; sometimes it is a temporary adaptation to a specific campaign theme.

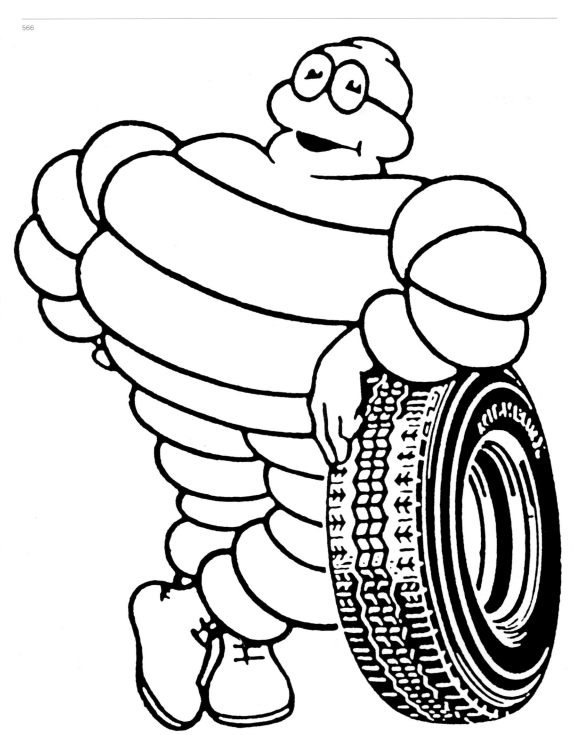

566

565

565
A temporary graphic pet supplement to design programme.
Company IBM, Denmark.

566–7
Michelin has benefited from its pneumatic-bodied figure of Bibendum ever since the founding Michelin brothers got the idea of a Michelin man from tyres stacked up in assorted sizes at a trade show. When the poster artist O'Galop visited the brothers with a cartoon for a German beer

manufacturer showing a large Bavarian raising his beer mug with the words 'Nunc est Bibendum', they asked him to adapt the image for their tyre man. The name Bibendum stuck, and over the years Monsieur Bibendum has developed his own fun loving personality. A lovable and familiar figure,

he has helped to make Michelin an instantly recognizable brand.
Company Michelin, France.
Design O'Galop, 1898.
* An image, a descriptive mark.

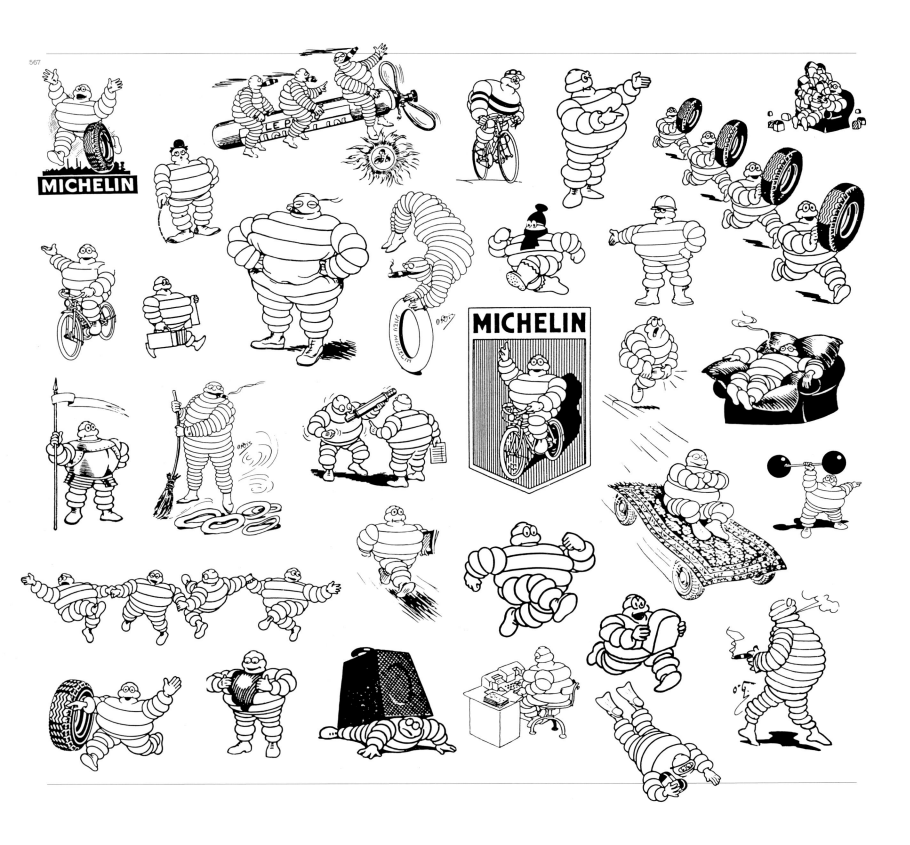

Sculpture

Graphic design is basically a two-dimensional activity, but sometimes it is possible to escape from graphic flatland by adding a spatial dimension that can turn a trademark into sculpture (see p 91).

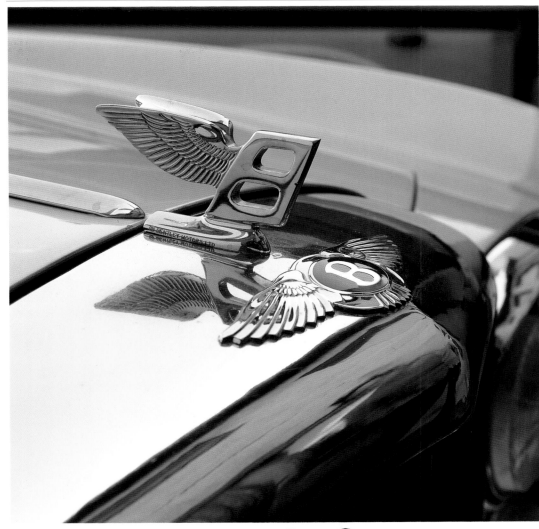

569

570

571

572

568
Trademark sculpture outside the Hirschsprung cigar factory.
Company Hirschsprung & Sønner, Denmark.
Design Johannes Hansen, 1957.

569
Radiator badge.
Company Bentley, automobiles, UK.
Design F Gordon Crosby, 1921.

570
When a truck owner buys new tyres, the trucker gets a three-dimensional Monsieur Bibendum, which he mounts on the cab roof.
Company Michelin, France.
Design O'Galop, 1898.

571
Wings-and-wheel trademark sculpture on Hotel Astoria next to Copenhagen's Central Station.
Company Danish State Railways, Denmark.
Design c1935.

572
The Carlsberg brewery named a strong export beer after its Elephant Gate (see overleaf). However, when the company discovered that in some alcohol-consuming areas of western Africa two elephants are a sign of mischief, it adjusted numerically to the market by adding a third live elephant to the label.

573
Overleaf
The Elephant Gate outside the Carlsberg brewery in Copenhagen was built in 1901 by the sculptor H P Pedersen-Dan and the architect Vilhelm Dahlerup. The brewer, Carl Jacobsen, who commissioned the gate took his inspiration from Bernini's elephant supporting an obelisk in Rome's Piazza Santa Maria Sopra Minerva.

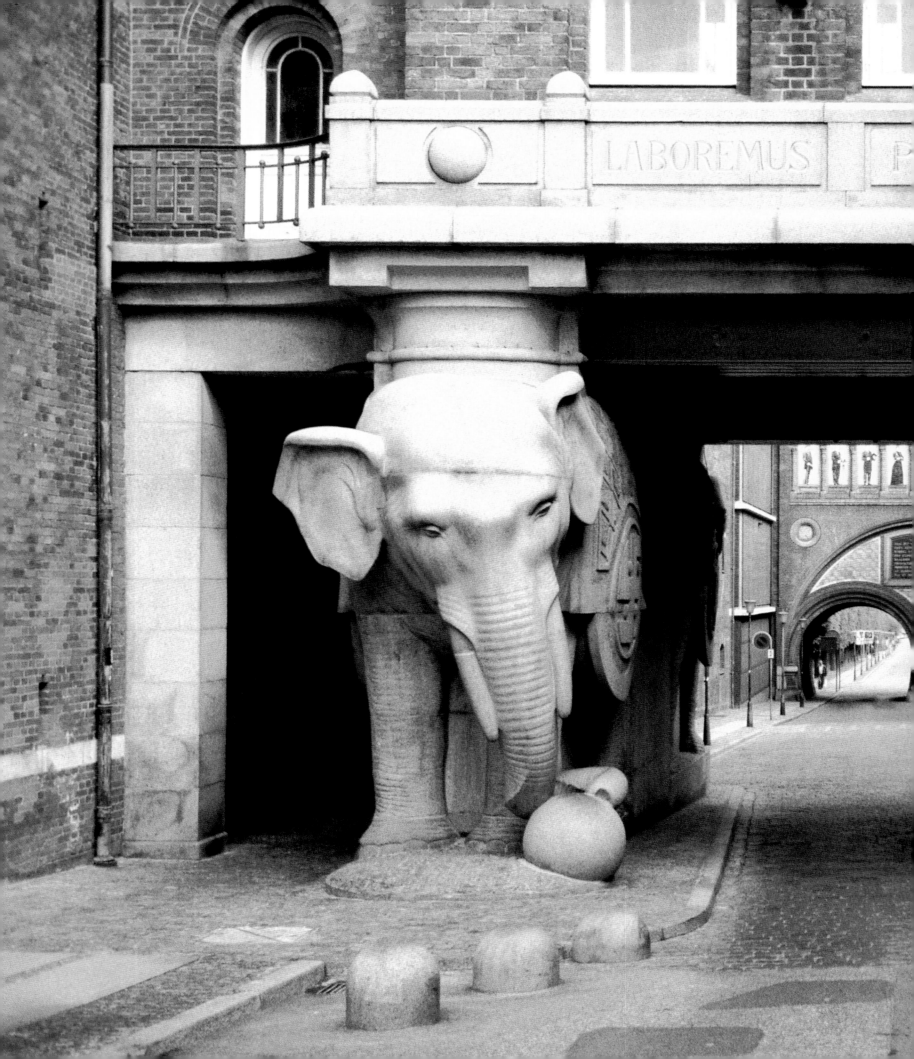

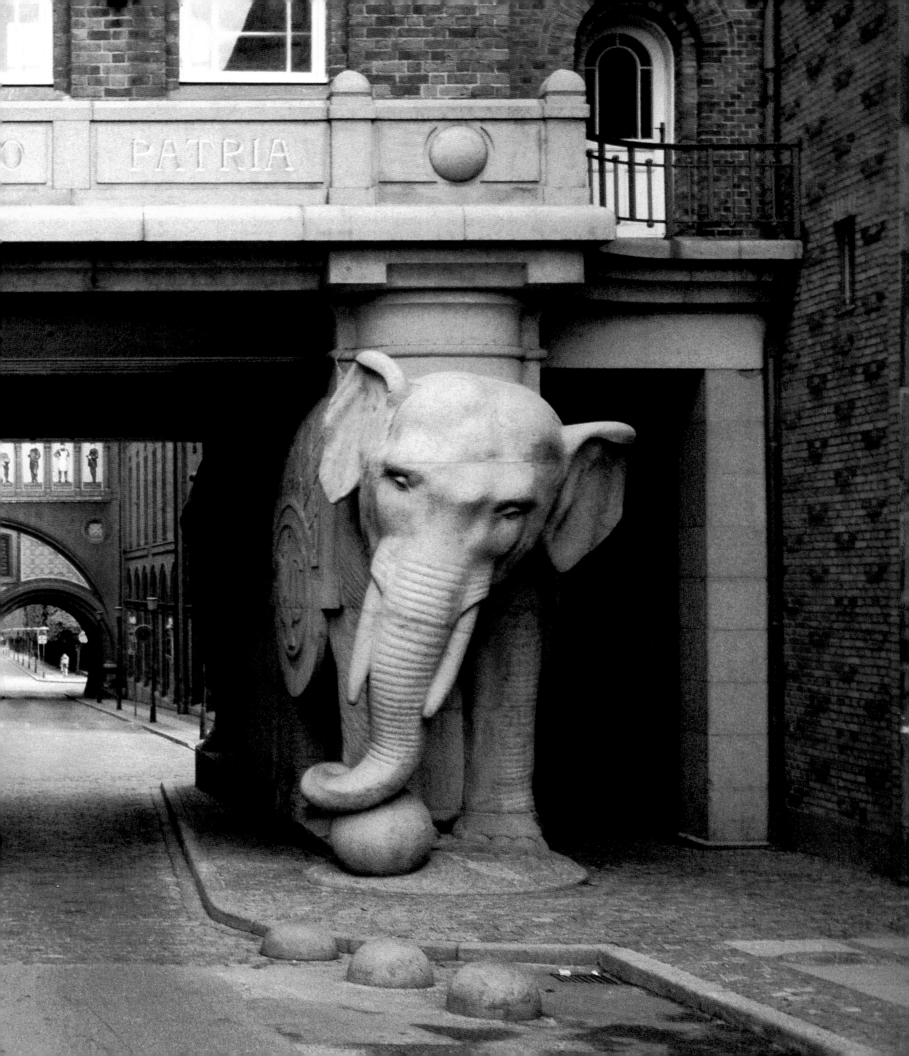

The fifth element

Immediate identification is the primary task of most trademarks. In certain cases, this immediate identification is best provided by a special type of trademark. This element is normally not thought of as a trademark, but as something extra, a fifth element in addition to the four basic elements of a design programme: name mark, picture mark, typeface and colour.

The fifth element can be any visual element that, under special conditions, is better suited to fast identification than the four basic elements.

On cars, the radiator grille often plays the role of a fifth element. When we look in the rear view mirror after hearing a honking car, we do not look for a name mark on the car behind us. Nor do we look for a picture mark or a typeface or a colour. We look for the radiator grille. The shape of the grille tells us in a split second that it is a BMW that wants to overtake us. BMW, Mercedes, Rolls and many less prestigious makes have fifth-element radiator grilles. They vary slightly from year to year, but never leave you in doubt as to their identity.

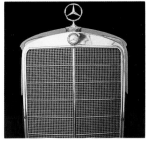

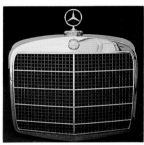

574
On BMW cars the shape of the fifth-element 'double kidney' radiator grille changes from model to model. But you are left in no doubt – the basic shape remains unchanged.
Company BMW, Germany.

575
Deviations from the standard pattern of radiator grilles are compensated for on Mercedez-Benz cars by extra large stars.
Company Mercedes-Benz, Germany.

The Pizza Hut chain of fast-food outlets has turned its roof shape into a fifth element. Wherever you encounter a Pizza Hut at the roadside, you can spot the roof from a distance. In downtown areas where Pizza Hut cannot build its own characteristic Pizza Hut buildings, it displays an image of its Pizza Hut roof on the shopfront.

Only the imagination limits what a fifth element can be. Along with its parasol (see p 122), the Tuborg brewery sponsors another fifth element; the shape of its bottle label, the so-called watchmaker label (see fig 675).

For Adidas, the sports clothes manufacturer, a powerful fifth element is three stripes. For Coca-Cola, it is the Dynamic Ribbon device. For the Olympic Winter Games in Lillehammer 1994, it was a crystal pattern. Finally, Absolut Vodka has chosen its bottle to be the fifth and most powerful element in its product imagery.

Basic elements in a design programme:
Name mark
Picture mark
Typeface
Colour
Fifth element

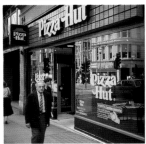
576

578

581

577
579

582

583

584

580

585

586

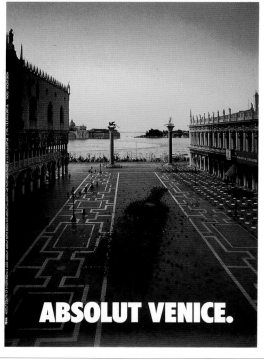

585
Company The Absolut
Company, Sweden.
Design Gunnar Broman
(bottle)/Hans Brindfors
(graphics), early 1970s.

586
This vodka advertising
campaign focuses on the
fifth element, the bottle,
and in so doing sets up
associations with particular
cities. The brand benefits
from connotations of an
urban and cosmopolitan
sophistication. Wherever
you are there is an Absolut
Vodka for you. There is also
the suggestion that there
are myriad flavours.
Company The Absolut
Company, Sweden.
Design TBWA Advertising
Inc, 1988–93.

ABSOLUT MIAMI.

ABSOLUT VIENNA.

ABSOLUT MUNICH.

ABSOLUT CHICAGO.

ABSOLUT COPENHAGEN.

ABSOLUT PEAK.

219

Speed Skating
500 m Men
Start List

1	Johann Koss	NOR
	Falco Zandstra	NED
2	Toro Itokawa	JPN
	Rijken Ritsma	NED
3	Stein Johansen	NOR
	Carl Eminger	AUT

587–90
The crystal pattern was chosen as a fifth element for the Lillehammer Winter Games because it is characteristic of Norwegian nature where it is found in rocks, snow and ice. At the Games it was successfully used in many colours at many places: on television screens, in advertisements, on brochures, on flags, on oars and so on.

Event Olympic Winter Games, Lillehammer, Norway.
Design 1994.

Translation

As international trade grows, so does the need for truly international trademarks. Time-honoured name marks, such as Coca-Cola and Carlsberg are sometimes transcribed with characters from non-Latin alphabets to ensure that the pronunciation is not lost and that the identity is legible. Sometimes the name is translated for use in a specific market. On occasions, a company changes its name once and for all, as did the German automobile manufacturer Horch, who after the Second World War translated his name into Latin *Audi* (listen!). Sweden's Volvo (I roll) was Latin from the outset.

In Scandinavia, special letters, such as Æ, æ, Ä, ä, Ø, ø, Ö, ö and Å, å, sometimes inspire translation away from these Northern anomalies. Thus Mærsk becomes Maersk, Göta-banken becomes Gotabanken and Skånska Cementgjuteriet becomes SKANSKA.

The opposite phenomenon takes place as well. In order to give their products a certain ethnic flavour, companies add linguistic peculiarities, such as diaereses. Two all-American ice-cream brands, Häagen-Dazs and Frusen Glädje, were created to appear Scandinavian.

Translations can be cultural as well as linguistic. The translation of Red Cross into Red Crescent in the Arab world, and into Red Lion and Rising Sun in Iran, is a matter of culture (including religion) as much as a matter of language.

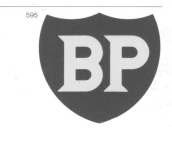

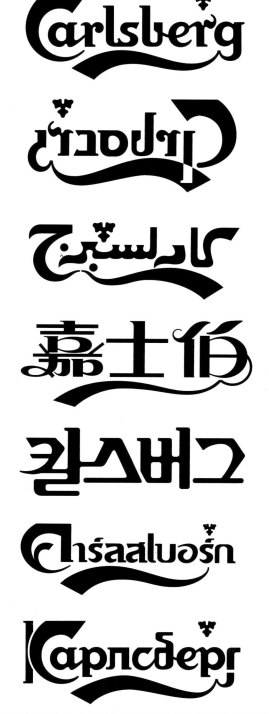

591
The Danish shipowners, airline and industrial group Mærsk became Maersk.
Company Maersk, Denmark.
Design A P Møller.

592
Before 1984, the name of the Swedish construction group was Skånska Cementgjuteriet. The hexagon dates back to the 1950s and 1960s.
Company Skanska, Sweden.
Design Jonsson & Essen, 1984.

593
The International Red Cross and Red Crescent movement use three separate symbols around the world. (Red Cross, Red Crescent and Red Lion and Rising Sun).
Company International Red Cross and Red Crescent Movement, Switzerland.

594
Translated name marks.
From top to bottom
Danish, Arabic, Hebrew, Chinese, Thai, Korean and Russian.
Company Carlsberg, Denmark.
Design Thorvold Bindesbøll, 1987 and 1904.

595
The European BP trademark.
Company BP, UK.
Design 1930
Redesign Siegel & Gale, 1989

596
This Arab version of the BP mark draws on the Farsi language, a Persian version of Arabic, and spells out a sound like *Bee-Buh*, as there is no equivalent of 'P' in Arabic.
Company BP

597
Previous page
This street in Hong Kong
displays signs and trademarks
in both Chinese and English.

598
Olympic Games, 1992,
Barcelona, Spain.
Design Javier Mariscal, 1992.

Notes

A history of trademarks

1. Sven Tito Achen, *Heraldikkens femten Gleader* (Copenhagen, G E C Gads Forlag, 1978), pp 55–6 and Ottfried Neubecker, *Heraldik. Kilder, brug, betydning* (Copenhagen, Hamlet, 1979), p 6.
2. Poul Bredo Grandjean, *Dansk Heraldik* (Copenhagen, J H Schultz Forlag, 1919), p 13.
3. M-C Guigue, *De l'origine de la signature et de son emploi au moyen age* (Paris, Dumoulin, 1863), p 25.
4. *Ibid* p 37.
5. Manfred R Wolfenstine, *Brands and Marks* (Norman, University of Oklahoma Press, 1970), p 3.
6. *Ibid* p 5.
7. *Ibid* chap XIX.
8. Fay E Ward, *The Cowboy at Work* (Norman, University of Oklahoma Press, 1987), pp 67–8.
9. Hermann Regner Riber, *Hollænderbyens bomærker. St Maglebys gårde, deres indretning og ejerforhold* (Kastrup, Kastrup Central Forlag, 1975), p 13.
10. *Ibid* pp 9 and 12.
11. A W Johnston, *Trademarks on Greek Vases* (Warminster, Aris & Philips, 1979), pp 48–53.
12. Bernard Rudofsky, 'Notes on early trademarks and related matters', *Seven Designers look at Trademark Design*, (ed) Egbert Jacobsen (Chicago, Paul Theobald, 1952), p 3.
13. D M Bailey, *A Catalogue of the Lamps in the British Museum* (London, British Museum Publications, 1980), p 90.
14. *Ibid* pp 96 and 101.
15. William Bowyer Honey, *European Ceramic Art* (London, Faber and Faber, 1952), p 393.
16. Franz Rziha, *Studien über Steinmetz-Zeichen* (Vienna, 1883), pp 20–2.
17. *Ibid*.
18. *Ibid*.
19. *Ibid* p 38.
20. *Early Printers' Marks* (London, Victoria & Albert Museum, 1962) and Rudofsky, 'Notes on early trademarks and related matters'.
21. C M Briquet, *Les filigranes: The New Briquet*, Jubilee Edition (Amsterdam, The Paper Publications Society, 1968).
22. Mogens Dupont-Petersen, *Franske Stolemagere i 1700-tallet* (Copenhagen, Gylendal, 1982), p 106.
23. Tove Clemmensen, 'Signerede arbejder af Kobenhavnske snedkere', *Georg Norregard og Helge Sogaard: Kobenhavns Snedkerlaug gennem fire hundrede år* (Copenhagen, 1954), p 272.

Function

1. Some authors define brands as though they were nothing but trademarks. Philip Kotler has stated in *Marketing Management: Analysis, Planning, Implementation and Control* (Englewood Cliffs, Prentice Hall, 1967): 'A brand is a name, term, sign, symbol, or design, or combination of them, intended to identify the goods or service of one seller or group of sellers and to differentiate them from those of their competitors', p 444.
2. Wally Olins, *Corporate Identity* (London, Thames and Hudson, 1989), p 78.
3. Per Mollerup, *The Visible Company* (Stockholm, Svensk Industridesign/Industri Litteratur, 1993), p 14.

Communication

1. Ferdinand de Saussure, *Course in General Linguistics*, translated and annotated by Roy Harris (London, Gerald Duckworth & Co, 1983), p 33.
2. Charles Sanders Peirce, *Collected Papers 1931–58* (Cambridge, Harvard University Press), vol 2, p 228.
3. The model is adapted from Claude E Shannon and Warren Weaver, *The Mathematical Theory of Communication* (Urbana, The University of Illinois Press, 1964, 10th edn), p 7.
4. *Ibid* p 24.
5. Umberto Eco, *A Theory of Semiotics* (Bloomington, Indiana University Press, 1976), p 142.
6. Charles Morris, *Signs, Language and Behaviour* (George Braziller, New York, 1946), p 219.
7. Shannon and Weaver, *The Mathematical Theory of Communication*, p 26.
8. *Ibid*
9. Henri Mouron, *Cassandre* (London, Thames and Hudson, 1985).
10. Roman Jakobson, 'Lingvistik og poetik', *Vindrosen* 7, Copenhagen, 1967.

11. Pierre Guirard, *Semiology* (London, Routledge & Kegan Paul, 1975), pp 9–10 and pp 13–14.
12. Charles Sanders Peirce, *Collected Papers 1931–58*, vol 2, p 228.
13. *Ibid*.
14. Guirard, *Semiology*, pp 45–65.
15. This table is adapted from *ibid*, vol 10, pp 45–59.
16. *Ibid* p 37.
17. *Ibid* p 38.
18. *Ibid*
19. Peirce, *Collected Papers 1931–58*, vol 2, pp 247–9, vol 8, p 335.
20. *Ibid* vol 2, p 27.
21. *Ibid* vol 8, p 368, note 23.
22. Table taken from *ibid* vol 2, p 229.
23. Paul Rand, *A Designer's Art* (New Haven and London, Yale, 1985).

Taxonomy

1. The US legal definition of service marks can be found in the *United States Code*, title 15, chapter 22.
2. Yasaburo Kuwayama, *Trademarks & Symbols of the World, The Alphabet in Design* (Rockport, Rockport Publishers, 1988).
3. Hans Weckerle, 'Typographer as Analyst', *Design Magazine* 240, December 1968, no 42.

Motifs

1. Correspondence from the Apple Law Department, 17 August 1994, to the author.
2. The symbols for the Greek alphabet are as follows.

Αα	alpha	Κκ	kappa	Ττ	tau
Ββ	beta	Λλ	lambda	Υυ	upsilon
Γγ	gamma	Μμ	mu	Φφ	phi
Δδ	delta	Νν	nu	Χχ	chi
Εε	epsilon	Ξξ	xi	Ψψ	psi
Ζζ	zeta	Οο	omicron	Ωω	omega
Ηη	eta	Ππ	pi		
Θθ	theta	Ρρ	rho		
Ιι	iota	Σσ	sigma		

Bibliography

Aaker David A, *Managing Brand Equity*, New York, The Free Press, 1991.

Aaker David A and Alexander L Biel (eds), *Brand Equity & Advertising*, Hillsdale, Lawrence Erlbaum Associates, 1993.

AB Svenska *Telegrambyrån*, Malmö, 1965.

Achen Sven Tito, *Danske Adelsvåbener. En heraldisk nøgle*, Copenhagen, Politikens Forlag, 1973.

Achen Sven Tito, *Heraldikkens femten Glæder*, Copenhagen, G E C Gads Forlag, 1978.

Achen Sven Tito, *Symbols Around Us,* New York, Van Nostrand Reinhold, 1978.

Achen Sven Tito, *Danmarks kommunevåbener*, Copenhagen, Forlaget Komma, 1982.

Adams Ramon F, *The Manual of Brands and Marks*, Norman, University of Oklahoma Press, 1970.

Adjouri Nicholas, *Die Marke als Botschaft*, Berlin, Vier-Türme-Verlag, 1993.

Aicher Otl and Martin Krampen, *Zeichensysteme dervisuellen Kommunikation*, Stuttgart, Verlagsanstalt Alexander Koch, 1993, 1977.

Aldersey-Williams Hugh, *World Design: Nationalism and Globalism in Design*, New York, Rizzoli, 1992.

Arnhem Robert, 'Perceptuell abstraktion och konst*', Konst ochpsykologi*, Lund, Gleerup, 1970.

Artéus Margareta, (ed), *Kosta 250 år*, Kosta, Kosta Boda, 1992.

Ayer A J, *The Origins of Pragmatism, Studies in the Philosophy of Charles Sanders Peirce and William James*, London, Macmillan, 1968.

Bailey D M, *A Catalogue of the Lamps in the British Museum, II. Roman Lamps made in Italy*, London, British Museum Publications, 1980.

Barthes Roland, *Elements of Semiology*, New York, Hill and Wang, (1964) 1968.

Barthes Roland, 'Billedets retorik' in Bent Fausing and Peter Larsen, *Visuel kommunikation*, Copenhagen, Medusa, 1980.

Bauer Konrad F, *Aventur und Kunst*, Frankfurt am Main, Bauersche Giesserei, 1940.

Bayley Stephen, *Coke!*, London, Boilerhouse, 1986.

Bedingfeld Henry and Peter Gwynn-Jones, *Heraldry*, London, Magna Books, 1993.

Biedermann Hans, *Symbol Lexikonet*, Stockholm, Forum, (1989) 1991.

Biedermann Hans, *Gads symbol leksikon*, Copenhagen, G E C Gad, 1991.

Birkigt K and M M Stadler, *Corporate Identity*, Munich, Verlag Moderne Industrie, 1980.

Bjerre Mogens, *Mærkevaren*, Copenhagen, Schultz, 1993.

Blonsky Marshall, (ed), *On Signs*, Oxford, Basil Blackwell, 1985.

Blumer Herbert, *Symbolic Interactionism: Perspective and Method*, Englewood Cliffs, Prentice Hall, 1969.

Bojesen Kay, *I anledning af mindeudstillingen i Kunstindustrimuseet*, Copenhagen, Kunstindustrimuseet, 1959.

Booth-Clibborn Edward, *Design à la Minale Tattersfield*, London, Polygon Trust, 1986.

Booth-Clibborn Edward and Daniele Baroni, *The Language of Graphics*, London, Thames and Hudson, 1980.

Briquet C M, *Les filigranes, The New Briquet*, Amsterdam, Jubilee Edition, The Paper Publications Society, (1907) 1968. Reprint.

Broby-Johansen 'R Hvem er mester for', *Berlingske Illustreret tidende*, 30, 28 July 1940.

Broby-Johansen R, *Kunstordbog*, Copenhagen, Gyldendal, 1965.

Brunius Teddy, *Estetik förr och nu,* Stockholm, Liber, 1986.

Brunner Gisbert L, *The Story of Creation*, La Chaux-de-Fonds, Corum Ries Bannwart and Co, 1993.

Bøje Ch A, *Danske guld og sølvsmede mærker før 1870*, I-III Copenhagen, Politikens Forlag, 1979.

Cauzard Daniel, Jean Perret and Yves Ronin, *Le livre des Marques*, Paris, Editions Du May, 1993.

Clemmensen Tove, 'Signerede og stemplede møbler', *Nationalmuseets Arbejdsmark*, København, Nationalmuseet, 1949.

Clemmensen Tove, 'Signerede arbejder af københavnske snedkere', *Georg Nørregaard og Helge Søgaard: Københavns Snedkerlaug gennem fire hundrede år* København, 1954.

Cooper JC, *An Illustrated Encyclopaedia of Traditional Symbols*, London, Thames and Hudson, 1978.

Cornfeld Betty and Owen Edwards, *Quintessence: The Quality of Having It*, New York, Crown Publishers, 1983.

Cousins James, *British Rail Design*, Copenhagen, Danish Design Council, 1986.

Dahlby Frithiof, *Symboler i kirkens billedsprog*, København, G. E. C. Gad, (1963) 1985.

Danmarks Adels Aarbog, Copenhagen, Vilh. Trydes Boghandel, 1910.

Dansk Mejeribrug 1882–2000, Århus, De Danske Mejeriers Fællesorganisation, 1982.

Delorme Christian, *Le logo*, Paris, Les Editions d'Organisation, 1991.

Dietz Lawrence, *Soda Pop*, New York, Simon and Schuster, 1973.

Draiby Ejvind, *Gamle Danske Milepæle*, Copenhagen, Miljøministeriet, 1993.

Dupont-Petersen Mogens, *Franske Stolemagere i 1700-tallet*, Copenhagen, Gyldendal, 1982.

Dyer Gillian, *Advertising as Communication*, London, Routledge, 1982.

Early Printers' Marks, London, Victoria & Albert Museum, 1962.

Eco Umberto, *A Theory of Semiotics*, Bloomington, Indiana University Press, (1976) 1979.

Ejlers Steen, *Ib Andersens Brugsgrafik*, Copenhagen, Christian Ejlers' Forlag, Forening for Boghaandværk, 1980.

Eksell Olle, *Design = Ekonomi*, Stockholm, Albert Bonniers Förlag, 1964.

Firth Raymond, *Symbols: Public and Private*, London, George Allen & Unwin, 1953.

Fiske John, *Introduction to Communication Studies*, London, Routledge, (1982) 1990.

Foley John, *The Guinness Encyclopaedia of Signs and Symbols*, Enfield, Guinness Publishing, 1993.

Fox-Davies Arthur Charles, *The Art of Heraldry*, London, Bloomsbury Books, (1904) 1986.

Frederiksen Erik Ellegaard, *Knud V Engelhardt: Arkitekt & Bogtrykker 1882–1931*, Copenhagen, Forening for Boghaandværk, Arkitektens Forlag, 1965.

Friar Stephen and John Ferguson, *Basic Heraldry*, London, The Herbert Press, 1993.

Frutiger Adrian, *Signs and Symbols: their Design and Meaning*, London, Studio Editions, 1991.

Gagliardi Pasquale, (ed), *Symbols and Artifacts: Views of the Corporate Landscape*, New York, Aldine de Gruyter, (1990) 1992.

Gerstner Karl, *Compendium for Literates*, Cambridge, Massachusetts, MIT Press, 1974.

Gibbs David (ed), *Pentagram: The Compendium*, London, Phaidon Press, 1993.

Glaser Barney G and Anselm L Strauss, *The Discovery of Grounded Theory*, New York, Aldine de Gruyter, 1967.

Gorb Peter (ed), *Living by design*, London, Lund Humphries, 1978.

Graesse J G Th and E Jaennicke, *Führer für Sammler von Porzellan und Fayence, Steinzeug, Steingut usw,* 18th print, Braunschweig and Berlin, Klinklardt & Biermann, (later than 1922).

Grandjean Bredo L, *Kongelig dansk Porcelain 1884–1980*, Copenhagen, Gyldendal, 1983.

Grandjean Poul Bredo, *Dansk Heraldik*, Copenhagen, J H Schultz Forlag, 1919.

Graphic Design in America, New York, Walker Art Center, Harry N Abrams, 1989.

Grobecker Kurt, *Kleine Chronik des Hauses Montblanc*, Hamburg, Montblanc-Simplo, 1989.

Gruel Léon, *Chiffre quatre. Recherches sur les origines des marques anciennes*, Paris and Bruxelles, G Van Oest, 1926.

Guigue M-C, *De l'origine de la signature et de son emploi au moyen age*, Paris, Dumoulin, 1863.

Guiraud Pierre, *Semiology*, London, Routledge & Kegan Paul, (1971) 1975.

Gyldendals *Tibinds Leksikon*, Copenhagen, Gyldendal, 1977–8.

Heineken History, Heineken, 1992.

Heller Steven and Gail Anderson, *Graphic Wit*, New York, Watson-Guptill, 1991.

Heller Steven and Seymour Chwast (eds), *Sourcebook of Visual Ideas*, New York, Van Nostrand Reinhold, 1989.

Hinrichs Kit and Delphine Hirasuna, *Typewise*, Cincinnati, North Light Books, 1990.

Hitchmough Wendy, *The Michelin Building*, London, Conran Octopus, 1987.

Hoffmann Hans-Henner and Drahu Kohout, *Zeichen der Zeit – Signs of the Times*, Glattbrug, Switzerland, General Motors, 1991

Hollis Richard, *Graphic Design: A Concise History*, London, Thames and Hudson, 1994.

Honey William Bowyer, *European Ceramic Art*, London, Faber and Faber, 1952.

Ibou Paul, *Banking Symbols Collection 1*, Zandhoven, Interecho Press, 1990.

Ibou Paul, *Banking Symbols Collection 2*, Zandhoven, Interecho Press, 1991.

Ibou Paul, *Famous Animal Symbols 1*, Zandhoven, Interecho Press, 1991.

Ibou Paul, *Famous Animal Symbols 2*, Zandhoven, Interecho Press, 1992.

Ibou Paul, *Art Symbols*, Zandhoven, Interecho Press, 1992.

Ibou Paul, *Logo World*, Zandhoven, Interecho Press, 1995.

Ideas on Design, London, Faber and Faber, 1986.

Il Piatto di Natale, Milan, Messulam, 1983.

Images d'utilité publique, Paris, Editions du Centre Pompidou, 1988.

Interbrand *Brands*, London, Mercury Books, 1990.

Jakobson Roman, 'Lingvistik og poetik', *Vindrosen* 7, Copenhagen, 1967.

Jepsen Anton, *Signerede danske møbler. Hovedstadens snedkere 1800-1900*, Copenhagen, Thaning & Appel, 1979.

Jepsen Anton, *Det kongelige Møbelmagasin og københavnersnedkerne. Danske møbler efter 1777*, Herning, Poul Kristensens Forlag, 1991.

Jepsen Anton *Danske snedkermøbler gennem 125 år*, Copenhagen, Rud Rasmussens Snedkerier, 1994.

Johansen Jørgen Dines, *Dialogic Semiosis*, Bloomington and Indianapolis, Indiana University Press, 1993.

Johansen Jørgen, Dines and Svend Erik Larsen, *Tegn i brug*, Copenhagen, Amanda, 1994.

Johnston A W, *Trademarks on Greek Vases*, Warminster, Aris & Phillips, 1979.

Jørgensen Keld Gall, *Semiotik*, Copenhagen, Gyldendal, 1993.

Kapferer Jean Noël, *Strategic Brand Management: New Approaches to Creating and Evaluating Brand Equity*, London, Kogan Page, 1992.

Kim Scott, *Inversions: A Catalogue of Calligraphic Cartwheels*, Peterborough, New Hampshire, BYTE Books, 1981.

Koktvedgaard Mogens and Knud Wallberg, *Varemærkeloven & Fællesmærkeloven. København: Jurist- og Økonomforbundets Forlag. Kongeriget Danmarks våben, flag og andre statskendetegn samt officielle kontrol-, garantitegn og -stempler*, 1974, Handelsministeriet, Copenhagen, 1994.

Kotler Philip, *Marketing Management: Analysis, Planning, Implementation, and Control*, Englewood Cliffs, Prentice Hall (1967) 1994.

Kraks Vejviser til agenturer og varemærker Copenhagen, Kraks Forlag, 1994.

Kraks *Vejviser til agenturer og varemærker* Copenhagen, Kraks Forlag, 1995.

Krampen Martin, 'Icons of the Road', *Semiotica*, vol 43–1/2, 1983, Amsterdam, Mouton Publishers.

Kunze Horst, *Das grosse Buch vom Buch*, Berlin, Der Kinderbuchverlag, 1983.

Kuwayama Yasaburo, *Magazine Logotypes*, Tokyo, Kashiwa-shobo Co, 1986.

Kuwayama Yasaburo, *Trademarks and Symbols of the World: The Alphabet in Design*, Rockport, Rockport Publishers, 1988.

Larsen Svend Erik, 'Manet, Picasso, and the Spectator: Identity or iconicity?', *Face*, 1:93–113, São Paolo, 1991.

Lassen Erik, *Dansk Sølv*, Copenhagen, Gyldendal, 1975.

Leach Edmund, *Culture & Communication: The Logic by which Symbols are Connected*, Cambridge, Cambridge University Press, 1976.

Lehner Ernst, *Symbols, Signs & Signets*, New York, Dover Publications, 1950.

Lévi-Strauss Claude, *Det vilda tänkandet*, Lund, Arkiv, 1962.

Lissarrague Jacques (ed), *La Cité des sciences et de l'industrie Paris – La Villette*, Paris and Milan, Electa, 1988.

Liungman Carl G, *Symboler, Västerländska ideogram: De icke-ikoniska västerländska grafernas semiotik*, Malmö, Aldebaran, (1974) 1990.

Loewy Raymond, *Industrial Design*, London and Boston, Faber and Faber, 1979.

Lötscher Andreas, *Von Ajax bis Xerox*, Zürich, Artemis & Winkler, 1992.

Maack Klaus Jürgen, *Design oder die Kultur des Angemessenen*, Vieweg Verlag.

Macrae Chris, *World Class Brands*, Wokingham, Addison-Wesley Publishing Company, 1991.

Marconi Joe, *Beyond Branding*, Chicago, Probus Publishing Company, 1993.

Meader Robert F W, *Illustrated Guide to Shaker Furniture*, New York, Dover, 1972.

Merleau-Ponty Maurice, *Maleren og filosoffen*, Copenhagen, Stjernebøgernes Kulturbibliotek, (1960) 1970.

Mollerup Per, *Signs of Denmark*, Snekkersten, Mobilia Press, 1982.

Mollerup Per, *The Corporate Design Programme*, 2nd edition, København, Dansk Design Center, 1987.

Mollerup Per, *Henry Anton Knudsen 1932–85*, Copenhagen, Design Biblioteket nr 1: Forening for Boghaandværk, 1989.

Mollerup Per, *The Visible Company*, Stockholm, Svensk Industridesign/Industri Litteratur, 1993.

Morris Charles, *Signs, Language and Behavior*, New York, George Braziller, 1946.

Moshus Petter T, *Rapport om Designprogrammet for De XVII Olympiske Vinterleker Lillehammer 1994*, Oslo, Kulturdepartementet, 1994.

Mouron Henri, *Cassandre*, London, Thames and Hudson, 1985.

Müller Lic L, *Fortegnelse over Oldsagerne i Thorvaldsens Museum*, Copenhagen Thorvaldsens Museum, 1847.

Nagai Kazumasa and Motoo Nakanishi, *World Graphic Design Now*, Tokyo, Kodansha, 1989.

Nakanishi Motoo and the CoCoMAS Committee, *Corporate Design Systems 2*, New York, PBC, 1985.

Neubecker Ottfried, *Heraldik: Kilder, brug, betydning. København: Hamlet.*
Neue Grafik 1-18. 1958–1965, Olten, Walter Verlag, 1979.

Nicolaisen Ch, 'Bomærker og Gaardnumre i Hollænderbyen paa Amager', *Aarbog* for Københavns Amt, Copenhagen, 1916.

Nordqvist Nils, *Berömda boktryckare. Bokvännens Bibliotek nr 20*, Stockholm, Sällskapet Bokvännerna, 1954.

Olins Wally, *Corporate Identity*, London, Thames and Hudson, 1989.

Osterwold Tilman, *Pop Art*, Cologne, Benedikt Taschen, 1991.

O'Sullivan Tim, John Hartley, Danny Saunders, Martin Montgomery and John Fiske, *Key Concepts in Communication and Cultural Studies*, London, Routledge, 1994.

Palazzi Lynne, 'The Eagle Has Landed', *ID* Magazine, February 1994.

Parker James, *A Glossary of Terms Used in Heraldry*, Rutland, Tuttle, 1970.

Pedersen Martin (ed), *Graphic Corporate Identity 1*, Zürich, Graphis Press Corp, 1989.

Peirce, Charles Sanders, *1931–58: Collected Papers*, Cambridge, Harvard University Press.

Pfäfflin Friedrich, *100 Jahre S. Fischer Verlag 1886–1986*, Frankfurt am Main, Fischer Verlag, 1986.

Phillips W Howard, *A Primer of Book Classification*, London, Association of Assistant Librarians, 1961.

Polenz Hans-Gerhard, (ed), *Meisterstücke für die Kunst des Schreibens*, Hamburg, Montblanc-Simplo, 1989.

Quinn Malcolm, *The Swastika: Constructing the Symbol*, London and New York, Routledge, 1994.

Railfreight Design Guide, London, Director of Architecture, Design & Environment (BRB), 1988.

Rand Paul, *A Designer's Art*, New Haven and London, Yale University Press, 1985.

Rand Paul, *Design, Form and Chaos*, New Haven and London, Yale University Press, 1993.

Rassegna, 6, Milano, Editrice CIPIA, 1981.

Riber Hermann Regner, *Hollænderbyens bomærker. St. Maglebys gårde, deres indretning og ejerforhold*, Kastrup, Kastrup Central Forlag, 1975.

Ricci Franco Maria and Corinna Ferrari, *Top symbols and trademarks of the world, Vol 1–11*, Milan, Deco Press, 1973–83.

Ries, Al and Jack Trout, *Positioning: The Battle for Your Mind*, New York, McGraw-Hill Book Company, 1981.

Rudofsky Bernard, 'Notes on early trademarks and related matters', in Egbert Jacobson, *Seven Designers look at Trademark Design*, Chicago, Paul Theobald, 1952.

Rziha Franz, *Studien über Steinmetz-Zeichen*, Vienna, 1883.

Sacharov Stanley *Symbols of Trade*, New York, Art Direction Book Company, 1982.

Saussure Ferdinand de, *Course in General Linguistics*, translated and annotated by Roy Harris, London, Gerald Duckworth & Co, (1983) 1990.

Schmidt Klaus, (ed), *Corporate Identity in Europe*, Frankfurt and New York, Campus Verlag, 1994.

Schmittel Wolfgang, *Process visual*, Zürich, ABC Edition, 1978.

Shannon Claude E and Warren Weaver, *The Mathematical Theory of Communication*, Urbana, The University of Illinois Press, (1949) 1964.

Sprigg June, *By Shaker Hands*, New York, Alfred A Knopf, 1975.

Storck H, *Dansk Vaabenbog*, Copenhagen, Vilh Tryde, 1910.
Symbol Signs, New York, The American Institute of Graphic Arts, 1993.

Sällström Pehr, *Tecken att tänka med*, Stockholm, Carlssons, 1991.

Thiset I and P L Wittrup, *Nyt dansk Adelsleksika*, Copenhagen, Vilh. Trydes Boghandel, 1904.

Thompson Philip and Peter Davenport, *The Dictionary of Graphic Images*, New York, St Martin's Press, 1980.

Thurah Lauritz de, *Den Danske Vitruvius*, Reprint, Copenhagen, Thaning & Appel, (1746) 1966.

United States Code Title 15, Chapter 22 – *Trademarks,* 1989.

Varemærket Billund, LEGO Gruppen, 1981.

Volborth Carl Alexander von, *Alverdens heraldik i farver*, Copenhagen, Politikens Forlag, 1972.

Ward Fay E, *The Cowboy at Work*, Norman, University of Oklahoma Press, (1958) 1987.

Weckerle Hans, 'Typographer as Analyst', *Design* Magazine 240, Dec 1968, 42, London, Design Council.
Who's Who in Graphic Design, Zürich, Werd Verlag, 1994.

Wichmann Hans, (ed), *Graphic Design*, Basel, Boston, Stuttgart, Mendell and Oberer, Birkhäuser Verlag, 1987.

Wichmann Hans (ed), *Armin Hofmann: His Work, Quest and Philosophy*, Basel, Birkhäuser, 1989.

Wiese, Stephan von (ed), *Anton Stankowski. Das Gesamtwerk 1925–1982*, Stuttgart, Verlag Gerd Hatje, 1983.

Wildbur Peter, *Trademarks: A Handbook of International Designs*, London and New York, Studio Vista/Reinhold, 1966.

Windahl Sven and Benno Signitzer with Jean Olson, *Using Communication Theory*, London, Sage, 1992.

Wingler Hans M, *The Bauhaus Weimar Dessau*, Berlin, Chicago, Cambridge, MIT Press, (1962) (1969) 1978.

Winstone H V E, *Royal Copenhagen*, London, Stacey International, 1984.

Wolfenstine Manfred R, *Brands and Marks*, Norman, University of Oklahoma Press, 1970.

Index

Index

599
Overleaf
Trademarks just where you
would expect to find them –
Broadway, the heart of the
Big Apple, and the centre
of overt commercialism.

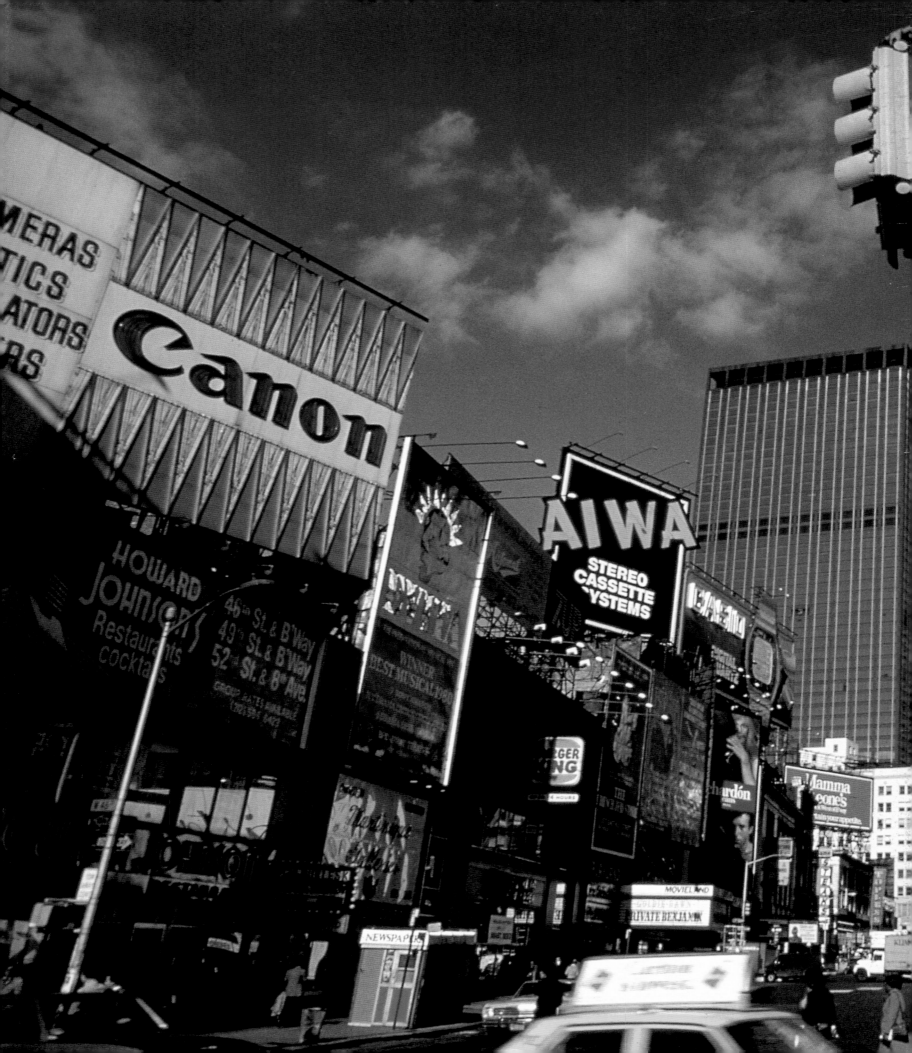

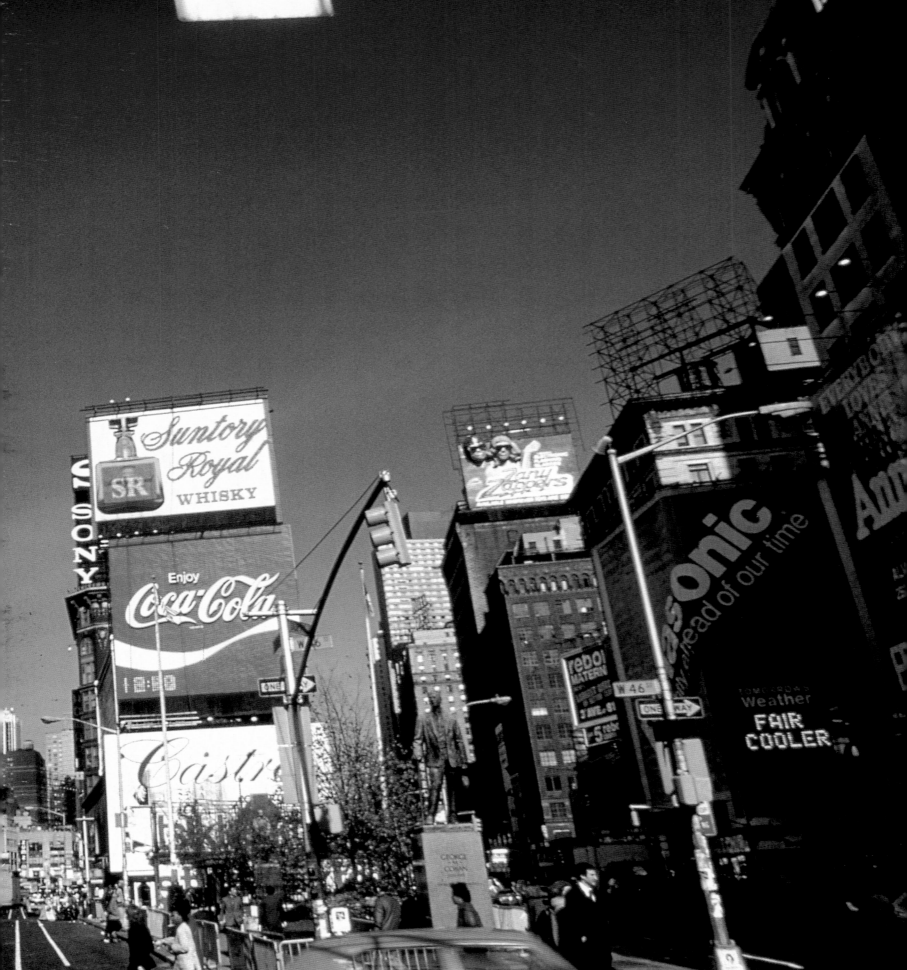

Acknowledgements

Author's acknowledgements

I would like to thank a number of individuals and organizations who inspired my work with the scientific doctorate from which this book developed, and who played a central role in the emergence of the book itself.

Professor Janne Ahlin of the University of Lund encouraged the project as my thesis supervisor, supporting it from start to finish.

Associate Professor Ken Friedman of the Norwegian School of Management (NMH) corrected the language and gave me valuable advice.

Associate Professor Svend Erik Larsen of the University of Odense offered coaching in semiotics and gave me valuable advice.

The publisher Christian Ejlers in Copenhagen, the designer Alan Fletcher in London and David Jenkins, the commissioning editor of Phaidon Press in London, all offered their encouragement and support.

My colleagues at Designlab, Copenhagen, helped to gather information, process graphic material and read proofs.

Birgitta Capetillo in Copenhagen read the manuscript with a critical eye, gave advice, and proofread the text.

Quentin Newark and Glenn Howard at Atelier Works in London offered their professional skills in the design of the book.

The Bergia Foundation and Danmarks Nationalbank's Anniversary Foundation of 1968 generously supported the research.

Many organizations and individuals provided help, information and examples of trademarks. There are too many to allow individual mention, but I am grateful to all of them.

Photography

Julian Anderson

Jacob Fløche: fig 145, pp 86–7.

Stig Nørhald fig 51, p 35; fig 94, p 58; fig 97, p 59; fig 98, p 59; fig 99, p 59; fig 102, p 60; figs 112–3, p 63; fig 562, p 208; fig 569, p 213; fig 580, p 217

Berlingske Tidende: fig 7, p 11

Ole Woldbye: fig 44, p 32

What Else: fig 6, p 11

Other studio photography: Michael Dyer Associates

Credits

The following are courtesy of Action-Plus Photographic: fig 199, pp 124–5. Anglia Television: fig 313, p 150. British Petroleum: fig 24, p 23, fig 595, p 222. Corbis UK Ltd: fig 526, p 196. CDT Design figs 85–6, pp 48–9; figs 87–8, pp 50–1; fig 150, p 91. Harvey Nichols: figs 563–4, pp 208–9. HMV Music Stores: figs 295, 299, pp 146–7. Image Bank: fig 1, pp 2–3; fig 2, p 8; fig 3, p 9; fig 150, p 100; fig 166, p 107; fig 514, p 189; fig 597, pp 223–4; fig 599, pp 238–9. © Shunji Ishida: fig 83, pp 42–3. Mary Evans Picture Library: fig 12, pp 18–9. McDonald's Restaurants Ltd: fig 383, p 164. Newell & Sorrell: fig 84, p 47; fig 293, p 146. Pentagram: figs 89–90, pp 52–4; fig 326, p 153. Tony Stone Images/© Peter Arnell: fig 103, p 61. Tim Street-Porter: fig 137, p 82. Texaco Ltd: fig 526, p 197. Topham Picturepoint: fig 116, pp 64–5. United Distillers: fig 15, p 20.

Phaidon Press Limited
Regent's Wharf
All Saints Street
London N1 9PA

First published 1997
Revised and reprinted 1998
© 1997 Phaidon Press Limited

ISBN 0 7148 3448 3

A CIP catalogue record for this book is available from the British Library.